# CRIMES OF WORCESTERSHIRE

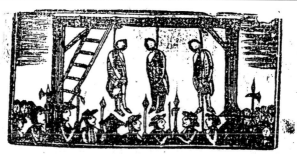

# The Last Dying Words and Confessions,

### TRIALS AND EXECUTION OF

# John Batty & W. Clements,

## FOR BURGLARY. AND.

# JOHN WATCHORNE

## *FOR FORGERY*

Who were EXECUTED at WORCESTER, on FRIDAY, March 22, 1816,

JOHN BATTY, alias BATES, is about 40 years of age, was born in Leicestershire, at a place called SHOWELL, near Lutterworth; he was of decent but humble parentage, and when of a proper age he was apprenticed to a *Stone Mason*, but being addicted to improper practices he very soon enlisted as a Marine, in which service he remained some years, when obtaining a discharge, he returned to his former habits, and being apprehended for a robbery, was committed to Warwick Gaol, from which place at the expiration of his Sentence he returned to the adjacent country loitering about till the 19th of September last, when in company with the other malefactor, WILLIAM CLEMENTS, he broke open the house of *Thomas Martin*, of *Paxford*, in this County, in the middle of the night, and putting the said Thomas Martin and his Wife in bodily fear, robbed the house of a considerable quantity of seven shilling pieces, a Bank post Bill for £50, several articles of wearing apparel, and many other articles.

WILLIAM CLEMENTS, was born at Kenilworth in Warwickshire, of poor parents, and was bred up as a labourer at country business; he is near 50 years of age, and being confined in Warwick Gaol for theft, became acquainted with BATTY, and at that time they are both supposed to have planned the above robbery, for which they paid the forfeit of their lives, and which, as appeared on their Trial, was attended by almost unexambled atrocity, in presenting a loaded gun at the heads of Thomas Martin and his Wife at the tim of awaking them, and Batty with the most horrid imprecations threatening their destruction if the money was not immediately delivered.

JOHN WATCHORN, alias JOHN ROWER, alias RAWER, was born in Leicestershire, on the 7th of October, 1769, his parents were respectable as Farmers, who having given him an excellent education, he set out in life with very superior prospects, and married a woman with whom he might have passed his life beloved by his family and respected by all, but having contracted a habit of gaming, and committing other excesses, we find him practising various plans for the support of his extravagance; in Nottinghamshire he made proposals for establishing a National School, for which he obtained Subscriptions

The above is a Broad Sheet, which were often distributed among the crowd at the public executions. They were normally sold at a penny each. They described the culprits, their crime, and suposedly their confessions. The scene above shows the triple hanging in 1816 of three men; each would climb the ladder in turn, and the rope adjusted, then the ladder would be turned over. The men with the pikes are Javelin men or guards.

# CRIMES OF WORCESTERSHIRE

## DON COCHRANE

AMBERLEY

*Dedicated to my wife Margaret, for her help in the research and the production of this book.*

First published 2012

Amberley Publishing
The Hill, Stroud
Gloucestershire, GL5 4EP

www.amberleybooks.com

Copyright © Don Cochrane, 2012

The right of Don Cochrane to be identified as the Author
of this work has been asserted in accordance with the
Copyrights, Designs and Patents Act 1988.

British Library Cataloguing in Publication Data.
A catalogue record for this book is available from the British Library.

ISBN 978 1 4456 0497 8

Typesetting and Origination by Amberley Publishing.
Printed in Great Britain.

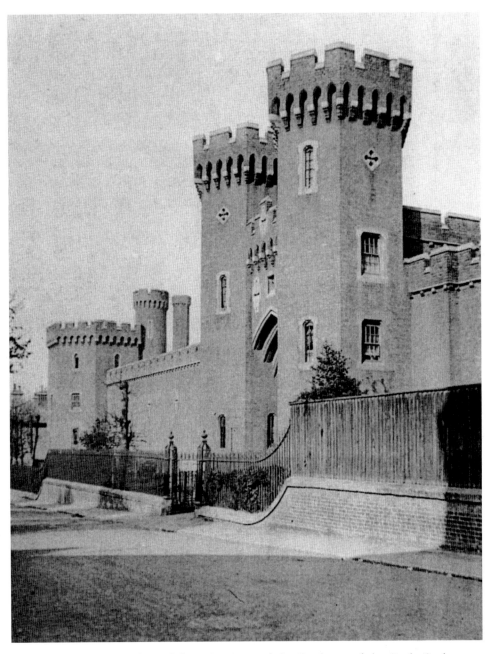

The above photograph is of the twin towers of the Gatehouse of the Castle Gaol at Worcester where, at one time, murderers and others were publicly executed in front of the gaol and later on the roof. The gaol once stood in Castle Street, where this photograph was taken in 1927, by A. J. Woodley. It is printed here with the kind permission of the Holland-Martin family of London, who own the copyright.

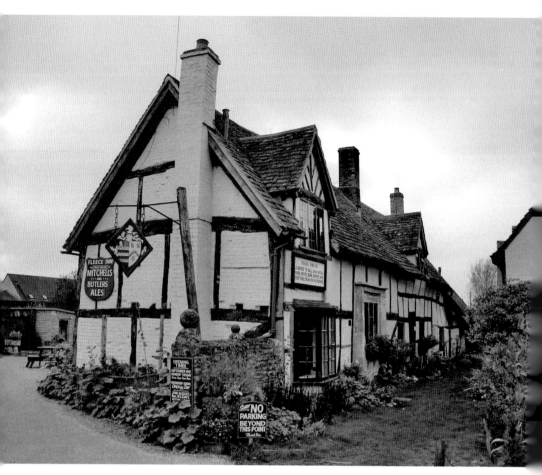

Bretforton is a picturesque village, famous for a notorious murder which took place here, and equally well known for having one of the oldest public houses in England called the Fleece Inn, built six hundred years ago as a farmhouse and first licensed in 1848 now owned by the National Trust. It is said to be haunted by a former landlady and it is also reproduced on the front cover.

# CONTENTS

# ACKNOWLEDGEMENTS

Worcester Records Office
William Salt Library Stafford
Wolverhampton Record Office
Dudley Archives
Guildhall Worcester
Shire Hall Worcester
Archives Office of Tasmania

Thanks to:
Jill Guest
Robyn Eastley (Tasmania)
Christine Woods (Tasmania)
Moira Gutterage (Drakes Broughton)
Richard Appleby (Bretforton)

About the Author:
Don Cochrane is a former President of the Stourbridge Historical Society. He is also the author of *Black Country Murders*.

# LIST OF ILLUSTRATIONS

# INTRODUCTION

In any civilised society laws are essential to safeguard life and property. Early laws in this country were draconian, and punishment for breaking those laws was extreme. Without such laws, however, there would have been anarchy and a lynch mob culture. Most crimes were punishable by death, with minor crimes being punished by humiliation or extreme pain, by use of the stocks, pillory or burning in the hand (a form of branding), or whipping. All punishments were administered in public to deter others from committing a similar crime.

In early times there was no police force; law and order was kept by the parish constable, and watchmen who were appointed by the Parish Council; their posts were part time and additional to their normal day job. They were equipped with a grey greatcoat, a lantern, a club like staff, a rattle (like a football rattle, which they 'sprung' to summon help) and sometimes a sword. They were often called Charlies, a figure of ridicule. The first uniformed Police Force was established in 1829 by Sir Robert Peel; they were known as 'Bobbies' or 'Peelers'. Parish Constables still continued to serve their parish and assisted the uniformed police as late as 1852. The parish constables and early police had no scientific resources to help them solve any crime, let alone one of murder, as cameras, finger printing, forensic science or DNA, were unheard of. They generally tended to be totally reliant on witnesses or informers, who were often unreliable, their honesty depending on the size of the reward, and who might even be settling old scores.

The legal team included the Coroner, who held an inquest on any corpse that had died suddenly. He was assisted by surgeons who carried out the post mortem, bringing in a verdict of accidental death, suicide, murder, manslaughter, or in the case of a heart attack or stroke, death 'by the visitation of God'. If his judgement was Wilful Murder, he would name the suspect, providing there was sufficient evidence, who would then be arrested and sent to the Assizes for trial. Finally came the Executioner, often known as the 'Finisher'.

Executions of any sort were big attractions, arranged purposely on market

days or 'gala days' (an abbreviation of 'gallows days') when a number of people, including murderers, would be executed in one go. 'Tyburn Fair', as it was known, was hanging day at Tyburn. Gaols were not used for long term incarceration of criminals, they were used principally as short term holding establishments for the accused before going to the courts for trial and sentencing. They would return to the gaol for punishment, if found guilty, generally in the form of capitol punishment, which was mainly hanging. There were in excess of 220 capitol crimes including sheep stealing, horse stealing, highway robbery, machine breaking, rick burning, coining, assault etc., including murder. Early hangings were often done in a field, or on a hill designated for that purpose, in which there might be a convenient tree where the culprit could be hoisted up on a rope around his neck, or dropped off the back of a cart, or turned off a ladder. In the absence of a convenient tree a special made gallows in the form of a letter 'T', or a timber beam supported on two posts would be erected, and the body left until pronounced dead. It would then be cut down and put in a coffin. These forms of hangings were crude and inhuman, as in most cases the victim died of strangulation as death was not instantaneous. None had sufficient drop to break the neck.

The measured drop was introduced in 1872, which related the drop to the weight of the victim, which was more efficient. Some executions were held at the place where the murder was committed. Executions then took place at the gaols where they were conducted outside the entrance or on the roof, where gallows were erected on each occasion, and where the public would gather in their thousands to watch the ceremony. Punishments of this nature were cheaper than having institutions such as Dartmoor, which was purpose built for long-term imprisonment. Such institutions cost money to feed the prisoners and maintaining prison staff, which had to be raised from taxes. In early times taxes were few and most of the population were peasants who had barely enough to live on, let alone pay taxes. Every city had a prison mainly in the form of a castle, which was used for short-term accommodation. They also had a town hall, or a Guild Hall or Shire Hall, where the Assize Courts were held. The Assize Courts met twice a year, and were where the worst criminals were put on trial and received harsher sentences. The minor cases were tried at the Quarter Sessions, which met four times a year and gave lighter penalties. The Judges at the Quarter Sessions consisted of Magistrates, chosen from local gentry or ministers of the Church, who were not qualified in law, whereas, Judges at the Assizes were highly qualified, having previous served as prosecution or defence counsellors. The sentences they gave were standard and could not be varied, if a man charged with murder was found guilty, there was only one possible sentence – Death. The Judge then put on the infamous black cap (a nine inch square of black silky material) and proceeded with the death sentence. Many Judges openly wept, others paused many times; they were so overcome with emotion with what they had to do. Execution would follow a few days later. The most notorious of the Judges was George Jeffreys,

who held the infamous 'Bloody Assizes'.

The Assize Judges were appointed from London, and each session, Lent (spring) or summer, they went around a circuit of County Courts administering the law, spending a few days at each. There were six circuits covering the whole of the country, and each circuit consisted of about eight counties. All six started on the same date. Worcester was on the Oxford Circuit. The arrival of the Judges was treated with a degree of pomp and pageantry. There were usually two Judges, accompanied by their wives, who were met at the County border by the High Sheriff. They joined him in his coach, and were escorted by Javelin men into the city to the Guild Hall, where the commission for the County would be opened, heralded by a fanfare of trumpets, which would be followed by a sumptuous banquet and washed down with the best wines, usually provided by the local wealthy landowners from their grounds and cellars. The next day they attended a service at the Cathedral where they prayed for guidance, immediately afterwards they went to their respective courts and took their seats, and the Grand Jury would be sworn in. A secondary role for the High Sheriff, was to sit on the right hand side of the Judge during the trials. He also had to witness the executions, seeing all the grisly details and certify it was carried out in accordance with the Law – not a job for the squeamish or faint hearted.

Finally, the poor wretch, in the last remaining moments of his life, and even after the hood had been placed over his head and the noose carefully adjusted around his neck, still had one final act to perform before he was launched into eternity – this was to signal, by dropping a white handkerchief, that he was ready to meet his maker and his victim(s)!

The actual reporting by the newspapers at this time was sensationalist, with every gruesome detail being given, not only by the reporter, but also by the doctors and surgeons who carried out the post mortem. Finally they described the scene of the hanging and what happened to the corpse afterwards, putting in every detail, and leaving nothing to the imagination.

The picture on the right shows the stocks at Painswick, which have withstood the passage of time, having been made of iron (a more durable material than their counterparts, which were usually made of wood and quickly decayed). They were probably made by the local blacksmith and used to punish petty criminals, by humiliation and ridicule. Such criminals were often pelted with rotten fruit and eggs, which made 'laughing stocks' of them.

## The Truth of the Case:

Or, A Full and True

# ACCOUNT

Of the Horrid

# MURDERS,

## Robberies and Burnings,

Committed at *Bradforton* and *Upton-Snodsbury*, in
the County of *Worcester*;

AND OF THE

*Apprehension, Examination, Tryal,*
and *Conviction,*

OF

JOHN PALMER, } *Gent.* { WILLIAM HOBBINS, }
AND                      AND          } *Labourers,*
THO. SYMONDS, } { JOHN ALLEN, }

## For the said Crimes.

To which is added,

An Account of the Occasion of the Bp. of *Oxford's* going to
the *Prisoners* after their *Condemnation,* and of his *Lordship's*
whole *Transaction* with them ; Written by the said Bishop.

LIKEWISE,

*An Account of what pass'd between the* Ordinary *and the*
Prisoners. *And* Remarks *on their* Dying Speeches.

Publish'd on Occasion of a late imperfect, false, and scandalous Libel,
Entituled, *The Case of* John Palmer *and* Thomas Symonds, *Gent.*
*who were executed,* &c. *By* R. W——

*The Law is made for the lawless and disobedient,* —— *for Murderers of*
*Fathers, and Murderers of Mothers,* 1 Tim. I. 9.
*Bloody and deceitful Men shall not live out half their days,* Ps. LV. 23.

LONDON: Printed by G. J. for JONAH BOWYER, at
the *Rose* in *Ludgate-Street.* 1708.

Bretforton is a picturesque village, famous for a notorious murder which took
place here.

# TRIPLE MURDER, ROBBERIES AND BURNINGS

Miss Ann Cormell, aged 66 years, lived on her own in the village of Bretforton, (old name Bradforton) 4½ miles to the east of Evesham (on the B4035) Stratford Road. She was a lady of independent means and considered by many to be well off, perhaps because she made loans to her friends and neighbours. A recent borrower was a man called Thomas Byrd who borrowed £8. who made out an I.O.U. in return for the same amount, another man named Joseph Wall, borrowed 20 shillings and gave her a silver trinket box as a security. On the 4th February 1707, her house was seen to be on fire, but the heat was so intense nothing could be done to save her. Her body was recovered next day from the charred remains of the building, and found to have a hole in her skull. The fire was considered to be an accident and the hole in her skull was thought to be due to the collapse of the roof, her death was treated as being accidental.

Some months later, on the 7th November 1707, a similar 'accident' occurred at Upton Snodsbury, about 20 miles to the north west of Bretforton, near Broughton Hackett, (on the A422) at the house of Mrs. Alice Palmer, a widow, who lived with her maid, Hester Loxley. The screams of Mrs. Palmer brought neighbours to her aid, but she was dead before she could be rescued and was recovered the next day, the body of the maid was found later. Both had been beaten and their throats cut. Immediate suspicion fell upon her son John Palmer, as he was known to have made threats on his mother's life, he also, seemed to make no attempt to find any other person guilty of the crime. Later, a man called Giles Hunt was also arrested because he had blood stains on his clothes, he confessed to having a part in the murder. A search warrant was obtained and his house searched, which revealed a small silver trinket box similar to the one belonging to Joseph Wall, which he gave to Miss Cormell for the loan of 20 shillings, there was also found an I.O.U. for the £8 borrowed by Mr. Thomas Byrd. Both given to Miss Cormell, together with other items from her house, and also other items belonging to Mrs Palmer. Upon being confronted with the items he also confessed to his part in

the Bretforton murder and turning Queen's evidence he gave the names of John Allen, Tom Dun, (William Hobbins) and Thomas Symonds, a gentleman with a dubious reputation, who had already been remanded in connection with the murder at Upton Snodsbury. All were held at Worcester Gaol.

Their trials were at Worcester Assizes 31st March 1708, before Mr. Justice Sir John Powel.

It appears that Hunt and Allen were good friends, they met Hobbings in a public house at Condicote who agreed to join them, and a further meeting was held at an Inn at Piddle, where they were introduced to a "gentleman" called Thomas Symonds, who appeared to have taken over leadership of the group, who suggested they carry out the robbery of the house of Mr. Poultney, this could not be agreed upon and was substituted by a suggestion from Allen who proposed the robbery of the house of Miss Ann Cormell at Bretforton, this was agreed. On the night of the 4th February, her house was broken into by Allen and Hobbs, who stole the I.O.U. the trinket box, £22 and other items, whilst Hobbins and Symonds kept a look out. It is thought Miss Cormell surprised her two intruders, who struck her on the head fracturing her skull, who then set fire to the building to destroy the evidence. John Palmer was charged with the wilful murder of his own mother and also that of the maid. It was not absolutely clear who actually did what, who were the murderers, who were the accessories, and who did the burglary, or who were the arsonists? Not that it mattered a great deal, since; all were capital crimes and all carried the death sentence. All were convicted except Giles Hunt, who had turned Queens evidence and was reprieved. The others were found guilty and sentenced to death. William Hobbins and John Allen were hung on the 16th April 1708 and John Palmer and Thomas Symonds got a three-week reprieve, but were hung on the 8th May 1708. Symonds climbed the ladder first, the noose was adjusted, and the ladder turned over, whilst Palmer intently watched the whole proceedings, then it was his turn!

*All were first hung at Red Hill, Worcester, Hobbins, Symonds and Palmer were then hung in chains on a gibbet at Upton Snodsbury, where they committed the murder. Allen was Gibbeted near a barn at Bretforton, which is now known as "Allen's Barn", and near the centre of the village can be found "Cormell's Yard".*

The following is an extract from a booklet, printed in 1708, called 'A Full and true Account of the Horrid Murders, Robberies, and Burnings, Committed at Bradforton and Upton Snodsbury, 1707, in the County of Worcester.' The booklet can be found at Worcester History Centre.

*The following extract is a description of the final hours of the four culprits, containing their confessions, as written by the Bishop of Oxford, and his eyewitness account of the executions.*

*A True Copy of Mr.* Palmer's *Letter, dated* Apr. 14. 1708.

*My most worthy Lord,*

I Have been a long time since often deluded, by several People, in hopes of a Reprieve, to conceal, and not make any Confession to the Fact I am convicted for. My Lord, It was my misfortune to be deluded in this horrid Fact, which I own. But, my Lord, I do assure you, this is the first Fact as ever I was in my whole Life; and, I don't question, but in a short time, I shall find out several more things, besides what I have discovered already, which will be of use both to the Queen and Country, who am.    *Your most dutiful and obedient Servant,* John Palmer.

*A True Copy of Mr.* Symonds's *Letter, dated* Apr. 14. 1708.

*My Lord,*

I Own myself guilty of the Two Facts, for which I am now convicted and sentenced to Death, meaning the *Bradforton* and *Upton-Snodsbury* Business. I shall, hereafter make such true Discovery to your Lordship, as will be serviceable to the Queen and Country.    *Your Lordship's most obedient servant,* Tho. Symonds.

I was so well satisfied with these Confessions, that I ordered my Servants and Horses to be got ready immediately, to go to the Judge; and desired Mr. *Mason,* and Mr. *Symonds,* the Attorney, to accompany me, that they might be Witness, in case I could not prevail, that I was not wanting in my endeavours to obtain a Reprieve for them. We set out with some more Company, from *Worcester,* about Twelve of the Clock; and though the Ways and Weather were bad, and the Waters out, got to *Gloucester* about Four in the Afternoon. As soon as I had chang'd my wet Cloaths, I took those Two gentlemen with me to Mr. Justice *Powel,* who was pleas'd, upon my reading their Confessions, which I carried with me, and at my earnest Request to him on their behalf, to grant them a Three Weeks Reprieve.

The next day, *Thursday* 15th, I return'd to *Worcester,* and went immediately to acquaint them with the Success of my Journey; with which, being something tir'd, I desired to be excused that Evening, and promised to visit them the next day. Sometime that Evening I received a Message from the Gaol, That *Hobbins* and *Allen* desired to be admitted to Mr. *Palmer* and Mr. *Symonds,* and that I would give order for it. I said, I would give no Order; but I thought it would be very well, if Mr. *Palmer* and Mr. *Symonds* would speak with *Hobbins* and *Allen,* provided that the Gaoler took effectual care, that *Hobbins* and *Allen* did them no mischief.

*Friday,* 16th, Mr. *Pountey* and Mr. *Mason* came into my Chamber, before I was up, and desired me to go to the Gaol, to persuade Mr. *Palmer* and Mr. *Symonds* to speak to the Two other Criminals, before they went to Execution. I immediately arose; and, as soon as I was dress'd, went to the Prison. When I got there I told

Mr. *Palmer* what Message I had receiv'd the Night before, and what Answer I had return'd. He said, That *Hobbins* and *Allen* had desired to come to them, but he had refused them, because he was apprehensive they had some ill Designs. I said, There were no grounds for such Apprehensions at this time, the Wretches being pinnion'd, and under the Guard of the Sheriffs Men; that, I thought, it might be of service to the public, if he would speak to them, before they went to Execution. He reply'd, He could speak only to One of them, [meaning *Hobbins*] for that he knew nothing of the *Bradforton* Business. I answer'd, I knew he was charg'd only with the *Upton-Snodsbury* Murder; and desired him to speak only to *Hobbins,* which he promised. I went from him to Mr. *Symonds,* and desired him to speak to them; and he readily comply'd. Upon this an officer was ordered to bring *Hobbins* and *Allen* to the Half space of the Stairs, and Mr. *Palmer* and Mr. *Symonds* stood with me, and several others, on the Stairs-head. Mr. *Palmer* spoke first, to this Effect: *Hobbins,* I have own'd my self guilty, and I advise you to do the same. Mr. *Symonds* said, I have confess'd myself to be guilty, and would have you to confess, and confess of every one you know. But these Words made no impressions on those hardened Wretches, who were hang'd soon after.

That Evening, I went again to Mr. *Palmer* and Mr. *Symonds* and told them, They would have little reason to thank me for the Three Weeks Reprieve I had got for them, unless they made a good use of it; for, that their abuse of that Mercy, would make their Conditions much worse. I assur'd them, I should be always ready to give them the best Help I could, and would endeavour to get them Assistance of some other Divines. I then went to Prayers with them, using such Portions of the *Liturgy,* as seem'd to me most suitable to their Conditions.

SIR,          *May* 8. 1708
You may think as you please, but, as I am a dying Man, 'tis true what I say; so, Sir, I desire you will be so kind to administer the Sacrament to me, before I depart this miserable Life. Sir, Your Faith may be what it will, but I declare I would not do the thing, and were Guilty, for Ten Thousand Worlds.          Sir, *Your expiring Servant,* John Palmer.

Within half an Hour after the Receipt hereof, I went to him, and gave him several Reasons why I thought I ought not to give him the Sacrament, unless he would confess of the Crimes of which he had been convicted, especially having retracted the Confession he had once made; But told him withal, That if he was, as he now profess'd, really innocent, by denying him the Sacrament could be no Disadvantage to him; for that God, in such case, would accept the Desire for the Performance; and that he might *spiritually* feed upon the Body and Blood of Christ, and he thereby partaker of the Benefits of his Sufferings, tho he could not *sacramentally.*

He desir'd me to read to him again the Discourse I had read the Morning before, upon the Last Judgement; which I did; and staid with him till about

Eight of the Clock. We began and ended with Prayers, at which *Palmer* seem'd very devout; but *Symonds* lay upon the Bed all the while, complaining of the Gripes; and would not be persuaded to do anything. Then, having given *Palmer* my Advice, in what manner to employ himself, till I should come again, I went home.

At Ten of the Clock, I went to them again, and found with them two Clergymen; one of which was exhorting them, very gravely to Confession. I desired him to continue his Discourse; which he did; and then desir'd leave to use a Prayer he said he had compos'd for the Occasion. I consented to it, and join'd in the use of it.

About Eleven of the Clock came the Criminals, out of the Castle, attended by the Sheriff, and a good Guard.

When they came to the Place of Execution, I was, in spite of all Endeavours excluded by the very great Crowd of Horse; nor could I get to the Tree in less than half an Hour.

When I got to them, I first made use of such Arguments, for the Duty and Necessity of their Confessing the Facts they were come to die for, occur'd; and then took out the Exhortation I had read before in the Gaol, and deliver'd it to them, with all the Earnestness and Concern I was able to express; but without effect.

Then *Palmer* pull'd out his Paper, and read it, and gave it to the Sheriff. When he came to the Passage, That he was induced to make a Confession by the Asseveration of Mr. *Symonds*, the Attorney, that the Bishop of *Oxford* promised, that, on Condition of their making a Confession, he would go to the Queen, and endeavour to get their Pardon; he look'd off the Paper and said, *Tho' this was certainly told me by Mr. Symonds, I do not believe his Lordship ever said it: he is a worthy good Man, and I have been much oblig'd to him.*

Then we went to Prayers. Prayers ended, the Criminals embraced, and took their Leave one of another. ['Tis said, they whisper'd in other's Ear; but that I did not observe.] and *Symonds* went up the Ladder, on the opposite side of the Tree, having his back towards me. When he was settled there, and the Rope about his Neck, he began to lay his Blood (as he had threatened he would) at the Justices Doors. I hearing this, went and faced him, and said, Mr. *Symonds*, What are you going to do? Have you not sins enough to answer for, but you must calumniate good Men for doing their Duty? It is the Duty of all Men, to make strict Inquisition for Blood; but of Magistrates much more. Why then, says he, turn me off, and put me out of my Misery. Nay, be not so hasty, Mr. *Symonds*, said I, say your Prayers first. The Horse from a small Ascent above the Gallows, press'd so hard upon me at that time, and I had so much to do to escape being trod upon, that I could not observe whether he Prayed or no. If he did, it was but a very little while. He deny'd any Knowledge of any of the Murders, upon his Salvation; and calling again to be turned off, it was done.

*Palmer* beheld the Heavings and Convulsions of the hanging Body, with all the signs of Horror and Amazement; in so much that I thought he might have fallen down under the Tree.

A little after, He went up the Ladder; where his Courage fail'd him so, that he seem'd ready to expire, before he was turn'd off. He pray'd there, in a very low Tone, and confused Manner, for some time; and then I apply'd myself to him again, and demanded, Whether he was guilty of the Death of his Mother, or no? To which he reply'd, He was not Guilty. And soon after was turned off.

Their Bodies were both hung in Irons, the same Day, next to Hobbins's, at Upton-Snodsbury.

*The Byrd family is well know in Bretforton, they were farmers, and are said to have built "The Fleece Inn," a well-known landmark, built six Centuries ago, now owned by the National Trust.*

Allen's Barn, named after John Allen of Bretforton who was hung for the murder of Miss Ann Cormell. His body was hung in chains on a gibbet close to this barn. The purpose was to warn people, both strangers and villagers, that this was the penalty for committing such a crime. The central part of the above building was probably the original barn that stood on the site in 1707; it might also have extended more to the left, where the lean-to now stands. The barn stands at the intersection of four tracks forming a cross roads with a very ancient tree on the opposite corner, which might have served as the gibbet where Allen was hung in chains as a warning to others! The tracks themselves are also important, with one leading to Bretforton, these were roads along which travellers would walk, and goods of all discriptions transported by horse and cart, packhorses, trains of mules and their drovers, to the rivers and then by barge. There would also probably be stagecoaches. The tracks that can be seen today, rutted, pot holed and filled with water, are typical of the roads of the eighteenth and nineteen centuries and have not changed in over 300 years. The crossroads would have been exceptionally busy in 1707, hence the reason for positioning the gibbet there where it could be seen by large numbers of travellers and residents going in all directions. The barn is said to be haunted, but no ghosts were seen on the day this picture was taken.

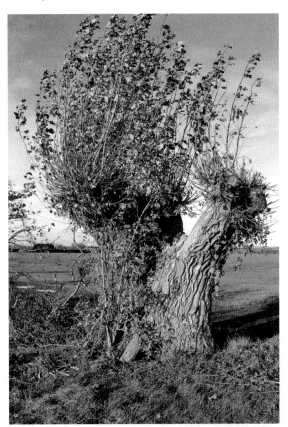

An ancient tree on the left stands opposite the barn. Its top branches have been lopped many years ago and its trunk is at least 10 feet tall and over 15 feet in circumference, split into three sections exposing a huge hollow inside. 300 years ago its branches would have been massive and would easily have supported the chains and the body of John Allen.

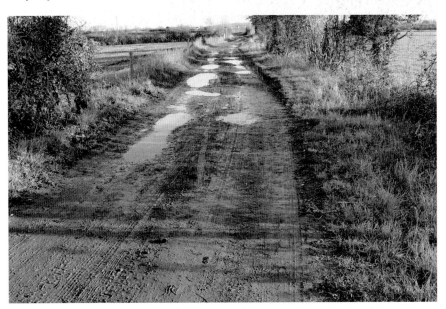

The rutted and pot-holed road leading to Allen's Barn, as it is today.

Upton Snodsbury, was where Mrs Palmer and her servant were murdered and where her son John was hung in chains, together with Hobbins and Symonds for their parts in their murder.

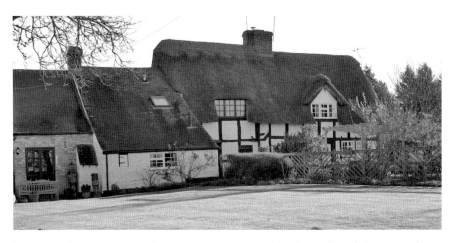

The gibbet for hanging the three men on was erected in the garden of the ruins of Mrs Palmer's house, which stood on the main road through Upton Snodsbury (A422). The house was later rebuilt, presumably as it was before and is shown above. It became The Bull Inn and it is said to be haunted by the ghost of a headless woman who wanders about, which is supposedly that of Mrs Palmer, who cannot find a resting place! It no longer serves as public house and is split into two properties known as the Bull Cottages.

*The "Gang" consisted of men of different class distinction, Symonds and Palmer, although having criminal tendencies, came from moneyed backgrounds, who were both said to have gambling debts. Both had been educated, they both wrote confession letters to the Bishop of Oxford. Their education would have been a private one, paid for by their parents, whereas, Hobbins and Allen, were uneducated, they received no schooling and were described as labourers, a rather derogatory term, often used today as meaning unskilled, which was not the case in 1707, when tradesmen such as Carpenters, Masons, Thatchers, and Bricklayers etc., who were often highly skilled, but nevertheless, were called labourers, they worked for a living, Gents or Gentlemen did not! The written confessions made by Symonds and Palmer were retracted just before they were hung, as they believed they had been tricked into making a confession by the Bishop of Oxford, who, it was said, would obtain a Queen's Pardon for them. The best he actually did, was to extend their lives by three weeks.*

From their confessions and information and admissions from Giles Hunt.
On the 7th November, at about midnight, Mrs Alice Palmer opened the door of her house in answer to a knock by Symonds, who then struck her a blow with his pistol breaking the butt, she screamed as she fell to the floor and her maid came to her assistance, Symonds, (brother in law to, Palmer who married Symonds sister), struck her with his fist knocking her to the floor along side Mrs Palmer. Tom Dun, (William Hobbins) then killed them both by cutting their throats from ear to ear, with a 'short tuck' or dagger.

John Palmer, together with his accomplices, were hung at Red Hill, and their bodies brought back to Upton Snodsbury, where they were hung on gibbets in the grounds of Mrs Palmer's house, which stood at the road junction on the A422. The estate of John Palmer at White Ladies Aston, was confiscated by the state and given to the Bishop of Worcester, who had no wish to receive it; it was tainted money, acquired under horrific circumstances! So it was decided to use it to endow a charity school in Worcester for sixteen boys and eight girls, which opened in 1714, known as Bishop Lloyd's Charity School. It was closed in 1896 due to reforms in educational institutions.

A local couplet, well known in Bretforton reads:
Allen, Symonds, Palmer and Dun,
The four biggest rogues under the sun.

# WORCESTER NEWSPAPERS

The earliest newspaper was the *Worcester Post Man*. It covered news items not only in Worcester, but also all of Worcestershire, the rest of Great Britain and the World. It was first published in 1690 and was a new innovation. It has to be remembered that most people were uneducated and could not read and although the papers were relatively cheap by today's prices, they were unaffordable for the masses. It was published haphazardly up until 1709 and changed its name to the *Worcester Journal* in 1748, after being taken over by the Berrow family. It changed its name to *Berrow's Worcester Journal* in 1753, which is said to the oldest newspaper in Great Britain.

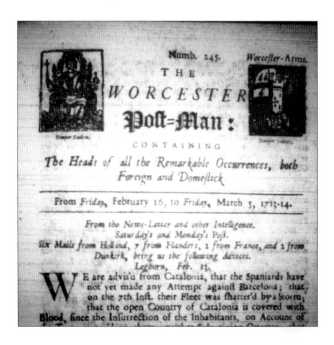

Before 1752, the 'Julian' Calendar was in use and the year ended on 24 March and the New Year started on 25 March (24 March 1712 was followed by 25 March 1713 for example). To accommodate this peculiarity, 'double dating' was often used as shown in the *Worcester Post Man*. The new system, which we use today, was introduced in 1752 when the 'Gregorian' Calendar was adopted.

The system of printing varied greatly from what we know today, and was done on a hand press, each sheet being printed separately. News items were short and to the point, but often jumbled, with births, marriages and deaths mixed with murders and executions.

Below are a number of typical examples of crimes and the sentences awarded, recorded here as they were printed in the *Worcestershire Post Man*:

Worcester, March 23rd 1712–13 This day our Assizes ended, when 6 Criminals were burnt in the hand, amongst which was William Turner, who was found Guilty of Manslaughter for the killing of his Father's Servant. One Bearn a Baker of Fladbury, committed to our Castle about a fortnight since, on suspicion of barbarous murder committed in the house of the Reverend Mr. Powntney, is to be continued in Prison until the next Assizes, the Evidence for the Queen not being ready. There was also 2 Women and one man sentenced to be whipt on Saturday next.

Worcester, April 3 1714 The Session being held this Week, one Smith was try'd for a Burglary and Robbery, who was Executed 4 Years ago at Tyburn, it seems he was turn'd off, and hung the usual time, and was carried away by his Friends in a Coffin, and after he was brought home, came to Life again; but it seems he could not forsake his old Calling: It's thought the Hangman will take more care of him this time.

Worcester, April 8 1715 Last Saturday the Assizes ended at Chelmsford, where 17 Persons receiv'd Sentence of Death. A Woman for Murthering [murdering] her two Daughters, and the rest for the Highway. At the Assizes held for the County of Northampton before Mr. Justice Powis and Mr. Justice Pratt, one Eliz Traceller was sentenced to be burnt [burned at the stake] for poisoning her husband.

Worcester, April 29 1715 *London*. Yesterday 2 Men and a Boy of 15 Years old, and 2 Women were executed at Tyburn, and 1 of the Women instead of craving for Mercy kept cursing and Swearing to the last, and cried out several Times, *She was going to the Devil*; and its generally reported that she pickt a Pocket going from Prison to the Cart.
*London, April* 24. They write from Kilkenny of the 16th Inst, that Sir Isaac Hainson lately cut his Throat there, after he had first despatch'd his Lady and 2

Daughters, by running them through the Body with his Sword. Its added that the Coroner's Inquest have brought him in a *Felo de se*; (self murder); upon which his Estate is forfeited to the Queen, and he is to be hanged in the Highway as such without ceremonies that are used at Christian Burials.

Worcester, July 22 1715 We have an account from Stowerbridge, that the mob rose there on Monday last, pull'd down part of, and gutted the Meeting-house burning the Pulpit and Seats. Our High-Sheriff with a considerable Body of Men went in Pursuit of them, the next day; but the Mobb being appriz'd thereof, dispers'd in a great Measure before their Arrival. However 3 or 4 Persons were taken and 2 brought to our Castle on Tuesday Night. Last week the Mobb very much infested our Neighbourhood, and began to make some Attempts on the Meeting-house, and committed other disorders, but thro' the Vigilancy of our Magistrates and Citizens, they were soon dispers'd, after knocking down and imprisoning the Ring-leader.

The Friends Meeting House can be found on the Stourbridge Ring Road, on the section leading to Amblecote, it is a Grade II listed building, over three hundred years old. It was built on land leased to the Quakers in 1689, at a Peppercorn Rent, by Ambrose Crowley, an iron master and Quaker. It is a plain and simple building, and still retains its original design with only the minimum alterations required by law made.

Worcester, April 5 1716 William Dod is sentenced to be hung for House-breaking. Abraham Balea, a shoemaker in Salop found guilty of helping to pull down the Meeting-house there, fined 20 Nobles.

Thomas Williams, for the same, fin'd 3*s*. 4*d*. and to be whipt at the Carts-Arse round the Town 4 times. At Stafford Assizes, Edward Lloyde was condemn'd to be hung for Horse-stealing: four burnt in the Hand. Will. Woolrich, Wolverhampton, Bell-man, fin'd 20*l*. and to stand in the Pillory for a riot there. Richard Tunks, fin'd 5*l*. to be Pillor'd at Walls-hall; and 2 Persons more of Wolverhampton fin'd 40*s*. each for, and to stand at the Pillory.

Our Assizes ended here (Worcester) on Tuesday Night last, when one R. Pigford, alias Pritchard, alias Brown, was condemn'd to be hanged for House-breaking. Bonny alias Bonniface Bing, a common Cheat, to remain in Gaol for three Months, to stand in the Pillory on Saturday following, between 12 and 2, with an Inscription affix'd over his Head denoting his Offence. He acted his Jugling Diversion with his Ball and Thimble in the Hall before the Judge. John Adey, to stand in the Pillory on the first Market-day in May next at Dudley, for being concern'd in pulling down the Meeting-house there. Four Persons for a riot, and assisting in pulling down the Meeting-house at Stowerbridge, to have the like Punishment as the former. Edward Raybold another Accomplice to

remain in Gaol for one Month, and to stand in the Pillory at Stowerbridge. W. Shelding, for the like Offence, to remain one Month in Prison, and to be whipt on a Market-day at Stowerbridge.

Worcester, April 2 1718 At the Assizes held there, (Monmouth) were three condemn'd, viz. Alice Jones to be burnt for the Murder of her Husband; The Tryal of John Moore who is to be hang'd for the Murder of Roger Penner at Hereford; Four burnt in the hand for stealing goods.

Worcester, April 9 1718 We have an Account from Monmouth, that on Monday Sev'n-nights last, Alice Jones was burnt pursuant to her Sentence, for the Murder of her Husband; she was a Woman very much addicted to Cursing, Swearing, and Drunkeness, being observ'd seldom to go Home sober from Monmouth Market, she living but a Mile from that Town; she dy'd very impatient without confessing her execrable Fact, and seem'd very little concern'd at the Approach of Death, which signified that the Devil had great Authority over her. She said when she was on the Ladder, *That should People be Hang'd upon Thoughts, there would be Burning Work enough*; and seem'd not to die in Charity, for before People expected, she turned herself off the Ladder, telling the Hangman, *He got his money easy.* Her Husband was an old Labouring-Man of about 80, and she was observ'd before she murder'd him to make Complaints to her Neighbours, that he was very burthensome [burdensome] to her, and she thought it hard work to maintain him.

Worcester, April 23 1718 Last Friday Thomas Matthews and Belshazzer Windser two condemned House-breakers were executed here. The latter denied the Fact for which he suffer'd, and seem's to be impatient of taking his Flight into the vast Regions of Eternity, That he tript up on the Under-side of the Ladder, desiring Jack Ketch to strain the rope about his Neck, which no sooner done, he flung himself off with great Precipitation.

Worcester, April 27 1718 We have an Account from Monmouth, that on Saturday was Executed there one Jane Edmonds of the Parish of Langew in that County for the Murder of 2 innocent Children, the Son and Daughter of one William Walters of Gwernessney in the said County. The particular Account thereof sent us by our Monmouth-Correspondent will not we suppose be unacceptable to our Readers.

Some time before she committed this barbarous Murder, she was by some People accounted crazy, and was chain'd up in her House upon that Account: In a little time after she broke her Chains, got away and hid herself in the woods; after about 5 or 6 Days not being heard of, she was cry'd in several adjacent Markets, but at last was found; then they brought her home, chain'd her up as

before and soon after appearing to be perfectly well in her senses, she was set at Liberty. Now she goes to live with her Son-in-Law, Wm. Walters, who having 2 Children by a former Wife, married the said Jane Edmond's Daughter, his second Wife. This wicked Wretch, being of a covetous, greedy, and unnatural Temper, would not allow these poor Innocents Bread to eat, but very often they were seen to feed on Grains with the Pigs out of the Pig-Trough, notwithstanding at the same time they were in good Circumstances, having a small Estate. Upon St. Luke's Day last, being Uske-Fair the Wretch appearing well in her Senses desires her Son-in-Law and Daughter and Servant to go to the Fair, while she tarries at home to keep house: No sooner were they gone, but this devilish Wretch, sends out the Boy to pick Sloes in the Fields; while she in the meantime with a Hatchet murders the poor, innocent Girl after a barbarous manner, and thrusts her dead Body up into the Lanset of a Barn. So soon as the Boy return'd, she serv'd him in the like barbarous manner.

> *Murder does always leaves a bloody Stain,*
> *Which hardly unreveng'd does long remain.*
> *Their Innocence from Earth just Vengeance cry'd,*
> *Till for this Fact this bloody Woman dy'd.*

Worcester, May 1 1720 *Monmouth*, The Hangman that hang'd the old Woman as mentioned in our last, being a fellow Prisoner with her, it seems she had notice of it, and 'tis reported promis'd to trouble the Fellow after her Death. Accordingly on Saturday Night last about Midnight, the Chain to which the old Woman had been chain'd from the time of her Condemnation, was rattled in a most hedious and terrible Manner, to the utmost surprise and astonishment of those who lay in the same-Room, especially poor Jack Catch, [Ketch] who was so terribly affrightened that he was not himself the next Day; however the Turnkey with some other stout Fellows to his assistance, bringing in Lights and some Weapons of Defence, soon dissipated those terrible Fiends.

## JACK KETCH

Jack Ketch, mentioned above, was a notorious executioner between 1662 and 1672 and well known for his poor quality skills in despatching his victims, including beheading and hanging. He was also known for taking bribes from their families to ensure they were efficiently put to death and did not suffer a long, agonising death. He died in 1686, but his name lingered on and became the nickname of many other executioners who followed in his footsteps. He was adapted by 'Punch and Judy' showmen and is well remembered in the scene where wicked Mr Punch tricks him into putting his head into the noose and hangs him saying, 'That's the way to do it!'

# THE MURDER OF JOHN HAYES

Catherine Hayes, wife of John Hayes, was born near Birmingham in 1690 to a poor man named Hall. At an early age she went into domestic service, as most girls did in these times and by the time she was fourteen she was an experienced, promiscuous young woman.

By the age of fifteen, she was a headstrong young lady with a mind of her own who decided to leave home after a quarrel. Determined to make her way to London, she instead met up with a group of army officers at Ombersley and joined their company as a camp follower, attending to their daily needs. At the age of seventeen she became pregnant, which left her with an illegitimate son. After a while the troops moved on and her services were no longer required. She probably continued to earn her living working as a serving wench in beer houses and taverns, offering other services to those who were willing to pay.

At the age of twenty-three she moved to the adjoining county of Warwickshire, to become the servant of Mr Hayes, a respectable well-to-do farmer, and his two sons. The eldest son John, aged twenty-one, was seduced by Catherine within a short time and they were secretly married at Worcester, in 1713. In 1719 she persuaded her husband to move to London, where they opened a Pawn Brokers Shop and a lodging house. This suited Catherine; income from loans and rents afforded her a higher standard of living and an opportunity to mix with their male lodgers. One of the lodgers, a man named Thomas Billings, aged eighteen, was said to be her own son from a previous affair, with whom she started an incestuous relationship under the roof of her husband's house. This continued until Thomas Wood, a butcher from Worcestershire, became her lodger and lover. By this time she was getting tired of her husband as he no longer satisfied her needs. He restricted her socialising and spending habits and she wanted him out of the way.

She took Billings and Wood into her confidence asking for their help. At first they refused, but with the offer of money and other favours, she persuaded them to join her in her evil scheme.

The four were often involved in drinking sessions, usually becoming drunk and incapable. It was planned that on the next occasion of their social gathering, John Hayes would be murdered. This opportunity came on 1 March 1726, after the three men folk returned home after drinking at their local. Having previously got an ample supply of wines and spirits, they continued drinking together and were joined by Mrs Hayes. The conversation was good humoured and small wagers were made to see who could drink the most and still stay sober! Mr Hayes was the first affected and was further encouraged by the others to drink more until he fell down blind drunk and passed out. He was immediately attacked by Billings with an axe, which fractured his skull. A second and third blow by Wood, who took the axe from Billings, finished him off. The noise of their activities disturbed a woman named Springate, who was a lodger in the room above. She came to see what the commotion was about. Catherine pacified her and apologised for her noisy guests who had 'got a little out of hand, but had now gone home'.

Having done the deed, the next problem was disposing of the body. It was decided they could not dispose of the body wholesale as it would soon be recognised. The head would have to be removed first, as this was the most easily recognisable part. The services of Wood was then called for again, he was a butcher and carried out the beheading with his pocket knife in the light of a candle held by Billings. Catherine held a bucket to catch the blood and the head when severed. They then continued to dismember the body into smaller more easily handled sections. Billings and Thomas disposed of the head in the Thames, but unfortunately it disturbed a sailor on a nearby ship by the splash it made, who was unable to see anything because it was dark. The body parts were then carried in a blanket and disposed of in a field at Marylebone, where they were submerged in a pond. Shortly afterwards the head was discovered on a mud bank, cleaned up and placed on a pole in a prominent place, hoping that it might be recognised. (This was standard practice in days when cameras were unavailable). There was no doubt in the minds of many that the head on display was that of John Hayes. In the meantime Catherine was busy putting a story around that he had left her and gone away.

Later, three friends of John Hayes started asking Catherine questions about the disappearance of her husband, who were fully aware that he had made no such commitments when they had last seen him as those stated by Mrs Hayes. Mrs Hayes had given three different answers to each of them when they separately questioned her. On this and other evidence, Catherine and her son Thomas Billings were seized, followed shortly afterwards by the apprehension of Wood, who made a full confession.

On 26 March the other body parts were found, enabling a coroner's inquest to be held on 16 April 1726, which brought in a verdict of 'wilful murder' and charged Catherine Hayes, Thomas Billings and Thomas Wood as the murderers. A further bizarre practice to this macabre story was that suspects of murders were

often confronted with the corpse and required to touch it to show their innocence or guilt. This was carried out by each of the three suspects upon the severed head, which by this time had been put in a jar of gin to preserve it, in front of thousands of witnesses. But this failed to prove anything and to further complicate matters, a woman whose husband had also disappeared claimed that the head was that of her husband.

They were confined to Newgate Prison and tried at the Old Bailey on 20 April. Billings and Wood pleaded guilty to the murder of John Hayes and Catherine Hayes said nothing, hoping to escape execution. Although all three were found guilty (the two men were sentenced to be hanged and Catherine was to be burnt at the stake), Thomas Wood died in prison from gaol fever. So on 9 May 1726, only Billings was taken by cart to Tyburn and hung in front of Catherine by dropping him off the back of the cart. He was left hanging for the normal time and then cut down and taken to the field in Marylebone, where he was hung in chains on a gibbet close to the pond in which the body of Mr Hayes was found. Later, Catherine was drawn to Tyburn on a hurdle (a type of fence) by a horse to the site of the execution and fastened by a chain around her waist to the stake. Females to be burnt at the stake were usually strangled before the fire was lit by means of a rope passed through a hole in the post. In the case of Catherine Hayes this was unsuccessful and she was in fact burnt to death.

The executions were carried out by Richard Arnet, who was the public executioner at the time. He made a botched job of the execution of Catherine, who he should have strangled before the flames reached her. Unfortunately, the fire burned fiercely in his direction, burning his hands and causing him to drop the rope.

This particular crime was classified as petty treason and it was applied to women who murdered their husband, master or mistress, hence Catherine was burned at the stake rather than hanged. High treason, for coining (clipping of coins) silver or gold or counterfeiting, resulted in the same punishment. Burning was a common punishment throughout Europe for both heresy and witchcraft. Punishment for High Treason by men was the same as what Guy Fawkes and his conspirators received. Hanging for women was considered indecent and where hanging was employed their skirts were fastened around their legs. Petty treason for men was normal hanging.

## TYBURN

Tyburn was the most infamous of all hanging sites in the history of capital punishment. It served the whole of London and is reputed to have hung 60,000 culprits. The gallows were close to where Marble Arch now stands at the present road junction of Oxford Street, Park Lane and Edgeware Road. It was built in 1571 and was made infamous by its unusual design. It consisted of three oak

posts about 12 feet high supporting three oak beams that formed an equilateral triangle. Eight people could be hung on each beam, giving a total of twenty-four. Its design gave rise to the inventiveness of the criminal fraternity to find suitable names to describe this killing machine, including the 'three-legged-horse', or 'a horse foaled by an acorn'. It had been an execution site since the twelfth century, when the original gallows was just a tree, possibly an elm, and criminals would be hung from its branches. It got its name from the Tyburn River – a tributary of the river Thames, which was nearby – but is now hidden underground for its entire length.

Prisoners would be held at Newgate Prison, which was a place as notorious as the gallows, until their trial at the Central Criminal Court nearby, often known as the 'Old Bailey'. If found guilty, they would return to Newgate to await their execution. On the appointed day, the condemned would be carried in an open cart, sitting on their coffin, to Tyburn. Their 3-mile journey through crowded streets, which took about 2 hours, was often broken by stops at the local pubs for refreshments. The Triple Tree at Tyburn was taken down in 1783 because of the obstruction it caused by the vast numbers of people present every Monday hanging day and moved to Newgate Prison where a new gallows was erected.

# DICK TURPIN

*Worcester Journal* 9 March 1738

**Richard Turpin.**

*York, March 3* As the Person who was committed to York Castle, under the Name of Palmer, about Michaelmas last, is discover'd, and has confess'd himself to be *Turpin*, 'tis presum'd an authentick Account of that Affair will not be unacceptable to the Publick. It seems about the Time that the Reward for taking him came out, which was June the 25th 1737, instead of going beyond the Sea (as was reported) he only cross'd the Humber and boarded at a Publick House at Brough-Ferry for some Time, but afterwards went to Welton, a small village, about a Mile from Brough, and wide of the High Road. He said he was a Butcher by Trade, but had taken up the Business sometimes dealing in Horses; used often to go over the Humber into Lincolnshire, and bring Horses over back again, which he sold to the neighbouring Gentlemen, with whom he frequently went to hunt: and it is imagin'd, that as his Father is in Chelmsford Gaol on Suspicion of Horse stealing, they used to meet and exchange, their having been but few Horses stolen about Hempstead in Essex where his Father liv'd, since old Turpin has been confin'd in Chelmsford Gaol, and this man in York Castle. However, this Trade he followed near two Years, 'till he happen'd to shoot a Country man's Game Cock or Hen, which anger'd the Fellow so, that to be reveng'd, he complain'd to some Gentlemen of Hull that had made a Visit to a neighbouring Gentleman at Ferriby. Upon what he alleg'd concerning this Palmer, and his manner of living, they ordered him to be taken up as a suspicious Fellow, and brought next Day to Beverley Quarter Sessions to give some Account of himself. He was carried next Day, and suffer'd to ride his own Horse and was very jocose 'till he came near Beverley, but then seem'd little daunted. Upon his examination, one Harris with whom he had boarded at Brough, gave Information, That one Day Palmer told him, if he would go along with him and have a good Heart, he would show him how he might easily take 2*0l.* As take up that Twopence which he had laid down upon the Board. Says *Harris, What signifies my going along with you, you have no Arms?* Palmer replies, *Have not I? I'll show you such*

*Pistols you never saw in your Life before.* Upon which Information, and his Horse being challeng'd he was committed to York Castle from the Michaelmass Quarter Sessions at Beverley. A small Time since, a Letter came with the York Post-stamp directed for one Pomp. Rivinal, to be left at the Blue Bell Inn in Hempstead, near Saffron-Waldren in Essex (It seems this Pomp. Rivinal married Turpin's Sister, and since the old man is confin'd, they manage the House for him.) Rivinal refused taking it, saying He had no Correspondent at York, which being observed by one Mr. Smith (who lives at Hempstead, and taught Turpin to write) he acquainted a Justice of the Peace with this, and he sent to Saffron-Waldren and took the Letter which was dated from York Castle, wherein he complains he was in for a Horse and a Mare, and desires them to come down, and bring Ten Pounds, &c. which Letter was sign'd John Parmen, which they say is Turpin's Mother's Maiden Name, and which he used to go by. Now Parmen and the Yorkshire way of pronouncing Palmer are very near, they always leaving out the *l*. Upon this several more Letters were intercepted, in which he heavily complains of Hardships, and presses them by all Means to bring Ten Guineas and two Witnesses, and then he don't fear he shall come off; and desires to persuade his Cousin Betty Millington to do something for him, it being the last she may ever do. Now his Wife's Maiden Name was Millington. Upon these Circumstances laid together, and the Hand writing being thought to be Turpin's, the Gentlemen of Essex having had an Account from the Governor of York Castle to whom they had wrote, that there was one Palmer that answer'd the Description, they had sent, they resolv'd to dispatch Mr Smith into Yorkshire, who knew him perfectly well, and taught him to write. As soon as he saw him he immediately declar'd and made Oath before the Recorder and Justices of the Peace, that he was the notorious Richard Turpin.– At first he denied it; but at Night confess'd 'twas true, he was the Man. He has endeavour'd to escape, and with two more Felons had laid a Plot to murder the Turnkey and Porter and so have rode off with the Governor's Mare, but it was discover'd and prevented. He seems sure that no one can hurt him, and told the Gentlemen with whom he used to hunt, That he hop'd to have another Day's Sport with him yet, and that if he had thought they would make such a Rout with him, he would have own'd to it before. He is put every Night in the Condemn'd Hole which is a very strong Place.

On Wednesday a Bill of Indictment was preferr'd to the Grand Jury at Chelmsford against John Turpin, the unhappy Father of Richard Turpin, the noted Highway Man, when the Old Man's general Character and Innocency of the Fact laid to his Charge, plainly appearing to the Satisfaction of the Grand Jury, of which Sir Caesar Child, Bart, was Foreman, the Bill was returned *Ignoramus.*

Dick Turpin was hung at York 7th April 1739 for horse stealing.

[In these days postage letters were not cheap, and were paid for by the person receiving it, rather than the one who sent it. It had to be paid for before it could be received by the recipient. If he did not know who had sent it he was quite right to refuse payment.]

# THE POISONING OF FRANCIS MORETON

*Weekly Worcester Journal*, 5 January 1743–44

Last Saturday Elizabeth Moreton, otherwise Owen, was committed to the Castle Gaol by William Churchley, Gent. Coroner of Evesham, for murdering with Poison Francis Moreton, her Husband. She is a very young Woman, and 'tis said she had been married about a Year, and that she is at present big with Child.

Worcester, 29 March 1744.
Elizabeth Moreton, otherwise Owen, who was sentenced at the last Lent Assizes to be drawn and burnt, for feloniously and traitorously poisoning her Husband, she pleaded her Belly, but being found *Quick with Child,* her Execution was respited, was called to the Bar, and having nothing to say why Execution should not be awarded against her, she is order'd to be executed according to her former Judgement, which is to be Friday 7'Night [se'nnight i.e. seven nights, or seven days], the 10th Instance, near Evesham and at the Place where she committed the horrid Fact.– She will be convey'd from the Castle very early the same morning.

Worcester, 16 August.
Last Friday Elizabeth Moreton, alias Owen, condemned at the last Lent Assizes to be burnt for poisoning her Husband and whose Execution was respited on pleading her Belly, was pursuant to her sentence, executed near Evesham, (the Place where her late Husband liv'd) in the Presence of a vast Number of Spectators, many of whom were greatly surprised at the shocking Sight.

Elizabeth Moreton was said to be twenty-two years of age when she was burnt at the stake, close to the place where she poisoned her husband. The charge for a crime of this nature was 'petty treason', and was punishable by death by execution by burning at the stake, rather than hanging and quartering, which would be the

punishment for men. At the time of her trial 'she was big with child' and was found to be 'quick with child' [near her time] and said to have pleaded her 'belly'. This gave her some respite or delay in her execution, until she had had her child. Shortly afterwards she was executed and what became of her child is unknown. Guy Fawkes was never burnt, except on bonfire night, and he and his fellow conspirators were sentenced to be drawn, hung and quartered, i.e. drawn on a hurdle, partly hung, then quartered, beheaded and other mutilations.

## ANNE WILLIAMS

Worcester, 12 April 1753

Yesterday se'nnight Anne Williams was tried at Gloucester, for poisoning her Husband, with White Mercury; that she had given to him in some Pap; after he had eaten the Pap, she desired him to draw her some Drink, which he did, and drank some of it himself, he was immediately seized with violent Vomittings and Purgings; her Husband told his Sister, whom he had sent for at his being taken amiss, that his Wife was a wicked Woman, that he was very well in the Morning till after she had made him some Pap, which (he said) had done his Business for him, and that he should die; and he did die on the Morrow Morning, she had little to say for herself, and called no one to speak for her, prevailed on the Jury to find her guilty: And the Judge immediately pronounced the proper sentence upon her which would be put in Execution next Friday, She pleaded her belly; but a Jury of Matrons being sworn, examined her, and she was found 'Not Quick with Child'.

Worcester, 19 April 1753

Last Friday was executed at Gloucester, Anne Williams, for poisoning her Husband, was burnt at the Stake, protested her innocence of the Fact for which she suffer'd with a Behavior quite unbecoming her melancholy Departure.

# THE KILLING OF DANIEL SMITH

*Worcester Journal*, 14 March 1750

On Tuesday last ended the Assizes here, when the three following persons were capitally convicted, and receiv'd, the Sentence of Death, viz. William Mackcolly, for the murder of Daniel Smith, a Baker, at Red-Ditch; Anthony Craddock for returning from Transportation and since that stealing a Bridle, and Saddle out of the stable of Jesson Humfray; and Francis Hemming, for breaking into the house of Walter Steward and stealing there from several things: but before the Judges left this City they were pleased to reprieve Francis Hemming; and the execution of the other two will, we hear, be next se'nnight the 27th instant.–

Worcester, 28 March.
Yesterday, between 11 and 12 o' Clock, William Mac Auly and Anthony Craddock, condemn'd at our last Assizes, were carried in a Cart, to the Place of Execution, where they remained about an Hour before they were turn'd off. [This is presumed to mean 'Turned off a ladder'.] They hung about three quarters of an Hour, then, being cut down, their Bodies were put into Coffins, and deliver'd to their friends.– Both of them very devoutly join'd in the prayers, and Mac Auly addressing himself to the People, desir'd them in pathetick Terms, to take Warning by his unhappy Fate, exhorting them, in particular to be very observant of the Sabbath Day; to avoid Drunkenness, Profaneness, and Debauchery, which have brought such Numbers, to so untimely an End; concluding with a declaration, that he was in perfect Charity and Forgiveness towards all Mankind, and in humble Confidence of Forgiveness from God resign'd with great Courage, to his Divine Will, dying in the Faith of the Church of England.

# A DEN OF THIEVES

*Worcester Journal*, 19 April 1753

On Thursday, the 5th Instant was committed to Stafford Gaol, by the Right Hon. the Earl of Stamford, the Landlord and Landlady of a House known by the Name of the *Rock Tavern*, at Caunsall, near Stourton, on information that their House had a long Time been a Reception for Highwaymen, &c. (etc. and the rest). In a Stable hewn out of a Rock were found many valuable Things, and a Horse worth thirty Pound. And the Person taken up at an Inn in Stowerbridge, on Suspicion of being a Horse stealer, &c. (as mentioned in the next Page) is said to have been a Frequenter of the above House.

Worcester, 19 April 1753
WHEREAS a Person, who calls himself JAMES RIPPON, and says he is the Son of Robert Rippon of Oldbeck, in the Parish of Leeds, in the County of York, Brasier, was apprehended at Stowerbridge, in the County of Worcester, and is committed to the Gaol for the said County of Worcester, by the Right Hon. The Earl of Stamford, and John Soley, Esq., on suspicion of stealing Horses, and other felonious Practices: The said James Rippon is about 28 Years of Age, five Feet five Inches high, a thick well set Man, flat Faced, has three Scars on his Forehead, (one above his left Eye) a Dimple on his Chin, is of a brownish Complexion, and his Hair is dark and grows low on his Forehead. He had on a brown Bob Wig, a thick set lightish colour'd Coat, with a small Velvet Cape, a black Cloth Waistcoat, and a blue and white check'd Linnen Waistcoat with small Glass Buttons, and Leather Breeches. – When he was taken he had with him a Dark Bay Gilding, with a Silver Tail, and broad bald Face, the near Eye-lid grey, four white Legs, about 14 Hands and a Half high, and five Years old; also a Bay Mare, both Feet before and the off Foot behind white, a grizle Snip full 14 Hands and a Half high, and six Years old. – There was found in possession of the said James Rippon a

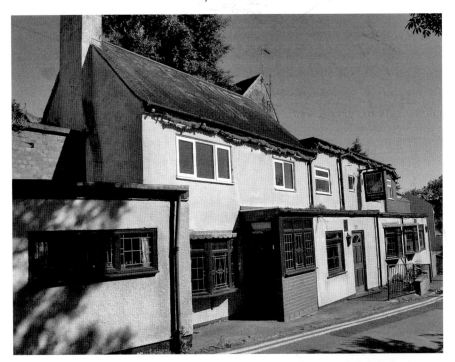

*Above and right:* The Rock Tavern at Caunsall, near Cookley, as it is today. It dates back to at least 1753 and was probably a beer house before that. It is now closed. The original building still remains, with additional new extensions built in front. It still has caves in the rear, cut into the sandstone, where the beer was stored to keep it cool, acting as the beer cellar. The caves where the highwayman's loot was stored can still be found. The last landlord is the present owner.

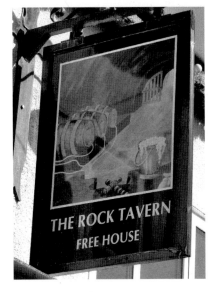

black quilted Petticoat, a blue Calamanco Women's Gowns, a small Trunk, with a Shift, Apron, and Women's Caps, two Pair of Stockings, One Pair white and the other green, and a brown Joseph. – N.B. the Horse, Mare and Goods, above mentioned, are now in the Hands of Mr. Josiah Powell, Constable, at the Cock Inn, in Stowerbridge, Worcestershire. James Rippon, charged at the Worcester Summer Assizes with stealing a Mare, was discharged by Proclamation.

# THE TRIAL AND EXECUTION OF DR ARCHIBALD CAMERON

*Worcester*, 24 May 1753

Thursday morning last Dr. Cameron was carried from the Tower (attended by several of the Warders and a Party of the Guards) to the Court of Kings Bench, and there arraign'd upon the Act of Attainder passed against him and others, for being in the late Rebellion, and not surrendered in due Time. The four Judges were on the Bench and the prisoner not being desirous to give the Court any Trouble, readily acknowledged himself to be the identical Person; whereupon, after due Deliberation, the Lord Chief Justice Lee pronounced the following moving sentence: Archibald Cameron, of Lochiel, in part of Britain called Scotland, must be removed from hence to his Majesty's Prison of the Tower of London, from whence you came, and on Thursday the 7th June next your Body to be drawn on a Sledge to the Place of Execution, there to be hang'd, not till you are dead; your Bowels to be taken out, your Body quarter'd, and your Head cut off, and affixed at the King's Disposal; [usually on a pikestaff, or on a convenient spike for display] and the Lord have Mercy on your Soul.– On receiving the Sentence he made a genteel Bow, and only desired he might have Leave to send for his Wife, who, with seven Children, entirely dependent on him for Support, are now at Lisle in Flanders; which was granted. He said, that in 1746 he came from France to surrender himself, agreeable to the proclamation, but was prevented by an Accident happening in his Family. He behaved with great Resolution before the Court, and answered to every Question with a becoming Decency.

### ACCOUNT of the BEHAVIOUR of DR. ARCHIBALD CAMERON.

At the place of EXECUTION, on Thursday June 7th 1753.

When this Gentleman came to the Place of Execution, he look'd on the Officers and Spectators with an undaunted and composed Countenance; and as soon as he was unloosed from the Sledge, he started up, and with a heroick Deportment stept up into the Cart by the help of one of his Executioners; whence looking

round, with Unconcern, on all the awful Apparatus of Death, he smiled: On seeing the Clergyman that attended him coming up the Steps, he came forward to meet him, and endeavour'd with his fetter'd Hands to help him up, saying So – are you come! This is a glorious Day to me! 'Tis my new Birth Day; there are more Witnesses at this birth than there were at my first. The Clergyman ask'd how he did: He said Thank God I am very well, but a little fatigued with my Journey; but blessed be God, I am now come to the End of it.

On hearing one of the Gentlemen that presided at the Execution, ask the Clergyman, whether he would be long about his office, Dr. Cameron immediately took the Word, and said, He required but very little Time, for it was but disagreeable being there, and he was as impatient to be gone as they were. The Clergyman then asked the Gentleman who had spoke whether he was the Sheriff, and on being answer'd in the Affirmative, he told him Dr. Cameron's Business there would be chiefly with him; and that he had something to communicate to him, if he would take the Trouble to come near, which he readily compli'd with, and endeavour'd to bring his Horse close to the Cart; but finding the Horse a little unruly, and he could not hear what the Dr. said, by Reason of the Noise of the Multitude, he beckoned with his Hand for Silence, but to no purpose; whereupon he very obligingly alighted and came up the Steps, and with Great Civility and Attention listened to the Doctor, who to this purpose spoke:

Sir, you see a Fellow Subject just going to pay his last Debt.

Dr Archibald Cameron of Lochiel was executed at Tyburn and was a clan chief and leader of 800 men and a supporter of Prince Charles Edward Stuart, i.e. Bonnie Prince Charlie of Scotland who was known as the 'Young Pretender'.

The Jacobite Rebellion in 1715 led to the invasion of England by the Prince, who almost reached Derby. The final battle between the two sides came at Culloden in 1746, when the English won the day. Bonnie Prince Charlie fled to France and so, it appears, did Archibald Cameron. Many of the Jacobite leaders were tried in London and elsewhere, on a charge of high treason and executed similar to above, which was reserved for traitors. Archibald Cameron was caught in 1753 and received the same punishment. Executions were normally carried out on Tower Hill.

# MURDER OF JOHN ADNEY

*Worcester Journal*, 26 July 1753

On Sunday last one John Morris, a Brass Clock maker in Pershore was committed to our County Gaol, for assaulting and dangerously wounding John Adney, who kept the 'Sign of the Plough' in the town.– The Affair, we hear was as follows, viz. a Quarrel happened between them, yet seemed reconcil'd soon after: But as Adney was returning home that Evening, Morris, 'tis said, way-laid him, and took an Opportunity as he was getting over a Stile to strike him a violent Blow on the Head with a Soldering Iron, of which Wound the said Adney remain'd very ill 'till last Tuesday Morning, and then died.– The Coroner's Inquest sat on his Body Yesterday, and, we hear, brought in their Verdict, *Wilful Murder.*

Worcester, 9 August 1753

At our Assizes (which ended Yesterday) a number of Prisoners were capitally convicted, amongst whom was John Morris the Younger, for the murder of John Adney. He was found guilty on Tuesday, and; agreeable to the late Act of Parliament, received sentence to be hang'd, dissected and anatomis'd, this Day: Accordingly, between 12 and 1 o'clock, he was convey'd from the County Gaol to the common Place of Execution, where he suffer'd; after which pursuant to the above Sentence, his Body was deliver'd to the Surgeons.–

Worcester, 16 August 1753

John Morris, who was executed here last Thursday for Murder, could not be brought to acknowledge he intended to kill Adney, tho', from the strongest Circumstances it appear'd he not only intended his Death, but likewise to rob him; he however confess'd he had been guilty of many heinous Crimes, even that of Murder, but could not be prevail'd on to descend to such Particulars as would have made a Discovery of his Accomplice.– When he came to the Place

of Execution he seem'd very impatient to make his Exit, pulling the cap over his Eyes two or three times before things were in Order for his being turn'd off. Just before the Rope was put around his Neck, he call'd out very audibly to know whether there was any Body there from Pershore, and being answer'd in the Affirmative, he pull'd off his Coat and gave it to a Man to carry to his Father. He was about 23 Years of Age, and has left behind him a wife (who is a very good Sort of Woman) and one child; and, 'tis said, he inveigled her into Marriage (she having a little Money, tho' a Servant at the same Time) by pretending to be violently in Love with her, and telling her he was a Country Esquire of considerable estate at the same Time appearing, as to Dress agreeable thereto; and to prevent all Doubt of his being such a Gentleman, dress'd up a Relation in a very grand Manner, and sent him to confirm what the other had declar'd.

The cap or hood was either black or white and served the double purpose of preventing the prisoner being able to see what the executioner was doing and prevented the observers seeing the agonised look on the prisoner's face as the rope tightened around his neck. A night cap was often used for this purpose and was positioned at the last moment, i.e. 'Pulling the wool over one's eyes.'

Worcester, 23 August 1753
John Alcock, alias Brown, who was condemen'd at our last Assizes for stealing a Mare, will certainly be Executed on Wednesday next.

We hear that the Landlord and Landlady of the *Rock Tavern*, in the parish of Kinver are to be tried at the next Assizes.

Worcester, 30 August 1753
Yesterday John Calcott, [Alcock?] alias Brown, was executed here for stealing a Mare, the Property of Mr. Stone, of Isbury.– He was to have been executed before, but it being expected he would make great Discoveries (admissions), a Respite was obtain'd for him, but which had not the desir'd Effect, he rather growing more hardened and obstinate; for tho' (as he acknowledg'd himself) he had it in his Power to impeach a great Number of his Accomplices, sixteen of the most notorious of whom, he said might soon be taken, yet he could not be prevail'd on to do it; he, however, declar'd, that Morris, (lately executed here for the Murder of one Adney, of Pershore) with some others of the Gang, robbed a Person some Months ago near Sutton Coldfield, in Warwickshire, of 400 Pounds, afterwards murder'd him, and then buried his Body; but he would not tell who were the other Persons concern'd in the said Robbery and Murder: He likewise acknowledged he had for some Years past belong'd to a numerous Gang of Rogues, consisting of about 40 Highwaymen, Horse Stealers, &c. many of whom were Frequenters of the *Rock Tavern*, in Staffordshire; and there is some Reason to believe his obstinacy proceeded chiefly from their promising to rescue

him at the Place of Execution, the vain Hopes of which, no doubt, prevented his impeaching them, who, however, deceived him, he remain'd to the last very obstinate and full of Resentment, particular against Mr. Stone, who, he said had best take Care of himself, insinuating, that the Gang would take an Opportunity of murdering him. Between Eleven and Twelve o' Clock he was carried to the place of Execution.

[John Calcott and John Alcock, both having the same alias, were apparently hung for the same crime. At this particular time, there were many reports in the newspapers, of armed highwaymen on horseback robbing mail coaches and passengers of their valuables.]

At the Assizes at Wells, for the County of Somerset, John Poulter, alias Baxter indicted for robbing Dr. Hancock, of Salisbury on Clerken Down, near Bath, pleaded guilty, and received sentence of death; but 'tis said that, on account of the Discoveries (admissions) he has made, he will receive His Majesty's Pardon. John Ford, Silversmith, of Bath, charged by the said Poulter with receiving stolen goods, was admitted to bail.

The trial of Mr. John Ford, Silversmith, at Bath, also accused by John Poulter of receiving some Pieces of Gold, a Girdle Buckle, a Silver Tankard, &c. stolen at various times by Poulter and his Companions, was put off until the next Assizes.

### Worcester, 7 March 1754

Bath, Feb, 26, On Sunday last an Express arrived at Ivelchester, ordering the Execution of the notorious John Poulter, alias Baxter; he said he was willing to die, provided he could first see his Wife, who was directly sent for from Bath.

Yesterday the said Baxter was Executed at Ivelchester, according to the Sentence passed on him last Summer Assizes, (none of his principal Accomplices having been taken since, whereby he could have admitted Evidence to save his Life, tho' with that expectation he was reprieved from Time to Time for the Space of eight Months.) At the Place of Execution he behaved very penitently: He then went and looked into his Coffin, and afterwards gave Directions to the Hangman to tie the Rope shorter, it was hanging down too long; then, having spent a short Time in private Prayer, he let his Book drop and calling aloud upon God to have Mercy upon his Soul, the Cart was drawn away. It was observed that he never struggled once after he was turned off, but hung quite motionless from the first moment.

### Worcester, 21 March 1754

William Harrison, now under sentence of Death for robbing on the Highway, will be executed tomorrow.

George Steel, alias John Pilkington, who was executed on Thursday last, behav'd, to the last with great Hardiness and Obstinacy.– On his Trial he was remarkably bold and Insolent; for when the Judge had pronounced the sentence

of Death on him, concluding with Praying the Lord to have Mercy on his Soul. Steel immediately cry'd out, *And the Lord have mercy on your Soul, and every Body's here*. He acknowledged he had formally belong'd to the noted Baxter's Gang and was principally concerned in Horse stealing, but could not be prevailed on to name any of the Accomplices. On his way to the gallows, he kept himself in View as much as possible, and often laught'd; and observing a Person crying of Hot Mutton Pies, he expressed an inclination to have one, and call'd out for that Purpose, but, upon recollecting himself, he thought it would be a useless Piece of Indulgence, and therefore had none. He said nothing material at the Place of Execution, but seem'd very impatient to be dispatch'd, and, as soon as the Rope was plac'd round his Neck, he threw himself off the Cart with a great Swing not waiting for its being drove away. After hanging about an Hour, he was cut down and his Body delivered to the Surgeons for Dissection.

Worcester, March 1755
Last Thursday Evening Mr. John Webster, of Salop, was robb'd by a Highwayman, on Stowerbridge Common of upwards of Twenty Pounds in money, his Watch, and Pocket Book, in which there were Bills to 171*l.* in Value.

On Saturday Night last about six o'clock, Mr. Phillips the Stowerbridge Carrier, and a Boy were robb'd by two Footpads, one and a half miles from Birmingham, near Five Ways, one of whom had on a white Frock coat, on the road to Hales Owen, of what Money he had about him, and his Letters and Parcels and the Boy of about 18*s.*

On Saturday, Samuel Edwards, who was convicted of Robbing Mr. Phillips, the Stourbridge Carrier, was executed at Warwick, he confessed to the Robbery of a man asleep between Stourbridge and Kidderminster, of 9*s.* – a man at Kidderminster, being drunk of about 3*l.* – Stole 3 horses at Bilston and 2 horses at Leominster and many other crimes.

# THE FATHERLESS BARN MURDER

*Berrow's Worcester Journal*, Thursday 19 April 1759

On Friday last a most cruel Murder was committed on the Body of John Walker, at Joseph Darby's near Hales-Owen, where the Deceased and one Nathaniel Gower, as Bailiffs, were in Possession of the said Darby's Goods on a Distress for Rent: About Nine that Evening, the said Darby's two Sons, Joseph and Thomas, came into the House, and with a Broom Hook and Bludgeon fell upon the said Bailiffs, and Gower escaping, they cut and beat the Deceased until he was almost killed; then stripping him naked, thrust him out of the House, and with a Wagon Whip cut him almost in Pieces: Gower made the best of his Way to Hales-Owen, from whence some Persons went to the Deceased's Relief in a Close near the House, who found him weltering in his Blood, and with great Difficulty carried him to Hales-Owen, where he immediately expired. Upon searching Darby's House early the next Morning, he, his Wife and two sons were secured, but not without great Danger to the Apprehenders, one of whom narrowly escaped being killed with an Ax with which the old Man struck at him. They were all four on Sunday last committed by the Rev. Mr. Durrant to Shrewsbury Gaol. Upon full and sufficient Proof made of the Fact, and of old Darby's standing by, and all the Time encouraging his Sons in perpetrating this Scene of horrid Villainy. The Deceased's Coat, Waistcoat, and Breeches, were at the Time of taking the Murderers found in the said House, all bloody.

Worcester, Thursday 16 AUGUST 1759
Letter from Stourbridge, dated Tuesday, Aug. 14:
Joseph Darby and his two Sons, indicted for the murder of John Walker, in the Execution of his Office of a Bailiff, at their House near Hales-Owen, were, on Thursday last, (the Day the Assizes ended at Shrewsbury) condem'd, and were hang'd on Saturday. The old Man's Body was given to the Surgeons in order

The road where the gibbet was erected was named Gibbet Lane as a grim reminder of what happened there. It was renamed Alexandra Road in recent times and no longer bears witness to the atrocious murder that was committed nearby, or the penalty paid by the perpetrators.

*Right and next page:* Newspaper reports taken from *Berrow's Worcester Journal,* 19 April and 16 August 1759. Note. ſ pronounced as an S.

**WORCESTER,** *April* 19.

On Saturday next will be held our ſecond Fair.

On Friday laſt a moſt cruel Murder was committed on the Body of John Walker, at Joſeph Darby's near Hales-Owen, where the Deceaſed and one Nathaniel Gower, as Bailiffs, were in Poſſeſſion of the ſaid Darby's Goods on a Diſtreſs for Rent: About Nine that Evening, the ſaid Darby's two Sons, Joſeph and Thomas, came into the Houſe, and with a Broom Hook and Bludgeon fell upon the ſaid Bailiffs, and Gower eſcaping, they cut and beat the Deceaſed till he was almoſt killed; then ſtripping him naked, thruſt him out of the Houſe, and with a Waggon Whip cut him almoſt in Pieces: Gower made the beſt of his Way to Hales-Owen, from whence ſome Perſons went to the Deceaſed's Relief in a Cloſe near the Houſe, who found him weltering in his Blood, and with great Difficulty carried him to Hales Owen, where he immediately expired. Upon ſearching Darby's Houſe early the next Morning, he, his Wife, and two Sons were ſecured, but not without great Danger to the Apprehenders, one of whom narrowly eſcaped being killed with an Ax with which the old Man ſtruck at him. They were all four on Sunday laſt committed by the Rev. Mr. Durant to Shrewſbury Goal, upon full and ſufficient Proof made of the Fact, and of old Darby's ſtanding by, and all the Time encouraging his Sons in perpetrating this Scene of horrid Villainy. The Deceaſed's Coat, Waiſtcoat, and Breeches, were at the Time of taking the Murderers found in the ſaid Houſe, all bloody.

> *Letter from* Stourbridge, *dated Tuesday, Aug 14:*
> "Joseph Darby and his two Sons, indicted for the Murder of John Walker, in the Execution of his Office of a Bailiff, at their House near Hales Owen, were, on Thursday last, (the Day the Assizes ended at Shrewsbury) condemn'd, and were hang'd on Saturday. The old Man's Body was given to Surgeons in order for Dissection. His Wife was tried for being concern'd in the said Murder, but was acquitted." And
> "Yesterday Morning, about Eight o'Clock, the Bodies of the two Sons were brought through this Place, and carried to Haley-Green, about a Mile from the Place where the Murder was committed, and hung in Chains, between Four and Five in the Afternoon, in the View of a prodigious Number of Spectators. The Reason why they were not hang'd up till so late in the Evening, was, that a convenient Spot was not fix'd on to erect the Gibbet, and now it stands very close to the Common Road. As they, while living, were a Terror to their Neighbours, they may, probably, terrify them a long Time yet, their Faces not being cover'd, which render them very ghastly Spectacles.
> "Since the Execution 'tis reported that one of the Persons hung in Chains was not a Son of old Darby's, but was nurs'd in the Family from his Infancy.

for Dissection. His Wife was tried for being concern'd in the said Murder, but was acquitted. And "Yesterday Morning, about Eight o'clock, the Bodies of the two Sons were brought through this Place, and carried to Hayley-Green, about a Mile from the Place where the Murder was committed, and hung in Chains, between Four and Five in the afternoon, in the view of a prodigious Number of Spectators. The Reason why they were not hang'd up until so late in the Evening, was, that a convenient Spot was not fix'd on to erected the Gibbet, and now it stands very close to the Common Road. As they, while living, were a Terror to their Neighbours, they may, probably, terrify them a long Time yet, their Faces not being cover'd, which render them very ghastly Spectacles." Since the Execution 'tis reported that one of the Persons hung in Chains was not a Son of old Darby's, but was nurs'd in the Family from his Infancy.

At this particular time Hales-Owen was in the County of Shropshire, so the prisoners were tried at Shrewsbury.

# MURDER OF THE SON OF ANN NOTT AND MARY BUCKLEY

*Berrow's Worcester Journal* 1761–1762

Worcester, 15 October 1761

On Sunday last Ann Nott, Servant in a Gentleman's Family, in High Street, was committed to our City Gaol, being charged, by the Coroner's Inquest, with murdering her Male Infant, which was found in the Necessary House, [a privy or toilet in an outhouse] that Morning, and taken out alive, but died in about an Hour after.– She denies throwing it in, but says it dropped from her as she was at the Necessary in the night.

Last Week a Child, about four Years old, Son of William Amphlet, Esq; of Hadzor, in this County, slipt through the Hole of the Necessary House, was smother'd before any Assistance could be given it – At the Time this melancholy Accident happen'd, Mr. Amphlett and his Lady were at Worcester.

William Amphlett was Lord of the Manor of Hadzor and he died in 1786 aged fifty. The Manor was held by the Amphlett family up to 1822, when it was sold to John Howard Galton, a gun manufacturer, who made gun barrels at Belbroughton. The family home was Hadzor House, originally a sixteenth-century half-timbered Elizabethan building, standing on the site of the present Hadzor Hall, rebuilt about 1830.

Worcester, 11 March 1762

At our Assizes, which ended Yesterday, Ann Nott, late Servant in a Gentleman's Family in this City was capitally convicted, and order'd to be hang'd To-day, and her Body afterwards to be dissected anatomised, for the Murder of her Bastard Child, which was found in the Necessary-House, and taken out alive, but soon after died.

Worcester, 18 March 1762

On Thursday last Ann Nott was executed here for the Murder of her Bastard Child: She acknowledg'd the Justice of the Sentence, and exhorted the People present to take Warning by her ignominious Death. After hanging the usual Time, her Body was taken to our Infirmary, in order to be dissected and anatomiz'd.

Worcester, 8 April 1762

On Sunday se'nnight was found in Wyre Forest, near Bewdley, a Child, supposed to be about seven Years old, with its Throat cut from Ear to Ear, its right hand cut off, and several other Marks of Violence on its Body. A Pillow was found near the Place, which makes it imagin'd to be brought there some Miles on Horseback, and, as it was neatly dress'd, and some Money found in its Pocket, to have belong'd to some Person of Fortune.

Worcester, 15 April 1762

On Friday last, one William Buckley, by Trade a Butcher, and is a very well-looking Man, was brought to our County Gaol, being charg'd with the wilful murder of Mary his Daughter, about five Years of age, who about a Fortnight ago, was found in Wyre Forest, near Bewdley, with her Throat cut from Ear to Ear, as mention'd in our last Week's Paper.– This Child, it seems, he had by a married Woman, (whose Husband has been absent some Years) and being oblig'd to maintain it, put it out to Nurse, at Two Shillings a Week; but on old Christmas-Day last, he came on Horseback to the Nurse, and told her he had agreed with another person to nurse it cheaper, and therefore shou'd take it away: Upon which the Nurse, exceedingly fond of the Child, observ'd he had with him a large hook'd Knife, or Bill, which the Nurse being fearful might occasion some Hurt in riding with it uncover'd, gave him an old Stocking to wrap around it, likewise lent him a Pillow for the Child to ride on; which Stocking and Pillow, it is said, were found near the Place where the Body of the Child was taken up – He, however, denies the Murder, but acknowledges taking the Child away, and says, that as they were on their Journey, they met with some common Travelling People, to whom he gave Three Guineas to take the Child off his Hands, it being a material Obstacle and Incumberance to him, as he was then just on the Point of Marriage.– The Nurse's swearing to the Cloaths the Body of the Child was found in occasion'd Buckley's being apprehended, and was taken at Faseley, near Birmingham.

Worcester, 5 August 1762

On Wednesday next will be the Commission-Day for the holding of the Assizes for this County and City.– there are nine prisoners in our County Gaol, some of them for capital Offences, among who is William Buckley, charged with the Murder of his own Daughter, about five Years of Age, in a most shocking Manner.

Worcester, 19 August 1762

At our Assizes, last Week, William Buckley, was condmen'd, for the Murder of his Daughter: On Saturday last William Buckley was executed, amidst a vast Concourse of People, and on Tuesday last his Body was taken to be hung in Chains at Wyre Forest, near the Spot where the Body of his Child was found. He pleaded Innocence 'til the Morning of the Execution, when, by the pressing Exhortation of the Clergyman who attended him, he burst into Tears, acknowledg'd the Murder, and the Justice of the Sentence pass'd on him. At the place of execution he appear'd rather sullen, and was so impatient to be releas'd from this World, that he would not wait for the Cart's being drawn from under him, but, as soon as the cord was placed about his Neck, he threw himself off with great Vehemence, and instantly appear'd to be quite dead.

Worcester, 29 March 1764

Yesterday se'nnight (Executed 21st March 1764) Mary Saunders was burnt at Monmouth, agreeable to her Sentence, for robbing and murdering her Mistress. She was a poor ignorant Girl, about eighteen Years of Age. She confessed that, after she had done the Murder, she went up Stairs, and took 64*l.* out of a Box, and then went to Work in a Field where the rest of the Servants were at Harvest, and at the usual Time of dining returned with them to the House.

# MURDER OF FRANCIS BEST

*Berrow's Worcester Journal* Thursday 13 June 1771

Last Saturday Morning, between Nine and Ten o'clock, Mr. Francis Best, of Caldwall Mills, Kidderminster, a very substantial and reputable Meal man, was found murdered in the Ridd-Field near Kidderminster, having his Throat cut in so shocking a Manner that his Head was almost severed from his body, and his Scull so terribly fractured that his Brains were plainly to be seen. Mr. Best was going on Foot to Bewdley Market, and it was known by his Family that he took with him in his Breeches Pockets, about fourteen or fifteen Pounds, and in his Waistcoat Pocket he had a Bag containing about 80*l*. which last Sum remained there when he was found, but the other Cash was missing. The same Afternoon John Child, of Kidderminster was taken up, on Suspicion of being concerned in this Murder and Robbery from the following Circumstances, viz. that, in the Forenoon, he came to Bewdley, and paid a Person some Money he had lately borrowed off him; that, in the Afternoon, he returned to Kidderminster, changed his Cloaths, bought a Pair of Breeches and other Things, and ordered a Horse to be got ready directly, and taken to the Turnpike, while he walked through the Town: But just as he was going to mount, the Constables seized him. On his Examination the next Day, he made the following Declaration; viz. That, about three Weeks ago, it was agreed between him, and one Thomas Bourne, of Alverley, in Shropshire, to meet upon a Day then fixed on (being Saturday last) and to way-lay and rob Mr. Best; that they accordingly met, and went together to the place where they had agreed to attack him; that as soon as they had met and pass'd Mr. Best, Bourne turned about and knocked him down with a large Bludgeon, and cut his throat; and that then they rifled his Breeches Pockets. Upon this Accusation, some Persons immediately set out to find Bourne, but he could not be heard of by that Name, having changed it to that of Steel; however, by a Description given of him as having lost one of his Fingers he was discovered to be

in the Service, at Mr. Palmer's of Compton, in the Parish of Kinver, Staffordshire, and accordingly brought to Kidderminster for Examination, and Mr. Palmer attended on the Occasion; but it was clear on the Testimony of Mr. Palmer, that Bourne had been at Home the whole Day, it is pretty certain that this Murder and Robbery were committed by Child himself only. On his being searched, soon after he was taken, there was found upon him Money to the Value of about 12*l*. amongst which was a remarkable Nine-shilling Piece, which was proved to have been lately received, by Mr. Best's Son, off a Person at Kidderminster and afterwards paid by the Son to the Father; the identity of which Piece has been sworn to by Mr. Best's Son and the Person he received it off: The Bludgeon with which Mr. Best was knocked down, has since been found, by Child's Direction, near the Place where the Murder was committed: And a conscious Guilt, since the Discovery of these Particulars seems to have filled his Mind with Horror and Distraction; for, on Monday last, while at Breakfast, being entrusted with a Knife, he suddenly started up, and stabbed himself in two or three Places in the Belly, but the wounds, it is thought, by the Persons who attend him, will not prove mortal. He continues under Confinement, with a proper Guard over him, in the Town Hall at Kidderminster, and is to remain there till he's fit to be removed to our County Gaol. And as to Bourne, he likewise remains in Custody; for, though he may justly be pronounced innocent, in respect to the Murder of Mr. Best, yet he frankly acknowledged his being well acquainted with Child, and that he had been concerned with him in divers Robberies, &c.

Worcester, Thursday 20 June 1771
On Friday last Thomas Bourne was brought to our County Gaol, being charged by John Child as an Accomplice with him in the Murder and Robbery of Mr. Best, near Kidderminster: But Bourne, most solemnly protests he is entirely innocent.
On Tuesday last the above John Child was likewise committed to the said Gaol: He was conveyed from Kidderminster between two Horses, who supported a Kind of Bier, with a Bed upon it, and on that he was placed full length, properly fastened down, and over him was a sort of tilted Covert; so that the vast Numbers of People who waited all the Way on the Road, and in the Streets of this City, to view him as he passed, were disappointed upon seeing him. He is kept in a Room by himself; and, to prevent a second Attempt to destroy himself, his Hands are stapled down to the Floor.

We are assured, that John Child, under confinement in our County Gaol, for the Murder of Mr. Best, begins to be properly effected with his unhappy Situation. He has recanted his Accusation against Bourne, declaring that himself only was concerned in that shocking Transaction. As this, seemed to be the Reality of the Case, the Rev. Mr. Taylor, who has attended Child, was the more pressing and assiduous in order to bring him to an Acknowledgement of his false Charge against Bourne.

Worcester, 18 July 1771

On Tuesday last ended our Assizes, when John Child was capitally convicted, for the horrid Murder and Robbery of Mr. Best, and this day he is to be executed at our County Gallows, after which his Body is to be dissected and anatomised. He stood with unyielding confidence, and unconcerned through out the trial and received the awful Sentence of Death without any apparent, alteration of countenance or Spirit. Thomas Bourne, who Child had falsely accused of being an Accomplice, was discharged.

Worcester, 25 July 1771

On Thursday last John Child, for the Murder and Robbery of Mr. Best, near Kidderminster, was executed at our County Gallows, amidst a vast, crowd of People; and the next morning his body was taken to our Infirmary for Dissection. He was very penitent and devout, he acknowledged the Crime for which he suffered, and desired the Spectators to take Warning by his untimely End. We are assured, that the famous Mr. Bourne, in his great Modesty and to shew particular Respect for his old Acquaintance, John Child, attended the Execution, and showed himself very clearly.

Up until 1812 most condemned prisoners were executed at the county gallows at Red Hill and some were executed at the city gallows at Pitchcroft, better known today as the Racecourse. Elizabeth Morton and Walter Kidson were exceptions – they were executed in their hometowns, where they had committed the crime.

There are other places where executions are thought to have taken place, such as Gallows Brook, near Hagley Hall, named after the gallows that might have stood nearby, and there was also a Gallows Elm Tree, which stood in a field at Kinver. Both sites suggest that local hangings might have taken place, but no evidence has been found to support this theory. There is also a Gallows Green near Droitwich.

The clothes worn by the executed person became the property of the executioner; many wore their oldest clothes for the occasion, while others wished to look their best. The ropes used for the execution belonged to the executioner, who often cut them into short lengths and sold them to the onlookers as souvenirs or mementoes, the price depending on how infamous his victim had been – hence the saying, 'money for old rope'.

# MURDER OF OBADIAH ROLLASON

*Berrow's Worcester Journal,* 1 July 1773

On Tuesday last was committed to the said Gaol (by Harry Long, Gent Coroner) Walter Kidson, late of Amblecoat, in the Parish of Old Swinford, Labourer, he being charged by the Coroner's Inquest with the wilful Murder of Mr. Obadiah Rollason, of Stourbridge; the Particulars of which are said to be as follows:– About two o-Clock on Friday Morning last, the said Kidson went to Mr. Rollason's House, and called to him, as he lay in Bed, telling him that a white Horse was got into his mowing Grass; upon which Information Mr. Rollason got up, dressed himself, and went to examine his field with the said Kidson, as is supposed; when they had reached a Gate that overlooked the same; the Villain began to execute his wicked Designs; as appears by much Blood being spilt on the road and Bushes for many Yards. About Five o' Clock the Deceased was found thrown across the Road; with the back Part of his Scull beat into his brains; and mashed in a shocking Manner; a large Cut on the Side of his Neck, and several other visible Wounds.– As soon as the Body was found; the whole Town was alarmed; and Pursuit was made after Kidson, who had endeavoured to fled several People that had met him; however; he was taken about Seven o' Clock the same Morning and brought to a Room where the Deceased lay, some of the Gentlemen charged him with committing the Crime, which he denied with a bitter oath; they began to examine his shirt sleeve; which was stained with Blood that looked fresh; they then charged him again; when he trembled much, but would not confess: His house was then searched; where they found a bloody Smock Frock washed in places where any Blood appeared; and put out to dry.– This blood-thirsty Villain had an Intention of putting his Designs in Execution a Fortnight before, by calling Mr. Rollason in the Manner above mentioned, but he escaped then by not rising. The field was examined both Mornings, when it did not appear that any Horse had been in it; this certainly confirms the Villain's

being the Perpetrator: He is a Man who had led a loose life, and bears a bad Character, and was tried at Worcester Assizes, last Summer, for stealing Hay but was acquitted.—

It is supposed that the Reason of his committing this Murder, was to rob Mr. Rollason of a Sum of money he took at Bromsgrove Fair the Day before, who, in his hasty Rising, changed his Breeches, by which the Murderer was disappointed of a good Booty.— He is a very lusty-well looking Fellow, but has rather worn a gloomy Aspect ever since his Commitment to Gaol. He still positively declares that he is entirely innocent of the Murder; that he has not been in Company with: nor seen Mr. Rollason for a Fortnight before he was brought to view the dead Body; that he was at Home, in Bed with his Wife, at the Time, and long after it was said Mr. Rollason was called up and supposed to be Murdered. Being asked how his shirt, &c. became so bloody; he said he had been killing a Lamb the Day before, which had occasioned it:— He is much chagrined at being refused a Bed in the House instead of lying in the Dungeon with the rest of the Criminals; but when it is considered how dangerous it would be to admit him into the House, there was great Prudence and Propriety in not indulging him. – The following circumstances of great weight against this Fellow, we are told, arose in the Course of his Examination; viz; that when Mr. Rollason was called to, get up, that both himself and wife concluded it to be the Voice of the said Kidson.

Worcester, 21 August 1773

The Trial of Kidson (who is to be executed Tomorrow, near the Spot where the Murder was committed, and afterwards hung in Chains) lasted near six hours, in the course of which above thirty Evidences (Witnesses) appeared against him, and such a Multitude strong, corroborating Circumstances arose, that not the least Doubt could remain of his being guilty of the Murder; though he positively denied the Fact when called to make his Defence, and seemed not at all affected when the Sentence of Death was passed upon him; and even when he was measured yesterday in the afternoon for his irons, [chains in which he had to hang on the Gibbet] he stood with the utmost Composure.— Had this desperate, inhuman Wretch escaped, many People in Stourbridge, and that Neighbourhood, would have been under the most terrible Apprehensions, he having thrown out many severe threats and Menaces against those who were instrumental in bringing him to justice.

Worcester, 28 August 1773

On Friday last Walter Kidson, for the Murder of Mr. Rollason, of Stourbridge, was executed near that Town (and afterwards hung in Chains) amidst a Concourse of at least twenty thousand People, and to the great Satisfaction of the whole Neighbourhood, to whom he was become a great Terror, being a most vicious desperate Fellow; and he remained to the last such an obstinate, harden

Wretch, as to die in absolute Denial of the Fact. He was conveyed from our County Gaol in a Post Chaise [a hired travelling carriage, drawn by horses] to within about three Miles of the Place of Execution, and then put into a cart, which carried him through the Town of Stourbridge. It was a long Time before he expired, the Rope being very injudiciously fixed around his Neck, so as that his Head was near slipping through the Noose; and it is asserted, that he cried out, after he had hung near two Minutes, *O' Lord! I shall never die.*

Walter Kidson was hung at Amblecote, close to where he killed Mr Rollason. His execution was amateurish, the noose being incorrectly adjusted. He was probably 'dropped off' the back of the cart he was being conveyed on, which was an insufficient drop to break his neck. Consequently he suffered a long agonising death by slow strangulation causing him to cry out 'O' Lord! I shall never die.' On being pronounced dead, he was then conveyed to Stourbridge Common where he was hung in chains on a gibbet, possibly the gallows on which he was executed.

It will be noted that the county gaol is mentioned here, whereas the city gaol was mentioned previously. Worcester had two gaols and later two police forces.

Mr Obadiah Rollason was buried at Oldswinford Churchyard, 29 June 1773.

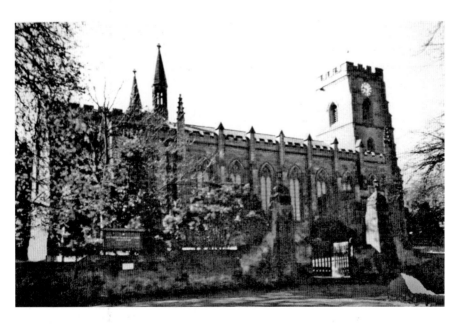

Above is St Mary's Church, the Parish Church of Oldswinford. In early times the parish covered Stourbridge, Wollaston, Lye, Wollescote and Amblecote, whereas today each have their own church and parish. Oldswinford derives its name from the Old Swine Ford across the river Stour in the lower part of Stowerbridge, where pigs once crossed, and which became Stourbridge once the bridge was built.

# MURDER OF BENJAMIN SMITH

Worcester. 8 April 1779

On Sunday last, one Isaac Snow, an imprest man confined in our city gaol, cut two of his fingers off with a chissel, to prevent his serving as a soldier; and we hear he is to be rewarded in a few days with 500 lashes.

Stafford. On Friday last George Eastop, convicted at the last Staffordshire Assize, for the murder of Benjamin Smith, a constable's assistant, in an attempt to impress him at Rowley, was hung in chains on Cradeley-Heath a small distance from the spot where the crime was perpetrated.

*Impress, to force a man to serve in the army or public service, to seize or make use of, as in press gang, i.e. to commander or take forcibly property, person or goods.*

*To impress a man into service, was a form of conscription, it was lawful, but objected to by many, as can be seen from the two above examples.*

George Eastop is thought to be a Cradley Heath man, who objected to being forced to join the army, and resisted arrest by Benjamin Smith. In the struggle that ensued, he killed him, and was charged with wilful murder. He was found guilty and sentenced to death and his body to be hung in chains on a gibbet, close to the place where the murder was committed.

Eastop was publicly hung at Stafford, 29 March 1779 and his body taken back to the Heath at 'Cradeley Heath,' where it was hung in chains, possibly in an iron cage, on a gibbet, at a convenient cross roads, close to where the crime was committed as an example to other people that his crime was unacceptable.

The district of Cradley Heath is often confused with that of Cradley; both can be found in the Black Country and are neighbours, divided by the river Stour, which is the boundary between the two parishes and possibly a barrier between the two,

On Sunday laſt one Iſaac Snow, an impreſt man confined in our city gaol, cut two of his fingers off with a chiſſel, to prevent his ſerving as a ſoldier; and we hear he is to be rewarded in a few days with 500 laſhes.

On Friday laſt George Eaſtop, convicted at the laſt Stafford aſſize, for the murder of Benjamin Smith, a conſtable's aſſiſtant, in an attempt to impreſs him at Rowley, was hung in chains on Cradeley-Heath, a ſmall diſtance from the ſpot where the crime was perpetrated.

The above item was found in the *Berrow's Worcester Journal* dated 8 April 1779. The first item refers to the Worcester Assizes amd the second to the Stafford Assizes.

before bridges were built. Originally Cradley Heath was in the parish of Rowley, in the County of Staffordshire, and is now in Sandwell, whereas, Cradley was in the parish of Halesowen, in the County of Worcestershire, although at one time it was partly in Shropshire. Rowley, for a period, was a chapelry to Clent, and the Vicar of Clent served both parishes, although there was a considerable distance between them, both Clent and the nearby parish of Broome were in Staffordshire. In early times probably, the whole area was known as Cradley, with the area north of the river Stour consisting mainly of heath land, known as Cradley Heath, but part of Cradley, where people grazed their cattle and sheep, later settlers or squatters built houses, they made nails and later made chain, which became the main industry of Cradley Heath.

France declared war on Great Britain 16 July 1778, and were joined by Spain 16 June 1779. Franco–Spanish siege of Gibraltar 1779.

# MURDER OF BABY GRIGGS

*Berrow's Worcester Journal*, 24th February 1780

The same day was lodged in Dudley Workhouse, until she is capable of removal to Worcester gaol, was Susannah Grigg, sometime since servant at a public house on Snow Hill, in this town, charged with the wilful murder of her bastard child, of which she had that morning delivered herself in a necessary [privy], in Dudley; it appeared upon the coroner's inquest, that this inhuman wretch had first endeavoured to destroy the child, by strangling it, there still remaining the marks of her bloody fingers upon its neck, which evidently had been twisted with great violence; but left this might not have effectually completed the atrocious business, she crammed down its throat, a quantity of horse-dung and ashes and afterwards hid the body in a dung hill.

Worcester, March 9 1780
On Tuesday afternoon ended our assizes, Before Sir George Nares and Mr Sergeant Heath; when Susannah Grigg, for the wilful murder of her female bastard child, of which she delivered herself about three weeks ago, at Dudley, in this county, received sentence of death, to be executed this day, and her body to be dissected and anatomised.

We are happy to hear, that Susannah Grigg, by the indefatigable pains taken with her by the Rev. Mr. Taylor, is brought to a proper sense of her approaching dissolution, and seems truly penitent; she acknowledges the justice of her sentence; says that what she is going to suffer is what she deserves; and confesses that the child was born alive, and that she was the murderer of it.

Worcester, March 16 1780
On Thursday last Susannah Grigg, for the murder of her bastard child, was executed at our county gallows, pursuant to her sentence. At getting into the

cart she was in great agitation, and cried bitterly; but before her arrival at the gallows seemed resignedly composed, and at the fatal tree joined devoutly in prayer with the clergyman who attended her. After spending some time in penitential ejaculations, and exhorting the female part of the spectators (great numbers of whom had assembled on the melancholy occasion from all parts), to take warning at her unhappy, and untimely end, being only 24 years of age, she dropped her signal [a white handkerchief] and was launched into eternity, calling upon the Lord to receive her soul.

This sad story is one that was quite common in these days, of girls leaving the security of the parental home to go into service and live at their master's home. Masters were prepared to provide a home for their servant, but not her illegitimate offspring, while the father of the baby, it seems, was not prepared to marry its mother or support his child. Her parents would not welcome her back into their home either because they were unable, or unwilling, to support her. Her situation would be desperate, making her unemployable and destitute.

# QUADRUPLE MURDER

*Berrow's Worcester Journal*, 11 May 1780

In the night between Saturday and Sunday last, a man, his wife, a child about nine years of age, and a brother-in-law, who had taken up his lodgings there for the night, were barbarously and inhumanly murdered in a cottage, at Birch-Moreton, in this county. This shocking scene was discovered by a man, who called upon the cottage early on Sunday morning; but hearing some horrible groans, and finding the door fast, went to a neighbour for his assistance.– On their return the door was open, and the miscreants, who were supposed to have been in the house when the man first called, were decamped, By this time the whole neighbourhood were alarmed, and immediately went in search of the murderers, when they came up on six trampers, whom they secured, and are now strongly guarded. Nothing yet has transpired to accuse them of the crime, that a child in the company with them, saying, *It was not my Daddy that killed them, but two men who are gone to Tewkesbury*. They are confined in separate places, and the coroner's inquest is expected to be taken this day. The horrid deed is supposed to have been done by an axe, but for what cause is only conjecture, as no property appears to have been taken away.

Worcester, 18 May 1780

Last week inquisitions were severally taken at Berrow, in this county, before Harry Long, Gent, coroner, on view of the bodies of Edward Gummery, Elizabeth his wife, and their daughter, aged nine years; and Thomas Sheen, brother of the said Elizabeth, who were the most cruelly and barbarously murdered in their beds, on Sunday morning the 7th instant (mentioned in our last), by some person or persons unknown, the people taken up last week on suspicion, being discharged.– The following is an authentic relation of this horrid transaction:– "Gummery was a poor, honest, industrious cottager, whose family consisted of himself, wife and daughter. Sheen unfortunately called the proceeding evening to sleep there. About four o'clock in the morning, Player (another cottager) who lived near Gummery, was awakened by a most dismal noise like the howling of a dog; he awoke his wife and they listened and heard another noise like persons scuffling together on a boarded floor, which noise they supposed came from Gummery's, he instantly got up and ran there, and found the fore door fast, and all quiet.

He called to Gummery several times, but received no answer, and whilst he was calling he heard somebody walking in the kitchen, which he imagined was Gummery's wife; he therefore repeatedly called to her, and on receiving no answer he went to the back door and found that fast; and being much alarmed, he immediately ran home, and bid his wife get up with all speed, telling her something was the matter at Gummery's; that she came down directly, and they ran together to Gummery's, where they found the fore door open, and saw a large stream of blood running through the crevices of the chamber floor into the kitchen; the drink house door off the hooks, and a pane of the wall broke down, which the villains are supposed to have broken and entered in to that part, and forced the door off the hooks, and got into the other part of the house. On going upstairs, he saw two dead corpse upon the chamber floor near the bed covered with blood, which affected him so much, that he had no power to proceed any further; and he and his wife immediately ran and alarmed the neighbourhood; the neighbours came, they found Gummery dead upon the floor, who had received one large wound between the shoulder and neck four inches long, which divided the clavicle and part of the sternum, and penetrated into the thorax; one other on the left temple, which extended to the interior part of the lower jaw, laying the cheek bone bare; one other on the back of the left hand, which divided the metacarpal bones; one other on the forefinger of the right hand; one superficial wound on the left thigh; one wound near the back bone under the right ribs, which penetrated into the cavity into the belly, from whence part of the intestines came through; and one other wound on the right leg, which divided the fibula.

They also found his wife dead upon the floor, having received a transverse wound on the face four inches long, which divided the cartilage and septum of

An Account of four People cruelly

# MURDERED

In their Beds in the Parish of Berrow near Castle Moreton in Worcestershire, about Six Miles beyond Newent.

ON Sunday Morning last about 4 o'Clock, a person who lived at a small distance from the House where the Murder was committed heard as he thought a groaning, accordingly he went to the House of one Edward Gommery a labouring Man, finding the outward Door fast, he called to them, but receiving no Answer he returned Home, and told his Wife that he feared all was not right at Gommery's, as they did not answer when he called, he then desired his Wife to go with him to the House : He now found the outward Door open, for the Villains were just gone away, for they were in the House when he first came there, having got in at the back part of the House, had the fore Door been open and he had gone in, he would have fallen a Sacrifice to their Fury : But his coming disturbed them, and they left the House.

When they came into the lower Room they called, but receiving no answer they went up Stairs, but shocking was the Scene, for Edward Gommery was lying with one Arm almost sever'd from his Body, and his Bowels hanging out : His Wife, with the upper part of her Head chopp'd in pieces, and her Nose cut off : Her Daughter with her Throat cut, and a Wound on the back of her Head : Mrs. Gommery's Brother lay with his Head split open, and the Blood ran in Streams through the crevices of the Floor. The Alarm being given, a general search began, and three Men with some Women and Children were found in a field about a quarter of a Mile off. On one of them was found a bloody Stick, and some Blood was found on the Cloaths of another. They were immediately secured, and taken to the Place where the Bodies lay, In returning, says one of them "The Girl looks just the same as she did when she was asleep."

One of them is named Evans, and is a Basket-maker. Another of them used to sell Toasting Forks about the Country

May 9th, 1780.

The above handbill printed 9 May 1780, is an account of the barbarous murder of a family of four in the parish of Berrow near Malvern. A stone tablet can be found on the outer wall of the Parish Church of St Faith, in memory of the Gummery Family and is shown below. No person or persons were apprehended for this atrocious crime, which remains unsolved.

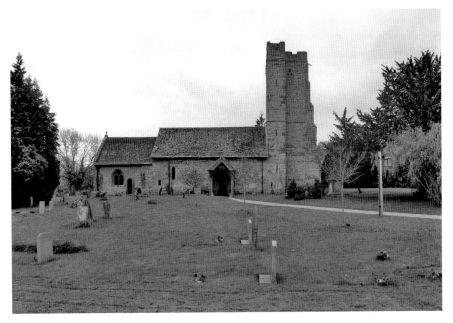

The church of St Faith at Berrow. The stone tablet shown below is on the lower right of the central doorway.

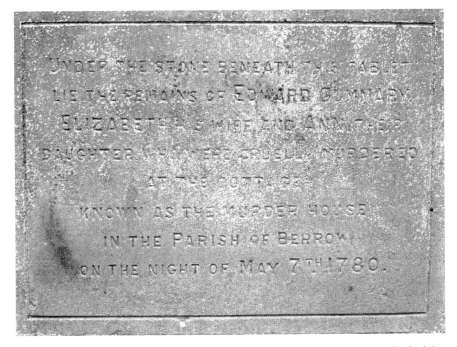

'Under the Stone Beneath This Tablet, Lie the Remains of Edward Gummery, Elizabeth his Wife, and Ann his Daughter, who Were Cruelly Murdered at the Cottage Known as the Murder House in the Parish of Berrow on the Night of May 7 1780.'

the nose through into the mouth; one wound on the fore head two inches long, laying the bone bare; one other on the top of the head, and the skull fractured so that the brain appeared; and one other wound on the right arm, below the elbow two inches long and one deep.

The child was found dead in the bed (where she, her father and mother slept) with one wound on the right side of the neck, the jugular artery cut through and the vertebrae of the neck wavered in two. Sheen was found dead in a bed in the adjoining chamber, and had received one large wound on the head, extending from the temple to the occiput; one other on the head under the left ear, which penetrated the brain; one other on top of the head which laid the skull bare from the forehead to the occiput; five other wounds on the left arm, one of which divided the head of the humerus; one other with a fracture of the arm; one other on the elbow penetrating the joint; and one other large wound on the back which divided the scapula, and thereby penetrated into the thorax. When the poor creatures were found they had nothing on but their shirts and shifts, and it is supposed they were murdered with a hatchet, or some such like instrument. The bodies being so shockingly mangled, and covered with blood, and an amazing quantity on the beds, chambers and the rooms underneath, it is impossible to describe the horrid scene.

Sheen, who was a labourer, had 3s. 6d. farthing in his pocket, and in Gummery's house was found 29s. 8d. which, is all as much as they were supposed to be possessed of at the time the murder was committed; nor doth it appear the house was plundered, none of the neighbours having missed anything that was there; or do they suppose either Gummery or his wife, gave offence to anybody, being very harmless, inoffensive people, and not given to quarrel. Notwithstanding Player immediately gave the alarm and a man being in a ground with some cattle at a small distance from the house, and heard Player call to Gummery, and an immediate hue and cry made for many miles, yet nothing has transpired likely to discover the inhumane murders, who had but just committed the barbarous deed and were in the house when Player first went there. [Player was very lucky not to have become the fifth victim.]

*Berrow's Worcester Journal*, 2 February 1809
Many of our readers may probably recollect on 7th June, 1780, a whole family was murdered in a cottage at Birtsmorton, in this county, and that the persons who were so active in destroying the fences of the Malvern Link Enclosure were suspected of being concerned in the perpetration of the horrid deed; however, from that time to the present, the murderers have never been discovered; but circumstances have within these few days occasioned at our Infirmary which seem to have a very close connection with the business:– On Thursday se'nnight, a man of the name of James Taynton of Malvern Link, about 80 years of age, a labourer on the highway, was brought to our Infirmary with one of his legs

dreadfully fractured; the day after his admission, he began to be delirious, and continued on with little intermission until the day of his death; during this time he often exclaimed "I only reared the ladder against the window, and supplied them with drink;" these words being heard by another patient, who remembered the murder at Birtsmorton, he asked Taynton if he knew anything of the murder. He replied, "I helped to throw down the railing, (he meant by this, the railing of the Link Enclosure) and to burn it, and I found them drink," he was afterwards asked whether the murderers were living.? he replied they were all living, and as old as himself. On Saturday last, the nurse, in his hearing was remarking to some of the patients that it was a pity he would not own to the murder, as she thought he knew something of it; he exclaimed quickly, "aye, damn you, but you have not got hold of it yet" in consequence of being asked what he took with him to the house, he said *bills*, and from the nature of the wounds inflicted on the bodies, it appears that these things have been the instruments used in committing the murders. He insisted continually that demons were coming to seize and torment him and was upon the whole a most affecting instance of the power of conscience upon a guilty mind, since his death it has been ascertained that he was one of the labourers employed upon the Link Inclosures, and bore a very bad character. He died on Monday.

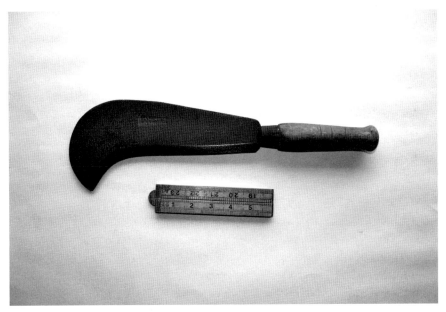

A single-sided Bill Hook, the inner edge is razor sharp. A double-sided 'Bill' would also have a cutting edge on the outer side.

# MURDER OF MARY HIGGS

*Berrow's Worcester Journal,* 25 October 1781

Committed to our castle Catherine Higgs charged with the wilful murder of her daughter, two years old, by throwing her into a pool near the Bell-Inn in the parish of Bell-Broughton.

Worcester, 14 March 1782
On Tuesday evening Mr. Justice Nares and Mr. Jus. Heath finished the business of the Assizes here; at which Catherine Higgs, for the wilful murder of her own daughter, about two years old, by drowning her in a pool near the Bell-Inn in the parish of Belbroughton, was capitally convicted, and immediately received judgement of death, to be executed this day.

Worcester, 21 March 1782
Thursday last Catherine Higgs, for the murder of her own daughter, was executed at our County gallows, [Red Hill] pursuant to her sentence.

Mary Higgs was buried at Belbroughton and is recorded in the parish records as:

Mary Higgs a poor child of the parish of Bromsgrove, two years old, was drowned by her own mother Catherine Higgs in a stream at Bell End, and buried here October ye 11th. The said Catherine Higgs was executed at Worcester ye 14th March 1782.

Belbroughton is historically known for its manufacture of scythes. It is situated on the Belne Brook, which rises at Clent and supported a number of water mills along its length. Most were used for scythe production, either as hammer forges

to make the blades or blade mills for grinding them. There were two water mills at Bell End and they were both fed by the Belne Brook, which was joined by the Penn Brook. The first, known as Bell End Mill, was used for scythe grinding and was at the junction of Hartle Lane and the Stourbridge–Bromsgrove Road. It was demolished in the building of the feeder way. The second, further up Hartle Lane was known as Galton's Mill and made gun barrels. Both had extensive pools.

Most of the mills in Belbroughton and Clent belonged to the Waldron family, of 'Field House'. Their scythes were known as Crown Scythes, which were also produced in Lye and Cradley by the Hill family. They also owned large expanses of land in the same area. William Waldron was probably the richest of them all. He married Mary Hill in 1764, the daughter of Thomas Hill of Dennis, who he was in partnership with at Stourbridge in various ventures including the glass industry, brick making and banking – they owned the 'Old Bank' in Coventry Street. He was High Sheriff of Worcestershire in 1795 followed by Thomas Hill in 1796.

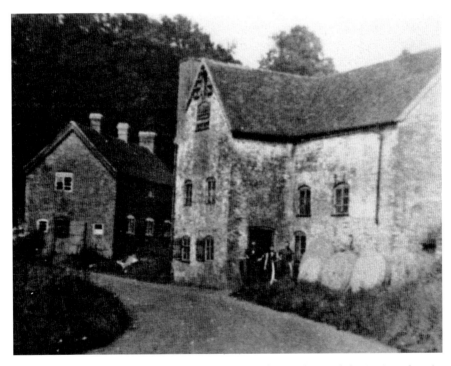

The above picture is the water driven blade mill for the grinding and sharpening of scythe blades, originally belonging to the Waldron family. The picture is old and in poor condition; it shows spare grinding wheels leaning against the wall on the right hand side of the doorway. The mill stood at the junction of Hartle Lane and the main road opposite the Bell Inn, but was demolished when the feeder way to the Motorway was built.

# MURDER OF JOHN WEBB

*Berrow's Worcester Journal*, 20 March 1783

Early on Friday morning the body of Mr. Webb, a farmer in the parish of Northfield, in this county, was found in a marl pit near the Bell Inn, Northfield. He had been at Birmingham market the preceding day, and in returning home late in the evening was robbed and murdered. His brains were dashed out, and his body otherwise barbarously mangled. The villain, supposed to have committed this cruel murder, was seen in company with Mr. Webb, on the road between Birmingham and Northfield, about seven or eight o'clock on Thursday evening. It is thought the wretch immediately after the horrid act stole a horse from Mr. Green of Rednal Green, which he rode to Lydiate Ash turnpike, there left him on Friday morning, and ran away. He was afterwards seen by several persons near Bell-Broughton. He is about five feet 10 inches high, stoops a little in the shoulders, has remarkable strong thighs and legs, and a large foot. He wore his own light-brown hair, had an old round hat, a claret coloured great coat, and light coloured ribbed stockings.

Worcester, 14 August 1783
At the assizes for this county Thos. Wardle was found guilty of the wilful murder, in March last of Mr. Webb, a farmer in the parish of Northfield, by beating out his brains, with a large stick, and afterwards throwing the body into a marl pit, on his return from Birmingham market. Immediately after his conviction the Judge, in a most awful and pathetic speech passed sentence upon him to be executed this day, and his body to be hung in chains on the further part of Bromsgrove Lickey, near Northfield.

Worcester, 21 August 1783
On Thursday last was executed, at Redhill, near this city, Thomas Wardle, for

the murder of Mr. Webb, at Northfield, in this county. He appeared to be near 40 years of age, of a sallow complexion, and his behaviour betrayed a sullenness of disposition, and a seeming insensibility of his awful situation, which was shocking to behold. At the fatal tree the clergyman repeatedly interrogated him with respect to the crime for which he was about to suffer, and pathetically expostulated with him on the enormity of launching into eternity with a lie in his mouth; but he continued inflexible and persisted in denial of the murder to the last. After hanging the usual time, his body was taken back to the castle, from whence it was next morning conveyed to the Lickey, and there hung in chains pursuant to the sentence.

At this time Northfield was in the County of Worcester, where Thomas Wardle was tried for the murder of John Webb. He was executed at Red Hill, where it appears he was hung from a tree. His body was later hung in chains at Bromsgrove Lock.

Lock-ups were the first forms of prisons or gaols, often found in villages and are now a quaint part of English history. They were only intended for over-night accomodation usually for drunken yobs who were noisy and belligerent and were often released the next day when sober. They could, however, be used as temporary accommodation for more serious crimes, like poaching etc., before being removed to a major establishment to await trial. In a way they were very similar to dungeons in castles, which were small, dark window-less confines, solidly built and not designed for comfort.

They can be found various shapes and sizes, but generally small and without windows, serving not as a punishment but as a means of securing disagreeable yokels overnight who might have taken on board large quantities of local scrumpy (dry cider) and become noisy and belligerent. The interior of such places was claustrophobic and dark, and smelt of the usually overflowing slop bucket, which was sufficient to sober up many delinquents who would not generally wish to stay a further night.

# MURDER OF MARY SMITH AND THOMAS ASHCROFT

*Berrow's Worcester Journal*, Thursday 13 September 1787

Committed to our county prison, by J. Sidkin, Coroner, Richard Rook, charged with the wilful murder of Thomas Ashcroft, an infant, at Wolverley, in this County.

William Smith, was committed to our county prison, on the 12th inst., by George Moult, Esq. charged on the coroner's inquest with the murder of Mary Smith, his wife, at Droitwich in this county by strangling her – The particulars of the above transaction, we hear are as follow. The deceased had been on Saturday at a Harvest Home where the prisoner went and was asked to partake of some refreshments, which he refused, and went away; the deceased soon after followed, and next morning some suspicions arising, enquiries were made, and the unfortunate woman was found in a situation, which gave cause of suspicion that she had been murdered.

Worcester, 13 March 1788
At our Assizes, which began on Monday last, before Mr. Justice Heath and Sir John Wilson, Knight, William Smith, for the murder of his wife; Richard Rook, for the murder of a boy; John Thomas and William Weston, for burglary; Joseph Twigg, for horse-stealing; Thomas Ford, for sheep-stealing; and William James, for a highway robbery, all received the sentence of death.

Worcester, 20 March 1788
William Smith and Richard Rook, for murder, are to be executed this day, and their bodies dissected; John Thomas, William Weston and Thomas Ford, are to suffer on Friday se'ennight.

Worcester, 27 March 1788

On Thursday William Smith, for the murder of his wife, and Richard Rook, for the murder of a boy, were executed at Red Hill, near this city, pursuant to their sentence. After hanging the usual time, their bodies were delivered to the surgeons for dissection. Smith stated that his untimely end was occasioned by excess of liquor. Rook prayed fervently, but persisted, to the last in his innocence of the crime for which he suffered.

Tomorrow will be executed pursuant to their sentence, John Thomas and William Weston for a Burglary at Longdon in this county, and Thomas Ford, for stealing a gold watch. The unhappy situation of Ford, who is to suffer tomorrow, should be a warning to servants, not to violate the trust reposed in them, as the opportunities they have of defrauding their masters by residence under their roof, and too frequently an easy access to their property, has induced the legislature to make severe examples of those who may in future be found offending.

This second lock-up can be found at Lacock and is owned by the National Trust. It is not too obvious to visitors as it blends in well with the rest of the village. A lot of these unique buildings have now disappeared. Many were built by the local Lord of the Manor, who had an invested interest in such buildings, as he employed most men of the village who might occasionally take a little extra beverage, and become drunk and disorderly and required restraining. There were of course others who also might indulge in a little poaching or illegal fishing of his Lordship's game, and since his Lordship was also the local Magistrate, it was his prerogative to award a day or so in the local lock-up as he thought necessary.

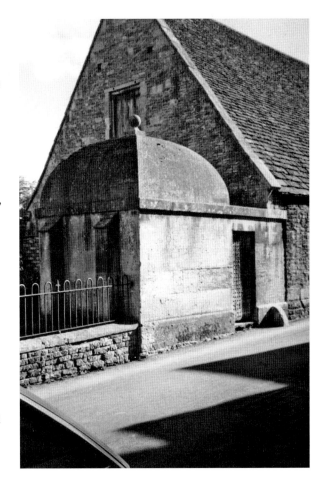

# MURDER OF JONATHAN PARTINGTON

*Berrow's Worcester Journal*, 6 October, 1796

Monday night last as Mr. Jonathan Partington, of Wyre Piddle, in this County, was walking home from Evesham Market, he was accosted on the road by a person who entered into conversation with him, and they walked together about a mile and a half, when the stranger stopped behind under some pretence, and coming up again gave Mr. Partington a severe blow on the back of his head with an hatchet; the latter on turning round and endeavouring to defend himself received several more blows on different parts of his head, which fractured his skull in a dreadful manner. The villain then demanded his money, and took from him seven guineas and half in gold and 3s. 6d. in silver.

Not content with this, he insisted, with horrid imprecations, on having some bills, which, he said, he knew he had about him. The unfortunate man implored his mercy, and gave him three five-guinea bills, with which the inhuman brute made off.– A man of the name of John Dobbins, a slater and plaisterer, at Evesham, was yesterday taken into custody on suspicion of being the perpetrator of the above act of barbarity, some blood having been observed on his cloaths and lath-hatchet, and was examined by Benjamin Johnson and George Perrott, Esqrs, at the Unicorn Inn, in this city, by whom he was committed for further examination.

Mr. Partington has been trepanned in two places by an eminent Surgeon from hence; and, we understand, was this morning better than could be expected. [Trepanned – An operation of cutting a circular hole in the skull with an auger type surgical tool called a trepan, fitted with saw toothed blade.]

Worcester, 20 October 1796

Saturday last an inquisition was taken before G. Best, Gent, on view of the body of Mr. Jonathan Partington, of Wyre Piddle, who died on Thursday of the

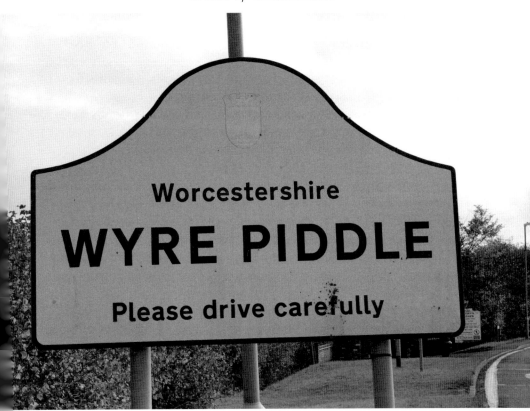

The Piddle Brook joins the river Avon at the village of Wyre Piddle, The village is famous for its picturesque black and white half-timbered buildings, and because it was once a Roman settlement.

The Parish Chuch has a number of Jonathan Partingtons buried in the churchyard, none of them match the date of the murder described above.

wounds he received in the attack made upon him on the 3rd inst. as mentioned previously. The jury returned a verdict of *Wilful Murder* against John Dubbins, who we stated in our last to have been committed on the oath of Mr. Partington being the person who robbed and ill-treated him on the above day.

Worcester, 16 March 1797
MURDER of Jonathan Partington.
Yesterday, at one o'clock, the trial of John Dubbins, for the robbery and wilful murder of Jonathan Partington, in the neighbourhood of Evesham, [the circumstances of the whole death were announced sometime since in this paper] came on before Mr. Justice Soulden Lawrence. The peculiar atrociousness of the offence had excited much of the public curiosity, and the court was consequently greatly crowded. The indictment was read, and the prisoner pleaded not guilty,

Mr. Plummer, one of the counsel for the prosecutor, in affecting yet candid speech addressed the Jury, and disclosed the several circumstances which lead to the suspicion, the apprehension, and finally the conviction of the prisoner; the most strong of which were, his having been seen in the company of the deceased when the latter was receiving money the evening on which he was observed by three witnesses to follow him on the road within a mile of the fatal spot – his own bloody clothes and lathing hatchet – the many different and irreconcilable accounts he gave of himself when he was apprehended and afterwards – but last of all the death bed declaration of Partington himself, who, when the prisoner was shown to him, exclaimed, "ah! you are the man who has done me this sad injury;"– this was often repeated by the deceased when he believed that the awful hour of his dissolution was fast approaching.

After the Learned Judge had, in a most clear and comprehensive manner, summed up the evidence to the jury, they immediately found him guilty. During the whole of his trial he remained unaffected by the dreadful details of this atrocious murder as they were related.

After a most pathetic exhortation to repentance, the Judge pronounced the awful sentence of the law, the last words of which did wring from his stubborn eye one solitary tear. He was ordered for execution tomorrow, [Thursday] and his body to be dissected and anatomised.

Worcester, 23 March 1797
Thursday last John Dubbings, convicted at our Assize of the wilful murder of Jonathan Partington, of Wyre Piddle, was executed, pursuant to his sentence, amidst the largest concourse of people ever known to have assembled upon such an occasion.– He persisted in his innocence to the last, and delivered a written note to the Clergyman who attended him to the place of execution, purporting that he was neither guilty of the crime for which he was about to suffer, nor of other felonies of which he had been suspected. After hanging the usual time, his body was conveyed to our Infirmary for dissection.

# MURDER OF JOSEPH GREEN

Worcester 4th April 1799

At Stafford Assizes, Charles Squire and Hannah his wife were tried for the murder of Joseph Green, a poor boy, their apprentice. It appeared on the clearest evidence that for the three years the miserable being was with them, he was compelled by the inhuman monsters to suffer the greatest cruelties – they beat him with red hot iron, hammers, tongs, &c. and only gave him for food, broth diluted with water, the washings or swillings of a pot in which thickened milk had been boiled, potatos but in small quantities, and *sometimes* a little meat. They frequently immersed him in water, dragged him through it, and afterwards suspended him naked, by the middle, to a beam;- they tied him by the heels in the shop until [to use the expression of a witness] his face was as black as a bat, and his mouth full of blood, indeed till much exhausted; that he lay for two hours without sense; and but for the humanity of a poor boy from the workhouse at Willenhall would have perished at that time; this boy cut him down, washed him and gave him a pork pye, which was for his own meal, and a half penny being all the money he had! – Mr. Stubbs, the surgeon who opened the body, was of the opinion that the boy died for want of nourishment; and as the learned Judge was enquiring how far the ill treatment he received from the woman might accelerate his death, Mr. S. [being very ill] fainted, and was obliged to be taken away; in consequence of which the man only was found guilty, and his wife acquitted, his Lordship stated to the Jury, that the law in such a case was, that as the cruel treatment [exclusive of want of food] could not be proved to them to be the cause of the unfortunate boy's death, and as the master only was answerable for the apprentice not having received sufficient sustenance, the wife [as the servant of the husband, and acting under his control] must be acquitted.

Neither of these deprived people shewed any signs of contrition; and the woman, who stood during the whole of the evidence with her head down, and a handkerchief at her eyes, as soon as she found she would be acquitted, put the

handkerchief calmly in her pocket, and stood with the greatest composure till ordered down, nor could any apparent concern be observed in her countenance, when the awful sentence of death was passed on her husband, which was, that he should be hanged by the neck, and his body dissected.

Charles Squires was Executed at Stafford 1st April 1799.

It was a common practice for children of poor families, or orphans from the workhouse between the ages of eight and ten to be apprentices to craftsmen or women in the parish, in order to learn a trade. It was also to ensure they did not later become a burden on parish funds. Most boys were apprenticed to 'naylers', whereas, girls learned housewifery. The master was supposed to feed them and clothe them and treat them humanly.

# MURDER OF JOHN WOOD

*Worcester Herald* 11 February 1797
We have been favoured with the following authentic particulars of the late horrid murder committed in Staffordshire, mentioned in the last page of this paper:

Mr. Oliver, a respectable Surgeon and Apothecary, of Burslem, and for a considerable time past entertained a strong attachment for Miss Wood, (Maria) daughter of Mr. John Wood, of Brown Hills near Burslem; but the connection on some account being disagreeable to the family, Mr. Wood sometime since forbid Mr. O. to enter his house. Mr. O. could not bear with patience this disappointment, and resolving to seek satisfaction, he went to Mr. W.'s house early on Friday morning, the 27th January, before Mr. W. was up, and sent one of the servants upstairs to say that he Mr. Oliver, wished to speak with him. Mr. W. immediately dressed himself and went down into his counting-house, and supposing that Mr. O. had come to receive the amount of his apothecary's bill, sent his clerk into the parlour, to Mr. O. with the money to discharge it.

Mr. O. informed the clerk that the business he had to settle must be done with Mr. Wood himself; the clerk accordingly delivered this message to his master, who went to Mr. O. when the latter presented his bill, and soon after pulled out a brace of pistols from his pocket, while Mr. W.'s back was turned; the clerk seeing them asked, what those were for? At this moment Mr. W. turned towards Mr. O. who instantly levelled one pistol at Mr. W. and the other at himself; that pointed at Mr. W. immediately went off, and shot him in the body. The clerk then knocked the other pistol out of his hand before it discharged.

Mr. W. exclaimed, "Sir, you have killed me." Mr. Oliver replied "that is what I intended." The family being alarmed a surgeon was sent for; Mr. O. told them it was useless, as Mr. W. would be a dead man in two hours; and I said "Mr. Oliver shall be dead before I leave this room; – at that instant he put something into his mouth, which it appeared afterwards was poison, but Providence frustrated even this second attempt to kill himself; for although it made him extremely ill, yet the

dose being too strong threw it off his stomach. – Mr. Wood languished until the following Monday when he died.

We are sorry to add to this dreadful recital, that Mr. Oliver has for several years past associated with characters who endeavoured to reason themselves into the belief of Atheistical sentiments several of whom have been known to declare, they thought a man had a right to terminate his existence when ever it became burdensome to him. – The horrid consequences arising form these principles such an obvious tendency toward the total destruction of all civil society, that observation becomes totally unnecessary.

*Worcester Herald* 18 February 1797

We are happy to find the circumstance relevant to Mr. Oliver, sent us for insertion last week, were greatly exaggerated particular as to its being his declared intention of committing the act of murder. – As we are desirous of obliging correspondence in giving information of a public tendency, we trust they will ever be cautious, and pay the strictest adhesion to the fact. In justice to Mr. O. we are horrified to say that he had not the least intention of firing the pistol; but from the state of his mind at the instant it is more properly be attributed to the frenzy of the moment. At all events, the public ought not to be prejudiced against the unfortunate person, previous to a fair investigation of the melancholy transaction. There are many circumstances much in his favour.

*Worcester Herald* 2 September 1797

STAFFORD ASSIZES

Ended on Saturday: Lord Kenyon presided at the Nisi Prious Bar, and Baron Perryn at the Criminal Bar: at the latter Thomas Wilmot Oliver, charged with the wilful murder of Mr. Wood, by shooting him on Friday the 27th day of January last, was, after a trial of nine hours, found guilty, and sentenced to suffer death on Monday, and his body to be delivered to surgeons for dissection. A plea of insanity was brought forward, which was endeavoured to be proved hereditary; and Drs. Johnston and Arnold, who had examined Mr. O. in vain for him, gave evidence tending to prove a mental derangement. In the distraction occasioned by disappointed love, Mr. O. committed the crime for which he suffers. The daughter (Maria) of Mr. Wood was the object of his unfortunate affection. On Monday Mr. Oliver suffered pursuant to this sentence, admits a commiserating multitude. At his trial, and after condemnation, his behaviour was composed, decorus, and even exemplary. – He spoke of Mr. Wood, the deceased, with respect and kindness; he was deeply concerned for the affliction that he brought on Mr. Wood's family, and forgave, with the strongest marks of sincerity, both his legal prosecutors and the unprovoked slanders of his reputation. He acknowledged his rashness, but solemnly disclaimed all malignant design against the life of Mr. Wood, and died with a spirit of perfect resignation to human laws, and a firm and

well founded confidence in the justice and mercy of his God. – His body, after such dissection as the law requires, was, by the great humanity of the Sheriff, given to his friends for interment.

In addition to the humane and useful assistance of Mr. Rathbone, the Ordinary (Chaplain) of Stafford gaol, he was attended several time by the Rev. Dr. Parr of Hatton, and the Rev. Mr. Matthew Booker (his brother-in-law) of Alcester.

Prior to the late unfortunate Mr. Oliver's execution, he requested the following state of his mind might be made public; which he communicated in his own handwriting;

"I die unconscious of the imputed guilt for which I suffer. – I am in perfect charity with all mankind, and repose that hope, which becomes me as a Man and a Christian, in the justice and Mercy of my Heavenly Judge."

"Aug. 28, 1797.          T. M. Oliver."

The picture above is the factory of Moorcroft, which is probably one of the best known pottery manufacturers at Burslem where Dr Thomas Milward Oliver had his practice.

The picture on the left is a map of the Parish of Oldwinsford showing Lye Cross. It is dated 1782 and was drawn by Harry Court. It shows the principle landowners at that time, including Hungerford Oliver, father of Thomas Milward Oliver, and his grandfather Thomas Milward.

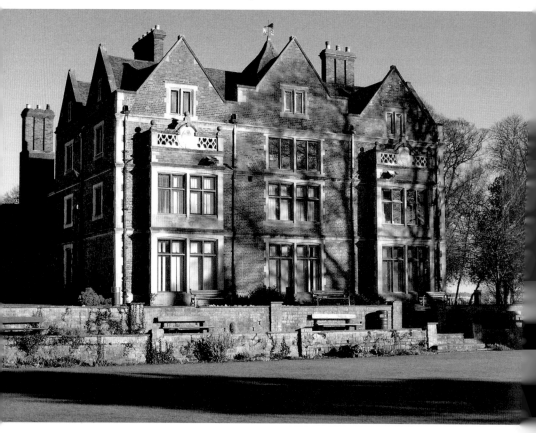

Wollescote Hall has been the home of many wealthy industrialists and landowners throughout its life; the most well-known was Thomas Milward of Alvechurch and Ouscote. Mentioned in the *Heraldy of Worcestershire* by H. Sidney Grazebrook, who describes Thomas Milward of Alvechurch as a Captain in the Parliamentary Army during the Civil Wars, 'Ouscote' is probably Wollescote, where the Milward family is said to have resided as early as the reign of Henry VIII.

It is said to have been used as the headquarters of Prince Rupert during the Civil Wars, who lived upon the generosity of the Milwards' eating up their stocks whilst maintaining a garrison on Wychbury Hill.

Meanwhile, the Parliamentary troops were garrisoned at Stourton Castle, Kinver. Eventually they met on Stourbridge Common, where battle commenced, and Prince Rupert's army was defeated. He made a speedy retreat from the field of battle on horse back, closely pursued by a Parliamentary Trooper towards the Heath Gate, which he found was closed against him. A panic cry of 'Open the gate', prompted a boy standing by to carry out this order. Once through the gate, a second panic of command of 'Close the gate' came, and the boy again obliged, stopping the trooper in his tracks allowing the Prince to escape.

After his defeat, Prince Rupert left Wollescote Hall unable to pay for his lodgings, giving his signet ring to Thomas Milward and instructing him to present it to the King, who once his affairs had prospered, would compensate him for his losses incurred during the occupation of the hall. It is here that Thomas Milward Oliver, surgeon, was born. The hall and its estate are now part of Lye and Wollescote Park.

Thomas Milward Oliver was executed on 28 August 1797, on the roof of the gatehouse of Stafford Gaol. The gallows broke down and had to be re-erected, which was not a very good omen for such a sad story.

Both the Oliver and Milward families were extremely rich, living in the district of Stourbridge, where they owned large areas of land. Thomas Milward Oliver was the son of Hungerford Oliver and his wife, Prudence Milward, who was named after her father, Thomas Milward. He was born 25 December 1766, and was baptised at Oldswinford Church. His parents were married 12 February 1761.

The family home of the Milward family was Wollescote Hall, it was the ancestoral home of the Milwards. The pedigree of both the Milwards and Olivers was of the highest order. Thomas Milward and Hungerford Oliver owned most of the land in Lye, and Hungerford Road in Stourbridge, which was named after the land on which it was built, which of course, previously belonged to Hungerford Oliver.   Hungerford Oliver and his wife Prudence lived at The Grange. Other members of their family was Prudence Milward, his sister who married the Revd Matthew Booker, one time minister at Christ Church, Lye, whose brother Luke Booker, was the vicar of Dudley. John Wood was a local industrialist engaged in the pottery business at Burslem. In 1782 he built himself a house at Brownhills, known as Brownhills House. It stood on 35 acres of land next door to his manufactory, where he was shot in 1797. After his death, it passed to his son, who improved the house and took down the manufactory.

In 1927 Brownshill High School for 420 girls was built behind John Wood's original house and formally opened in 1929. The Brownhills House was demolished in the 1950's. Local legend has it that the ghost of Thomas Milward Oliver haunts the surrounding lands.

Another story is that Thomas Milward Oliver, was buried at Oldswinford, in St Mary's Churchyard, in the Milward family vault, which when opened sometime later his skeleton was found with a rope around its neck. Although the body may have been dissected, it was handed back to his friends afterwards for burial. Mr Oliver was a gentleman, and was addressed as such during the trial, with the title Mister.

# MURDER OF JOSHUA PHILPOTS

*Worcester Herald*, 28 December 1799

In the month of September last, a person of the name of Joshua Philpotts, in coming from Bromgrove to this city with his cart, was assaulted upon the road, and severely beat and wounded with the butt end of a sword by one Francis Hague, a sergeant of Marines, and two soldiers.– He'd died last week, of the wounds he received – an Inquest was held on the body and a verdict of Wilful Murder found against all the parties.–

Worcester, 28 February 1800

Thursday last a Coroner's Inquest was held on the body of Joshua Philpots, found lying dead in the Parish of St. Clements, in this City, when a verdict of *wilful murder* was found against Francis Hague, a Sergeant of Marines, and two other persons (soldiers) unknown. We are informed that this unfortunate man, being on his way from Bromsgrove to this city on the 11th of September last, with his cart and two horses, was overtaken on the Droitwich Road, near the Raven public-house, by the soldiers, who wanted a ride in his cart, and on being refused they beat and abused him, and struck him with the butt end of a sword or bayonet, which laid bare his skull, and very much otherwise bruised him about the head; the Sergeant unhooked and mounted the fore horse, and rode with it in its gearing towards this city, but the son of the deceased, a lad of 13 years of age, who was going to meet his father, seeing the Sergeant on the horse, stopped him and challenged the horse, upon which the Sergeant dismounted, saying, he should have left the horse at the turn-pike; that a man behind had been very much hurt, and that he had ran a quarter of a mile to catch the horse – he then went towards Worcester. The boy and another boy with him afterwards found the deceased kneeling in his cart, with his clothes bloody, and nearly in a state of stupefaction; he said that he had been hurt by three soldiers and rendered

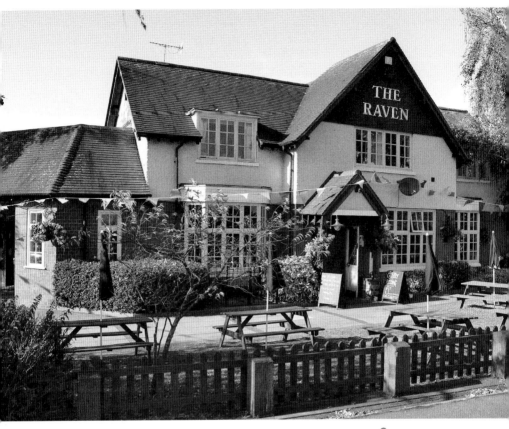

The Raven Public House on the Droitwich Road, Worcester where Mr Philpotts was killed. There has been a Raven Public House on this site for many years and it is said that it is mentioned in the *Domesday Book*. The present building is relatively recent and would not be the one mentioned above. On the opposite side of the Droitwich Road is the historical site of Perdiswell, where a prehistoric circular enclosure site, dated 1600–1200 BC has been found. In recent times it was the site of Perdiswell Hall built 1787, which was used by the RAF in the Second World War with an airfield on its eastern side.

senseless for sometime from a blow he received from the weapon, and that one of them had taken away his horse. He was conveyed to our Infirmary, and great hopes were entertained of his recovery; but a fresh collection of matter having formed on the brain, brought on his dissolution. The Sergeant appeared in public until the day of the inquest, when he quitted his quarters, and is supposed to be gone towards Staffordshire; proper inquiry, however, is, we understand, making after him. The other two soldiers have not since been heard of. Francis Hague has since surrendered himself on being charged with the murder of Joshua Philpots in an affray on the Droitwich road and is held in our city gaol.

Worcester, 1 March 1800

Francis Hague was committed to our City gaol on Saturday, charged by the Coroner's warrant with the murder of Joshua Philpotts, in an affray on the Droitwich Road, stated in a former paper.– As various reports have been circulated respecting this unfortunate business, which may tend to prejudice the public mind against the party, judgement ought to be suspended 'till after trial, when, if proved guilty, a due punishment will follow; but if declared innocent a pre-judgement must be the greatest cruelty.

Worcester, 13 March 1800

Francis Hague, a sergeant of Marines was then called upon to take his trial, being charged on the Coroner's Inquest with the murder of Joshua Philpotts, on the Droitwich Road; when after a minute investigation of every circumstance that could be brought against him, both Judge and Jury were so well convinced of his innocence, that the latter requested his Lordship would not trouble himself to sum up the evidence, and immediately pronounce an acquittal, which appeared highly satisfactory to a crowded Court. We have been thus particular in this trial, from the report of the case in December last, which was started in very strong terms, and may have made an unfavourable impression on the public mind; but we are always happy in the opportunity of rescuing innocence on every occasion from the malevolent part of the world, so in this case, we trust no imputation will here after attach to this man, should his future conduct merit equal protection with his past.

# MURDER OF THOMAS GOOD

*Worcester Herald*, 2 November 1799

A few evenings since, a most cruel murder was committed at Redmarley, in this County, on the body of Mr. Thomas Good of that parish, who was returning home about seven o'clock, when he was shot by some villain within a short distance of his own house; but finding he was so mortally wounded, the horrid purpose was effected by beating him with the gun-stock which was afterwards found broken. The report of the gun alarmed the inhabitants of a neighbouring farm-house, the servants of which went out to find from whence they supposed it to proceed, where they discovered the poor man weltering in his own blood, and speechless; he was immediately taken care of, but expired a short time afterwards. A suspicion having fallen on John and Richard Lane, two of his nephews, they were apprehended in consequence thereof, and yesterday they were committed to our Castle, by George Best, Gent. one of the Coroners for the County, sufficient circumstances appearing before the inquest to warrant a further enquiry by a Grand Jury.

Worcester, 9 November 1799

Thursday last was committed to our county gaol, by George Best, Gent. Coroner, John Lane and Richard Lane, (brothers) the former charged with the wilful murder of Thomas Good, of Redmarley, in this county, and the latter with being an accessory to the murder before the commission thereof.– It appears that the deceased, who was a freeholder of Redmarley, and a man much beloved in his neighbourhood, was way-laid on his return home on Saturday se'nnight, and assaulted with fire-arms at a small distance from his own house, a little after seven o'clock the explosion of a gun and the groans of Mr. Good having alarmed the neighbours, the ruffians absconded, and he was conveyed home speechless, and languished until the next day. Intelligence of this event having

been communicated to the Rev. Dr. Yate, the nearest Magistrate, he directed the Church wardens to summon a Coroner, and also charged some confidential persons to make pursuit after the above two prisoners, another brother named James, was also suspected. By these exertions two of them were apprehended at Ashelworth, on Sunday afternoon, and the other at Gloucester at midnight. An Inquest was taken on Wednesday, when after an investigation of 18 hours, without intermission, a jury of respectable farmers brought a verdict charging John and Richard as before stated. James, the youngest brother, having provided an alibi was liberated.

Since they were committed to our Castle for the murder of Mr. Good, of Redmarley, John Lane, one of the men, has made an ample confession of the horrid crime, and has pointed out the pool where he threw the gun-stock, which he broke in the commission of his diabolical purpose. It appears that he was actuated to the crime from Mr. Good's having conveyed to him the Reversion of a small place he lived in, under 5*l.* a year, reserving to himself an annuity for his own life.

Worcester, 21 November 1799
We deem it necessary to state, that the report which has gone abroad of John Lane, lately committed to our gaol for the murder of Mr. Good of Redmarley, having confessed the share he took in the murder, it is entirely groundless. On the contrary, he has declared his own innocence of the crime and is merely related a conversation which took place between him and his unhappy brother, tending principally to criminate the latter; and in consequence whereof the barrel of the gun with which the foul deed is suspected to have been perpetrated, was found in a pond near the spot where the crime was committed.

Worcester, 13 March 1800
Yesterday morning about eight o'clock came on the trial of John and Richard Lane, (brothers) the former charged on the Coroner's inquest with the wilful murder of Mr. Thomas Good, of Redmarley, and the latter with being an accessory to the murder before the commission thereof. This trial occupied the attention of the Court until nine o'clock in the evening. It appeared that the deceased was way-laid on his return home, in the evening of Saturday the 26th of October last, through a narrow lane a short distance from his own house, and two shots were fired at him through the hedge, which not having the desired effect, he was afterwards most cruelly beat with a gun-stock, of which wounds he expired on the next day. By the laudable exertions of Dr. Yate, the prisoners were soon apprehended; and on their trial they both evinced the most hardened depravity, mutually charging each other with the commission of the atrocious deed. Upwards of 30 witnesses were examined, and the prisoners took up more than two hours in their defence, in which they principally endeavoured to

impeach the evidence against them; but after an excellent summing up by Mr. Baron Thomson, the Jury found them both *Guilty,* and they were sentenced to be executed tomorrow [Thursday] and their bodies to be dissected and anatomised.– They heard the dreadful sentence without emotion, and retired from the bar apparently unmoved by the reflection of the awful fate, which awaited them.

This morning the above unhappy criminals made a full confession of their guilt to the Chaplain of the gaol.– The account each of them gave of the circumstances attending the murder exactly corresponded.– It seems that Richard, on the death of Mr. Good, (who was their uncle) was to succeed to a small estate belonging to the latter; and that he proposed to his brother John to give him 5o*l.* if he would assist in murdering Mr. G. to which horrid proposal John assented. John discharged a gun and Richard a pistol through the hedge at the unfortunate Mr. G. as above related, but the shots not depriving him of life, John afterwards struck him several blows with the butt-end of the gun. – Before they left the Court yesterday evening, they expressed so much malice against each other, that the Judge ordered them to be confined apart, but this morning they professed sincere and mutual forgiveness.

Worcester, 20 March 1800

Thursday last Richard and John Lane were executed pursuant to their sentence awarded at our assizes, for the murder of Mr. Good, of Redmarley, as stated in our last. The former appeared totally indifferent to his fate, while the latter seemed very penitent. After hanging the usual time their bodies were conveyed to our Infirmary for dissection.

# MURDER OF SARAH YOUNG

*Worcester Herald*, 7 March 1800

John Young, was charged on suspicion of having murdered his wife by forcing her into the Severn at Bushley, was remanded for trial at the next Assizes. Her body has not yet been found.

Worcester, 22 March 1800

The body of Sarah Young, for whose supposed murder, by forcing her into the Severn, her husband was committed to our county gaol, on the 16th of last month [as mentioned in a former paper] has been taken out of the river about six miles below Gloucester.– The hands of the unfortunate woman were tied down to her thighs, and a bag drawn over her head and part of her body.– Upon examination she proved to be far advanced in pregnancy.

Worcester, 29 March 1800

The body of Sarah Young was found about a quarter of a mile from the Lower Load near Tewkesbury. Not tied with a cord or her head in a bag as previously reported.

It was currently reported in Tewkesbury at the beginning of last week, that the body of Sarah Young had been taken out of the Severn at Gloucester; and having received some particulars of the circumstances from very respectable authority in Tewkesbury, we were induced to relate them, as they were transmitted to us, in our last paper – but we have since found that our informant was deceived, the report being premature. The body of the unfortunate woman was, however, taken up on Thursday last, at the Upper Load, near Tewkesbury, having been washed against the side of the passage boat while crossing the river; and a wound in the forehead was the only mark of violence discovered upon her. An Inquest was held on Saturday, and after examining several witnesses, which occupied

upwards of 13 hours, the Jury returned a verdict of *wilful murder* against John Young, the husband of the deceased, now in our county gaol on suspicion of having committed the atrocious act.

Worcester, 7 August 1800
John Young, who was removed from hence by habeas corpus to Gloucester, to be tried on a charge of having murdered his wife, was found dead in his cell on Saturday morning, having hanged himself by his handkerchief up to the staple of the window.

Worcester, 13 March 1806;
John Davenport and William Lashford were convicted of burglary at Belbroughton and sentenced to death, they were hung at Red Hill about the 22nd March, and their bodies brought back to Belbroughton for burial, where they are recorded in the Parish Records. They are still remembered by wreaths, from their families, recently laid in the Churchyard.

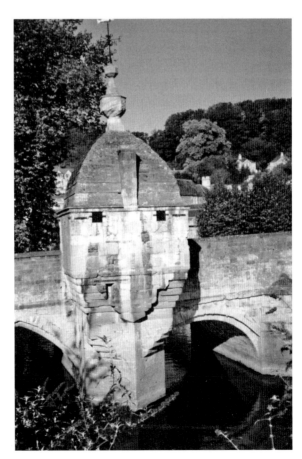

This lock-up at Bradford on Avon is a little unusual, since it is situated on the bridge over the river, and makes quite an architectural feature. It is also convenient for drainage purposes and it is of sufficient distance from neighbours who might object to the obnoxious smell, foul language and noise from the building and its occasional occupants.

# MURDER.

## ONE
# Hundred Pounds
### REWARD.

WHEREAS *William Hawkeswood*, late of SWINDON, in the Parish of Womborne, in the County of Stafford, farming Servant, stands charged by the Coroner's Inquest with the wilful MURDER by Poison of *WILLIAM PARKER*, of Swindon aforesaid, Gentleman, in whose House he lived as a domestic Servant.

Whoever will apprehend the said William Hawkeswood, or cause him to be apprehended and safely lodged in any of His Majesty's Gaols of the United Kingdom, so that he may be brought to Justice, shall receive

## ONE HUNDRED POUNDS,

to be paid on Application to Mr. *John Wilson*, one of the Executors of the Deceased, at Swindon aforesaid.

The said William Hawkeswood is a Native of Pedmore, near Stourbridge, Worcestershire; is twenty Years of Age, about five Feet six Inches high, florid Complexion, his Eyes quick and lively, either hazle or dark blue, high Cheek Bones, full Mouth with front Teeth large and projecting, dark brown Hair, and is slim made.

The said William Hawkeswood had on when he absconded on Friday last, a smock Frock, dark brown lapelled Coat, and white metal Buttons, with cloth Collar, and corduroy Breeches.

December 3, 1807.

Reward poster for William Hawkeswood of Pedmore.

# THE PEDMORE POISONER

*Berrow's Worcester Journal*, 10 December 1807

Mr. Parker, of Swindon, in the parish of Womborne, Staffordshire, a Gentleman of considerable fortune, and universally respected, was poisoned on Tuesday se'nnight; this gentleman was in the habit of taking a cup of camomile tea every morning; and on the above day it was brought to him by William Hawkeswood, but before he had drank much of it, he perceived so unpleasant a taste that he declined taking any more, and was soon after taken ill; he immediately suspected that he had been poisoned. The surgeon, who attended, desired Hawkeswood to bring the cup to him in which he gave his master the tea; upon tasting the little liquid that adhered to it, he discovered that arsenic had been mixed with it. Hawkeswood was then asked if he had tasted it himself upon his master's discovering the disagreeable taste; he said he had, and that it made him very sick.

William Hawkeswood, was born at Pedmore, and baptised at St. Peter's Church, 4th February, 1787, by Richard and Hannah Hawkeswood. He was employed by Mr. William Parker, of Swindon, Womborne, and lived in his house, where he was treated like a son. He often went home at weekends to his father's house at Pedmore, returning to his Master on Monday morning, occasionally calling at Stourbridge to purchase items for use on the farm, which he did on Monday 23rd November, and bought poison on the pretence of treating sheep for scab.

Realising he was suspected of carrying out the wicked deed, and conscious of his guilt, he decided to go home to his father's, house at Pedmore, where he hid until the Coroner's Inquest had declared him to be the murderer. The next day he went with his father to Worcester, and caught the mail coach to Bristol, and enlisted under the name of John Gilbert, on board a ship and received 10 guineas bounty.

Meanwhile, a Sheriff's officer of Worcester, named Mark Guier, caught the next coach from Worcester to Bristol, where he found Hawkeswood, dressed as a sailor. He secured him and brought him back to Worcester, from where he was transferred to Stafford Gaol.

William Hawkeswood, aged 20, was tried at Stafford Assizes – For the wilful murder of Mr. William Parker, of Swindon. Before the Hon. Baron GRAHAM.

He was charged with the wilfully poisoning and murdering of the deceased, by administering white mercury in camomile tea on Tuesday the 24th day of November last, which the deceased took down into his stomach, and languished until the Sunday following, when he died.

*Sarah Sheldon* deposed that she was the House keeper to Mr. Parker. On 22nd of November (Sunday) the prisoner went to his father's at Pedmore, and returned on Monday 23rd, Stourbridge is betwixt Pedmore and Swindon. The deceased was in the habit of taking camomile tea each morning before he came down, which she always made, in a white teapot. The tea had been made on Tuesday, the 24th; she sometimes took it up, but not on Wednesday, as the prisoner rose early, before his usual time and took it up to his master.

She saw the deceased betwixt 6 and 7 o'clock on Wednesday morning; he was sick and vomiting; he asked her what tea she had given him, and said he was poisoned. She drank some of the tea, which did not taste of camomile, it was very hot in the mouth, brackish, it made her sick and she was not well the whole day after.

*Mr. John Parker Wilson* deposed, that he was the nephew of the deceased, and lived in the parish of Enville, about four miles from his uncle; his uncle had turned over his land to him and was to live with him. Witness slept at his uncle's on Tuesday the 24th; being a general custom previous to going to Wolverhampton market on the Wednesday. His uncle went to bed in good health. In the morning before he was up he heard his uncle vomiting; he got up to see what the matter was, and found him dreadfully sick on the chair.

*Hawkswood* was then called upon for his defence; he handed over a written paper making a full confession, admitting he had put poison in the camomile tea, not intending to poison Mr. Parker, but to spite Mrs. Sheldon, with whom he was not on very good terms. He had previously seen her drinking some of the tea; thinking it would make her vomit, but not seriously harm her.

The Judge in summing up the evidence took a view of the relative situation of the prisoner to the parties concerned; it was difficult to believe the prisoner to be ignorant of the qualities of the drug, from his having been so long accustomed to seeing it used. What could be his business with the drug? The complaint of the sheep did not require it. Had it been for the design of playing the housekeeper a trick, the quantity used was too great to suppose him ignorant of its power. Would he not in that case have employed another means; or have taken other opportunities to have put it in the house-keepers tea? But there was nothing

in their quarrel that could warrant such revenge. If he were ignorant that the camomile was for the deceased, so he must be ignorant that it was for the housekeeper. The judge then commented on the defence of the prisoner, and submitted it to the Jury how far the prisoner's conduct might be due to the effect of ignorance and wantonness, or whether the poison was not prepared and destined solely for the old man?

He was found guilty and the Judge pronounced the sentence of death.

William Hawkswood was publicly executed agreeable to his sentence on the roof of the Old Gate House of Stafford Prison about quarter-to-twelve on Wednesday 6 April 1808. On 31 March 2007, family descendants came from New Zealand and visited Pedmore church and the local area to find out more about their infamous ancestor.

Executions at Stafford were held on the roof of the Old Gate House up until 1817, when they came down to ground level and were carried out on a mobile gallows that was wheeled into position in front of the gaol when required. On the other side of the road, opposite the Gaol, spectacular stands were often erected in peoples' front gardens, by enterprising persons for the purpose of viewing the executions from an advantageous position at a cost of 18 pence up to half-a-guinea, and depending on the position of the view and how notorious the culprit. Dr William Palmer, the Rugeley poisoner, was hung here on 14 June 1856.

# THE MURDER OF BENJAMIN ROBINS

*Berrow's Worcester Journal*, 24 December 1812

*Daring Robbery and attempt at Murder.*– On Friday evening about 5 o'clock, as Mr. Benjamin Robins, of Dunsley, was returning from Stourbridge market, he was overtaken by a man who walked and conversed with him for some distance; but when within less than half a mile of Mr. Robins's house the villain drew behind Mr. Robins and discharged a pistol at him; the ball, struck Mr. Robins on the back bone, which caused it to take a direction round his ribs to near the belly; from the place it entered to where it was found, was from 14 to 16 inches. The villain, as soon as he had fired, demanded Mr. Robins's money, who said, "Why did you shoot me first? If you had asked me for it before, you should have had it." Mr. Robins. then gave him two 10*l.* notes, a 1*l.* note, and 8*s.* in silver. The rascal then said "Your watch;" Mr. Robins said,– "if you demand it, take it." As soon as the villain had possession of the watch, he presented another pistol, and desired Mr. Robins to proceed or he would shoot him again; Mr. Robins replied – "You scoundrel, you have already shot me enough; you have taken my life from me." He then walked home. The villain made towards Stourbridge. Mr. Causer, jun. and Mr Downing, surgeons, of Stourbridge, were immediately sent for and soon extracted the ball; it was of a large size, and appeared to have been lately cast. Mr. Robins, is not yet pronounced out of danger. A man is under confinement at Stourbridge on suspicion.

Worcester, 25 March 1813
*Murder of Mr. Robins* – at Stafford Assizes, yesterday se'nnight, William Howe, alias John Wood, was charged with the wilful murder of Mr. Robins, of Dunsley, near Stourbridge, on the 18th December last. Mr. Pearson shortly opened the case and was succeeded by Mr. Jervis, who stated the particulars of the murder, which agreed with what is already before the public, I cannot tell what, not

knowing how it took place, but I can say what happened in the consequence of that conversation a watch proved to have been that of the deceased was found to have been pledged by the prisoner, at Mr. Power's, of Warwick; Power is here; he will state that the prisoner is the man who on the 21st December, three days after the murder, sold it,– he offered to pledge it – Power offered 1£., he wanted 2£. and would sell it, but as a family watch wished to have it again; said he had had it repaired at Mr. Gammon's, late Brown's of Birmingham: When watch-maker's repair watches they generally put in a paper with their name. Mr. Robins had had it repaired there – this is sufficient proof. It will be proved by the family of Mr. Robins that the watch was his; Mr. Justice Bayly then summed up the whole of the evidence with the utmost perspicuity and impartiality. The Jury conferred together for about seven minutes and brought in a verdict of guilty. The learned Judge then addressed the prisoner in a very pathetic manner, and pronounced the dreadful sentence of DEATH *and his body to be hung in chains, near the spot where the murder was committed.* He did not call a single witness to his character, and on being taken from the bar exclaimed, "My heart is innocence."
The Execution.– About 11 o'clock on Thursday, the unhappy criminal was conducted to the new drop in the front of the County Gaol. He freely confessed to the murder of Mr. Robins; he went to Stourbridge for the purpose of committing a robbery, supposing it probable that he might attain a considerable booty being the old market; he did not know Mr. Robins. He deplored the "badness of his heart," which had led him to the commission of his dreadful offence, prayed most devoutly for the forgiveness of the Almighty, and entreated the prayers of the surrounding multitude. He then submitted to his fate with firmness and composure. He was 32 years of age. The dead body (enclosed in a case of ribbed iron) was conveyed to Stourbridge, on Saturday, when it was hung in irons, near the spot where Mr. Robins was shot, about 2 miles from Stourbridge. So great was the curiosity excited on this occasion that it is supposed no less than 40,000 persons visited the place on Sunday.

James Cooke of Leicester was the last man to be hung in chains or gibbeted; the practice was abolished in 1834. Gibbeting was considered to be an additional punishment as people believed they could not go to heaven without a body.

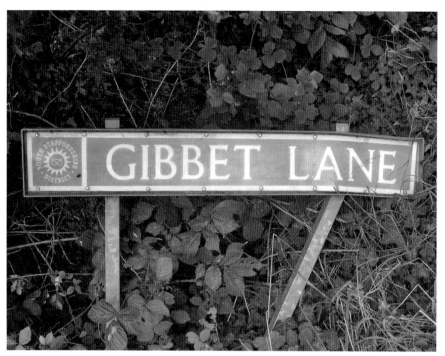

The Gibbet Lane road sign at Dunsley, Kinver, is a grim reminder of what took place in this lane almost 200 years ago, when Benjamin Robins was murdered by William Howe. The wood in the surrounding area is known as Gibbet Wood.

Dunsley Hall, the home of Mr Benjamin Robins. Now known as Dunsley Hall Hotel.

# MURDER OF JOHN HORTON

*Wolverhampton Chronicle*, 6 August 1828

Shropshire Assizes. William Stevenson, a miner, aged 31, was indicted for the wilful murder of John Horton, at Hales-Owen. It appeared that on the 31st March Inst, the prisoner was drinking at a public-house at Oldbury, when the deceased, who was an officer of the Oldbury Court, entered. The prisoner said that he knew that the deceased had an execution [*Warrant for his arrest*] against him, but the deceased made no reply. After being pressed upon the point several times, he said he had an execution against the prisoner, and asked him what he intended to do. The prisoner requested two or three days time to send to his wife, but Horton said he would not agree to that, and as soon as he had finished his pipe he meant to take the prisoner with him. The prisoner then asked leave to go home and put a clean shirt on, and the deceased consented; they then left the house together; the prisoner returned in about ten minutes with a long knife in his hand, and when the deceased approached him and urged him to settle the matter, he pulled the knife from under his coat, jumped up and placing his hand on the decease's eyes, and ran the knife into his body, and it passed through his liver; he died shortly after. –The Jury found the prisoner guilty, and he was ordered for execution on Monday and his body to be dissected.

EXECUTIONS AT SHREWSBURY.
On Monday morning, Joseph Pugh and John Cox for the horrible murder at Market Drayton, of James Harrison and William Stevenson, for the murder at Oldbury, underwent the last dread penalty of the law in front of the county gaol. Stevenson lamented much the course of life he had pursued, which he mainly attributed to the pursuits of bull-baiting and cock-fighting, and the practices of sabbath-breaking, drunkenness, and debauchery; and he was especially anxious that his brothers and children should be warned as to the mode of life that they

ought to pursue in order to avoid offences and their punishments.

The drop was erected at an early hour on Monday morning; Stevenson, Joseph Pugh, and young John Cox, were conducted to the place of ignominious exit. Neither addressed a word to the immense multitude before them; but, while the ropes were adjusting, they continued to pray for mercy at the Throne of Grace and in this most becoming state they were launched into eternity!– After the bodies were cut down, permission was given for the hand of the deceased to be drawn over several individuals suffering under the affliction of wens, that operation was performed!! The bodies were then conveyed to the Infirmary for dissection; [A Wen is a form of tumour on the skin, especially the scalp. The treatment here mentioned, is probably a superstition, or an old wives' tale – it is not a recommended treatment. It was believed that the body of a freshly hanged person had healing powers and people would pay the hangman to stroke the hand of the corpse over warts, carbuncles and other ailments.]

Ann Harris, the 50 year old mother of Thomas Ellson, was hung on Saturday for inciting Joseph Pugh and John Cox to murder John Harrison of Drayton, who was to give evidence against her son, who would have been sent to gaol.

# MURDER OF ANN COOK

On 24th August 1829, Michael Toll, a travelling hawker, and Ann Cook were walking back from Cradley to Stourbridge, a distance of about 3 miles.

Around 7 o'clock in the evening, they were about halfway up Hayes Lane, and turned onto a footpath known locally as the Lime Kilns, which led to a coal pit where they were later seen sitting. They sat for a while having a heated discussion. Suddenly Toll struck Ann a heavy blow on the head with his walking stick, which was a heavy club-like instrument. Ann screamed out Murder and Toll pushed her into the pit. About 8.30 the same evening, Toll made a number of enquiries, asking numerous people if they had seen Ann, his wife, saying that he had last seen her near Dudley. He went away for the next 5 days, on his return he was told her body had been found. Her body was found by T. F. Higgs and taken to the Swan public house in Lye Waste, where her body was examined and the inquest held. Mr. Higgs stated there was no fence around the pit to prevent anyone falling in. Thomas Homer said he had seen the couple together on the evening of 24th August, and mentioned it to the prisoner when they met at the Swan. The prisoner, in a show of affection, wrung his hands and kissed the dead body and said "why did you leave me, why did you leave me?"

He was committed to our County Gaol, by Mr Hallen the coroner, to stand trial at the next assizes.

Worcester, Thursday 11 March 1830
Worcester Assizes– *Michael Toll*, aged 29 (a native of Ireland,) appeared before Mr. Justice Littledale, charged with the wilful murder of Ann Cook, by throwing her into a coal pit at Lye-on-the-Waste, near Stourbridge, Oldswinford.

Mr. Whateley and Mr. Scott conducted the prosecution; Mr. C. Phillips for the defence.

[The Swan public house was in Lye Waste opposite the Talbot and Talbot Street.

Oldswinford should not be confused with the present day Oldswinford. The murder mentioned here, took place in Lye, at the Hayes, which was in the parish of Oldswinford. While Lye did have a church in 1830, built by Thomas Hill in 1813, it was only a Chapel of Ease, i.e. an annex of St Mary's Church, Oldswinford. Lye Church was dedicated as Christ Church in 1839, splitting Lye from Oldswinford to form the parish of Lye.]

Mr. Whateley then called witnesses, who proved the facts stated in the opening speech.

Joseph Bellingham said that at about half-past seven in the evening he saw deceased and prisoner close to the edge of the pit; she sitting, he standing.

John Westwood proved, that at about eight in the evening I heard a women cry "murder" from, the direction of the pit.

From the evidence of Jane Cook, the sister of deceased, it appeared that the prisoner had manifested great anxiety to find the deceased; and she told the prisoner at Kidderminster that the body was found, he went with her immediately to see it, and cried when he saw the body, saying "My dear Ann, why did you leave me at Stourbridge?" He made no attempt to escape. [Oldswinford parish burial records, dated 2 September 1829, state Ann Cook found dead was eighteen years old.]

Mr. W. B. H. Freer, Surgeon, Stourbridge, described the injuries, which the deceased had sustained; there was a wound above the right eye, which did not appear to have been inflicted by falling down the pit; but he admitted on his cross-examination that it might have been occasioned by a sharp stone projecting from the side of the pit. There was an injury on the hip, which he thought was inflicted while the deceased was alive. He thought death was occasioned wither by her falling or being thrown into the pit. The deceased was in the family way.

Mr. Justice Littledale, in summing up, said that this was a case deserving the most serious attention of the Jury and they would have to say whether the deceased was pushed into the pit by the prisoner, or whether she threw herself into it or fell in accidentally.

The jury having returned a verdict of GUILTY, the learned Judge addressed the prisoner, in an impressive manner, and passed SENTENCE OF DEATH on him, ordering the execution to take place on *Friday next.*

Worcester, 18 March 1830
EXECUTION.– on Friday at the usual hour, Michael Toll was executed in front of the County Gaol, pursuant to the sentence passed upon him on Wednesday for the murder of Ann Cook (who had lived with him), by throwing her into a coal-pit at Oldswinford. The prisoner being a Roman Catholic, was attended by the Rev. Mr. Tristram, the officiating clergyman of the Catholic Chapel in this city. His demeanour after his conviction was becoming. On reaching the foot of the gallows, nearly ten minutes were occupied by the culprit in joining

the Rev. Mr. Tristram in intercessions for mercy at that tribunal before which he was so shortly to appear. During this time he was firm and collected; and suffered himself to be bound and the rope adjusted without betraying any violent emotion. About eighteen minutes past twelve, the signal was given, the drop fell, and in a few seconds afterwards he was a lifeless corpse. It is not known whether the culprit made any confession of his guilt; if he did make such a confession to Mr. Tristram, that gentleman is prohibited from discussing it, by the rules of his Church. No doubt, however, is entertained of Toll's guile. The concourse of persons assembled to witness the melancholy scene was considerable; a large proportion consisted of women and children. The prisoners in the Gaol, as is usual on these occasions, were drawn up in the front yard to witness the execution. After hanging the usual time, the body was conveyed to the Worcester Infirmary, to be anatomised, as directed by the sentence. Upon opening the body it was found that Toll had swallowed [probably on the day before his execution] some pieces of blanket, we fear with the intention of committing suicide. The stomach was so inflamed that he could not have survived many days.

The Lime Kilns was a historical footpath from the Hayes to Hayes Lane, often used as a short cut. In early times it led to fields (which contained pits for the mining of coal, clay and lime stone, used in the manufacture of bricks) where three murders were committed. It is shown here to the centre right of the map dated about 1920. The author lived in upper Hayes Lane for over 20 years and well remembers the footpath known as 'The Lime Kilns', having walked it many times. It ran from Hayes Lane and came out below the Hayes, between the electrical substation and Browns scrap yard, almost opposite Wood Street. The Swan Inn and Swan Yard is towards the bottom left hand corner.

# THE ODDINGLEY MURDERS

Oddingley is a small village just outside Droitwich where a double murder took place that was extraordinary, unparalleled and of national interest at the time.

In 1793 the Revd George Parker was introduced to the living and received tithes from the local farmers to the value of £130. He considered this inadequate and wished to increase them to £150, which the farmers bitterly opposed and banded together to refuse to pay. On 24 June 1806, he was shot from a nearby field, but managed to stagger towards his assailant who battered him to death with the butt of the gun.

It was clear that the murderer was a local man, named Richard Heming, who went into hiding in a barn at Nether Wood Farm on the road to Crowle. He was also murdered and his body hidden in the barn, while a story was put about that he had gone to America. Twenty-four years later, in 1830, his body was found. Three men were accused of being involved in his murder and others were also implicated. They were tried at Worcester Assizes, 10 March 1830, as follows.

Worcester, Wednesday 10 March 1830
Worcester Lent Assizes. Before Mr. Justice Littledale. An indictment, charging Thomas Clews, George Bankes, and John Barnett, with being accessories before the fact to the murder of the Rev. George Parker, by Richard Heming – *Was found to be a true bill against all.*

The second indictment charged a similar offence against the three prisoners after the fact – *a true bill against Thomas Clews only.*

The third indictment was against Thomas Clews, George Bankes, and John Barnett, and charged Clews and Banks as principals in the second degree, in the murder of Richard Heming, and Barnett as an accessory before the fact. The Bill was *found true against Clews only.*

Beside these indictments, there was the Coroner's Inquisition, charging all the three prisoners, as principals, in the murder of Heming.

Mr Justice Littledale was appointed 8 o'clock on Thursday the 11th for the commencing of the trial. The persons wished to be present at the trial commenced assembling as early as six o'clock, and by seven the assemblage in front of the Hall was very great; at the latter hour the prisoners arrived at the Hall; so great was the curiosity of the crowd to see them, that it was somewhat difficult to make passage for them. It was soon after 8 o'clock, when the Learned Judge, took his seat, every place was crowded to suffocation; many respectable females were present.

Soon after his Lordship's entrance into the Court, the prisoners were placed at the bar. They were all dressed in black; *Clews* is in his 60th year; he is a heavy-looking man he manifested no particular emotion during the trial though his demeanour by no means indicated a hardened audacity. *Bankes* is a powerful man, about 46 years of age, with a striking expression of countenance. *Barnett* is 56 years of age; he is a respectable-looking yeoman. *Clews* has been reduced from the situation of a farmer to that of a labourer; *Bankes* manages a farm for a female at Hanbury; *Barnett* is a farmer of some opulence at Oddingley.

*Clews* was then arraigned on the indictment charging him with the murder of Heming, and pleaded "not guilty".

The three prisoners were then arraigned on the Coroner's Inquisition, charging them all with the murder of Heming.

The three prisoners pleaded severally "not guilty".

Clews was then arraigned on the indictment charging him as accessory after the fact, to Parker's murder; the objection was repeated and allowed, and the indictment laid aside.

It was then determined that Clews should first be tried upon the indictment, charging him as a principal in the murder of Heming.

## THE TRIAL OF THOMAS CLEWS

The Jury was sworn.

Mr. CURWOOD. (Prosecution). May it please your Lordship – Gentlemen of the Jury, I rise to address you upon a case almost unparalleled in recollection. The prisoner at the bar stands indicted for the murder of a person of the name of Richard Heming, whose murder is alleged to have been performed so remote as twenty-four years ago; and the circumstances of that murder are so complicated and intimately connected with the circumstances of another murder, that I do not know how they can be separated, or how the crime with which the prisoner at the bar is charged to-day, can be well understood without both statement and evidence of the previous murder. Gentlemen, at the period I mention, four-and-twenty years ago, in the year 1806, a reverend gentleman of the name of Parker, was Rector of Oddingley, in this county. Unfortunately there was great enmity between him and several of his parishioners, whom I will not name, but also with Thomas Clews, the prisoner at the bar.

On the 24th June, Mr Parker was inhumanly shot at and murdered in one of his own fields. It will be in evidence before you, that his murderer on that occasion, without question was Richard Heming, the man with whose murder the prisoner stands charged to-day. Between Richard Heming and Mr. Parker there was no enmity – he was not one of his parishioners; he was formally a labouring man in another parish; the consequence, therefore, was, that every investigation was set afloat to know why, or for what motive, this man could have committed the murder; and there was abundant evidence, to those who made the enquiries of those days, that he was the hired assassin of certain other persons. A search was made for Heming, the murderer, but from that day forth he never more made an appearance. Wherefore had he disappeared? The reasonable answer was that those who had employed him to do the foul deed, had, disposed of him, in order that he might not appear as evidence against them. Year after year, his fate remained in obscurity until Christmas last, when, upon pulling down an old barn, which at the time of Mr. Parker's murder was occupied by the prisoner Clews, his mouldering remains were found buried in a bay of that barn, and from the occurrences of that day the present investigation took its rise. Suspicion had all along been afloat that this man had been murdered; and suspicion also fixed on those by whom he was supposed to have been incited to the murder of Mr. Parker.

Singular to say, although the mouldering remains of humanity were but few, they were sufficient to identify him; his shoes were remarkable; by the side of his thigh bone was found a carpenter's rule, which his wife described before she saw it. Nay, more; when she saw the skull, she spoke to the identity of the teeth. Gentlemen, an enquiry having taken place, the natural consequence was, to look after those whose interest it had been to have committed the murder, as it appeared clear that Heming had been the murderer of Mr. Parker; the inference follows that he also had been murdered by those who had before instigated him to the murder of Mr. Parker, in order to provide for their own safety, because it being known the next day after the murder of Mr. Parker that Heming was his murderer, and a search having been made after him, it became of vital importance to those whom he could have impeached, if he had been apprehended, that he should be disposed of. I must now show you, in order to explain his motive, and without such, the case would not be intelligible, that he had a good reason for disposing of the murderer of Mr. Parker, and strange to say, I have evidence against the prisoner at the bar, of expressions of deadly hatred towards Mr. Parker – and repeated that he hoped he might be shot – that he wished he might be shot – he would give 5ol. (£50.) if he was shot; nay, that very day he was shot, being Bromsgrove fair, he said, in the hearing of the person whom I will call before you, that he hoped he should find a dead parson before he came home. Gentlemen, his hope was fatally verified; he did find a dead parson before he got home, for on the evening of that day Mr. Parker was assassinated. There is also

subsequent conduct of the prisoner which will thrown strong suspicion on him. You will scarcely believe it creditable but I will produce to you a witnesses before whom he avowed he knew what had become of Heming and that he would never more make his appearance and that declaration was made as late a period as the year 1815. Gentlemen, these circumstances coming to light, the Coroner, to whom great praise is due for a most laborious investigation thought proper to have him taken into custody. He remained in custody some days, when he made a confession, which I will read to you presently.

Mr. Serjeant. LUDLOW. (Defence). This is very unusual, I apprehend. I do not wish to interpose unless I am driven to it.

Mr. Justice LITTLEDALE.– perhaps it will be as well to abstain as much as you can from referring to it, unless you conceive it necessary.

Mr. CURWOOD.– I will adopt any suggestion your Lordship is good enough to throw out. Gentlemen, with regard to the confessions of the prisoners, you heard me make to you this preliminary observation, and I made it in favour of the prisoner, because I do assure you I spoke most sincerely when I said I had no wish to go one iota beyond the line of my duty. In order to make the confession of a prisoner evidence against himself, it must be wholly voluntary – it must not be extorted from him by threats – it must not be gained from him by solicitations; but if a prisoner, being warned of the consequences, being told that it would be used in evidence against him; and if, with those cautions given to him, he still persists in making a confession, that confession must be received in evidence. Now, Gentlemen, his Lordship has said perhaps I had better abstain from reading the confession; I, therefore, in obedience to his Lordship's direction, will abstain from reading it; however he confessed he was present at the murder.

Mr. Serjeant. LUDLOW.– I apprehend, my Lord, it is a most irregular for the Counsel for the prosecution to state the existence of any confession?

Mr. Justice LITTLEDALE.– confessions are always subject to a good deal of observation, and perhaps also, after what has taken place before the Grand Jury, some objection maybe made to the reception of it.

Mr. Serjeant. LUDLOW.– It is the first time I ever heard of its being done in the whole course of my life.

Mr. CURWOOD.– I will not be drawn into any discussion, but will only state that I have known it done a hundred times in the course of my practice. Then, Gentlemen, with respect to the confession, when you have had it before you, the law is, that the whole of it must be given to you – it must not be given to you piecemeal, but every part must be given to you – in order that you may judge the whole; but you are not bound to believe it; you may believe a part, and disbelieve a part; the prisoner may confess enough to satisfy you he was present at the fact, but when he comes to explain that away in another part of his confession, you may or may not believe it, as you please; I never knew an accessory to the foul crime of murder, or of any heinous offence, take upon himself to avow

he was the active hand in committing the crime; he, the accessory, is never the hand to strike the blow, or fire the shot; he always takes some insignificant part in the transaction, according to his own account; but Juries are not bound to believe that, if they are warranted in drawing a different conclusion. The man who murdered Heming must have had a motive in murdering him; there must have been, some strong motive; what stronger motive could a man have than knowing that if Heming was apprehended for the murder of Mr. Parker, the lives of several of them would be in instant jeopardy. Some of these men, or all three of them, must have been the person or persons who perpetrated the crime. That such man was the prisoner at the bar who could have that motive, the evidence will prove to you; that he was there you will judge when you come to hear his own confession. The strong fact afterwards of his avowing that he knew where Heming was, and that he never would again appear, it is for you to say whether that is conformation or not. Year after year have rolled away since this transaction passed; almost in a miraculous manner the grave has thrown out the mouldering remains of humanity to bring this transaction to light. Gentlemen, you have to be the judge of it; let me conclude as I began; remember you are to judge, not from what you have elsewhere heard, but upon the evidence you will hear to-day; remember you are so sworn to decide this great question, and may that Almighty Power, in whose hands are the issues of life and death, direct you to a right verdict.

The trial of Clews concluded about nine in the evening, with a verdict of acquittal.

On Friday, Mr. Justice Littledale and Mr. Baron Bolland were engaged in disposing of those cases which remained to be tried. The Assizes thus occupied *five* clear days.

We believe that no Assizes in this city ever continued for so long a time – nor was there ever an instance of so many atrocious offences being included in the kalendar. As therefore such an Assize is wholly without precedent, so, may we hope that such a one will never occur again! Beside *Toll*, who has been executed, judgement of death was recorded against *twenty-two* criminals.

This acquittal was founded upon a rule of law, that if a confession is received as evidence, and if no part of it is contradicted, it shall be received in all its parts, and consequently that if there are any circumstances favourable to the prisoner stated in the confession, he shall have the benefit of those circumstances; now, it must be borne in mind, that although Clews admitted in his confession that he was present at the murder of Heming, he stated also that he was unwillingly present; whatever may be the judgement of the men upon this statement the jury were obliged to give credit to it, and an acquittal was the consequence. Mr. Justice Littledale expressed himself perfectly satisfied with the verdict.– The case against Clews having failed, the Counsel for the prosecution did not deem it necessary to try the three prisoners upon the Coroner's Inquisition, as there would be no

Oddingley Church of St James where the Revd George Parker was Rector in 1806. He was brutally murdered and 'celebrations' after the acquittals of his murderers were held.

probability of conviction. They were all discharged on the following day.

We have seen a copy of the defence, which Bankes intended to have read had he been put upon his trial for the murder of Heming. The chief object of the defence was to show that the story told by Clews (whom he calls "a wicked and wretched man") could not be true. He dwells upon the absurdity of supposing that so many as four persons should have assembled at the barn, without previous deliberation to commit a murder – upon the improbability that the grave could have been made by Evans and Taylor in the hasty way represented – upon the artful but futile attempt which Clews uses to make it to be supposed that not even the spade was his – and upon the little likelihood that Taylor, an emaciated, feeble, and drunken old man, between 70 and 80 years of age, could have fractured Heming's skull with a blood-stick. Taylor, he says, it would be proved, was in bed at the time of the murder of Heming. The only truth, he

observes, spoken by Clews relates to his (Bankes's) having given him money, "on the morning of the fair-day (says Bankes) just as I was about to start, Captain Evans (to whom I was a servant) gave me a roll of bills, saying if you see Clews at the fair, give him this. I did see Clews at Pershore, and gave him the money and told him Captain Evans had sent it."

When the news of the result of this trial reached Oddingley, some persons ordered the bells to be set ringing; not content with this, a party actually assembled in the Church to drink and smoke, and while so doing, a quarrel took place, which ended in a fight! Upon such a scene as this – which indeed was to appropriate a conclusion of the tragedy acted near the same spot four-and-twenty years before, – we shall offer no remark; every right-minded man will contemplate it with unmingled disgust. When the ringing commenced, the Rev. Mr. Tookey, the Rector, was absent in Worcester; upon his return to Oddingley on Saturday finding that the ringing was re-commencing, he put an immediate stop to it and he has since not only suspended the clerk (who was present upon the occasion) but he contemplates the prosecution, in the Ecclesiastical Court, of those persons who took part in the riotous scene at the Church.

Some idea may be formed of the intense interest, which this case excited, when we state that there were at least ten reporters in Court from London, &c. Two expresses were sent to London during Thursday night and a report of the proceedings up to five o'clock appeared in the *Morning Chronicle of Friday morning!*

Chas. Burton, who discovered the skeleton of Heming, has claimed the reward offered in 1806, for the apprehension of Heming! The rewards offered, were, 50gs. by the County Magistrates, and 100gs [100 gold sovereigns] by the Home Secretary. This claim of course cannot be complied with; it would require some casuistry to prove that the skeleton of a murderer is the murderer himself. Burton was Heming's brother-in-law.

Perhaps a few remarks upon a case of so extraordinary nature may not be deemed irrelevant:– Clews, in his confession states that James Taylor was the actual murderer of Heming; considerable doubts, however, are entertained upon this subject; it is true that Taylor was a man of extremely bad character, but at the period of the murder he was so much enfeebled by age, as to render it highly improbable that he inflicted the dreadful blows which were required to batter into upwards of thirty pieces the skull of such a man as Heming. In this view of the subject, we have heard that if the case had proceeded against Bankes and Barnett, their Counsel would have called Mr. Downing, of Stourbridge, and many other surgeons of eminence, to prove the almost physical impossibility that an enfeebled man like Taylor could have so fractured the skull with two or three blows of a blood-stick.– Capt. Evans (and we cannot refer to the man's name without horror) was evidently the prime mover in the diabolical conspiracy,

which gave rise to two murders. He passed to his last great account a few months before the discovery which led to this investigation – The fate of Heming is to repeat with instruction; here was a man who, probably for some paltry gain, was persuaded to murder a fellow-creature against whom he does not appear to have had the slightest enmity; but, how long did he enjoy the wages of iniquity? In a few hours after the perpetration of the deadly deed, the "avenger of blood" overtook the murderer, and those who tempted him to the deed of darkness were made the instruments for hurrying him before his offended MAKER "with all his sins upon his head." Clews was acquitted in strict accordance with a known rule of law, and though the application of a general principle may in some peculiar instances, enable a great criminal to escape, it is far more consistent with the due administration of justice that general and known rules should exist. Were it otherwise, the criminal code would be a code of uncertainties.– Such, then, has been the issue of a trial, which was expected to produce a very different result. It is now highly probable that none of those who were engaged in the bloody conspiracy will ever be reached by the arm of human justice; but,

The ways of Heaven, though dark, are just In the dispensations of Providence there is much that our finite minds cannot comprehend; but the Day of Retribution will "Vindicate the ways of GOD to man" and will bring to light "the hidden things of darkness" make manifest the justice of HIM who has said "Vengeance is mine; I will repay."

# THE DREADFUL MURDER OF LITTLE SALLY CHANCE

*Berrow's Worcester Journal*, July 29 1830

On the 16th May little Sally Chance, aged 4, went missing from her home in the Lye Waste where she lived with her mother and younger sister. Her mother was a single woman and was being courted by *Charles Wall*, who she was about to marry. He appeared to be very fond of Sally, and was seen with her on the day in question by a number of witnesses. The search went on until the early hours of the morning without success and continued the next day. Her body was eventually found on the 19th May at the bottom of a lime stone pit shaft at Hays Hill. *Charles Wall* was arrested and committed to the County Gaol, under the warrant of Thos. Hallen, Esq. Coroner, charged with the wilful murder of Sally Chance. The pit is situated at Oldswinford and is but a short distance from that in which the body of the female was discovered, for whose murder Toll suffered at our last Assizes.

The Lye Waste was an area historically known for its mud houses, often built by their occupants who were mostly nailers – men, women and children as young as eight years of age, who worked the daylight hours in their small garden workshops forging nails. The monotony of life was broken only by regular visits to the numerous public houses that existed in Lye at this time.

Once again this murder took place at the Hayes in Lye. Lye was in the Parish of Oldswinford.

The Trial – Wednesday July 28th 1730
*Charles Wall*, aged 23, a nailer, was charged with the wilful murder of Sally Chance, in the parish of Oldswinford, in this county.

Mr. Whateley stated the case for the prosecution. The learned counsel begged to call the particular attention of the jury to the important charge he was about

to put under their consideration, as on their verdict depended the life of the prisoner.

Noah Stephens – I am a miner; on the 19th May I was at work in a lime-stone pit at Hay's Hill; I went to the bottom of the shaft where I saw a bundle lying in the water; I thought it was my breakfast that had fell in; I got a stick and dragged it up, and saw it was a child; the shaft of the pit was 240 feet deep.

Maria Pearson – I know a little girl called Sally Chance; she was lost on 16th May. I saw her in the evening near the house of John Brooks; she was playing on the road-side with two other children. I know the prisoner; at this time he came up to the child and said "Sally, your mother is gone home;" she said "Is her," and then walked away towards her mother's. [The house of John Brooks in the Waste was called 'Ivy Dene'. It was a very distinctive house of red and yellow brick work, with terracotta work to the central arched doorway and window heads.]

Mr. Davis stated, in answer to a question by Mr Carrington, that there was no fence around the pits, and if the slide was with-drawn, a person might fall in by accident.

William Newey – I know the prisoner; I saw him about a quarter before nine on Sunday, the 16th May; he was then near the Anvil public house. The deceased was walking about two yards before the prisoner; when I met him. I know the mother of the child; she came to my house about half-past nine to make enquiry after her; I said, "Mary, the last time I saw your child was with Charles Wall." The prisoner was present and she asked him if he had seen her; and he said, "he had not;" they then went away.

Mary Chance. – I am the mother of the child; I live at the Lye Waste; I am a single woman, I know the prisoner. On the 16th of May I was at Samuel Knowles's house, from four o'clock to nine; the prisoner was with me; he left about twenty minutes before nine. My child was in the house about a quarter after eight o'clock; she asked me for a half penny, to buy apples, which I gave her; she asked leave to go out to play; before she did so, she brought the apples to me; the prisoner was then present. Before I left Knowles's house I went in search of the child, but could not find her; about half an hour afterwards I met the prisoner, and asked him if he had seen Sally; he said, "No, not since she brought you the apples." The prisoner went with me in search of the child until about one o'clock, when he said he would go home and go to bed. I went to Newey's house; his wife told me that her husband saw Charles Wall take Sally up the road; the prisoner was present and denied it. Wright Rubens was the father of the child. On the Sunday evening she was dressed in a light pinafore, and had no cap or bonnet on. I never saw her alive again.

Cross-examined.– The prisoner used to call "Sall-y," I never knew him walk out with her before the day she was lost. I have another child about three years old.

Thos. Kendrick – I know the prisoner; saw him about a quarter before nine o'clock on Sunday the 16th May. I know it was about this time, as I heard the

clock shortly afterwards strike nine. He was near the Anvil public-house; the roads divide at that place, and the prisoner was taking the one leading towards the fields; the child was a few yards behind him; he called to her, and told her to come forwards; the child made haste, and ran after him; I then saw him get over the stile, but saw nothing of him again that night. About five o'clock the next morning, I went to the prisoner's house; he was in bed; I told him to get up; the constable was with me at this time; when he got up, I asked him if he had seen the child and he said no, not since eight o'clock. We then took him to the pit, where we supposed the child was.

William Baker – I live at Brettell Lane, near Oldswinford. I was at the Swan Inn, Lye Waste, on the 16th May. I left about ten minutes before nine o'clock; I went up the Birmingham road until I got near the lime pits, when I met Charles Wall; a young girl was with him; the child was in his arms; I did not know the prisoner before, but I am sure he was the man; I pointed him out at the inquest from amongst 13 or 14 people. When I met the child she was crying, and wanted to go home and get some victuals. He said, "don't cry my child, and I will get you some flowers," I got over the stile first, and the prisoner went towards the lime pits. I watched him down 30 or 40 yards; the child was still with him, and making a cry.

John Round – I saw the prisoner a little after nine o'clock on the 16th of May; I was in the Hay's Lane, between the stile leading to the pits and the Birmingham road; no one was with him at this time.

Ann Southall – I live at the Hays; my husband is clerk to the owner of the lime pits; on Sunday morning, the 16th of May about ten o'clock, the prisoner came to my house, and asked me if the path through a field leading to the coal pits was stopped, I said no, the path is not stopped, but the people are, as they do so much damage; he then asked me if I knew which of the pits was knocked off; I said, do you mean the lime quarry pits, and he answered yes that was the one in which the child was afterwards found; no one was with the prisoner at the time he made these enquiries.

John Yardley. – I am the constable of Oldswinford; I went to the prisoner's house on Monday morning to apprehend him; he was in bed; I told him the charge on which I took him in to custody; he said he had not seen the child since a quarter after 8 o'clock.

Mr. Freer. – I am a surgeon at Stourbridge; on the 19th of May I examined the body of a child; the head was fractured there was a very extensive lacerated wound on the scalp; it certainly was a wound such as might have been inflicted from the child being thrown down the lime pit, and was quite sufficient to cause instantaneous death.

This was the case for the prosecution.

Mr. Carrington, the prisoner's counsel, then called the following witnesses;

Benj. Robins – I am a nailer, and have known the prisoner 10 or 12 years. The

prisoner always appeared to be very fond of Sally Chance; he was very kind to her and other children. I know the pit where the body was found; it is situated in a field where it is very common for children to play. I saw several children playing there about 7 o'clock on the 16th of May; Sally Chance was amongst them.

Mr. Justice Park – Take care man, what you are saying; pray be careful.

Cross-examined – I saw the prisoner and Mary Chance about 6 o'clock; I was smoking a pipe near the pit; Sally Chance stood by the side of me nearly the whole time; I left her there when I went away about 7 o'clock, with my eldest wench.

Josiah Hunt – I have known the prisoner 15 years; I knew the child from its infancy; the prisoner behaved more kind to her than I can do to mine; my children and others used often to play near the lime pits; I saw Sally Chance playing there on the 16th of May.

This closed the defence.

Mr. Justice Park minutely recapitulated the evidence. His lordship said, he was at a loss to know what earthly motive the prisoner could have had for committing so diabolical an act as the one imputed to him; but motives could not be judged by an earthly tribunal, they were open only to that Eye that knew all secrets, and from whom nothing was hidden. If they were convinced the prisoner threw the child down the pit, they must suppose it was from a malicious motive arising from some cause or other; and it would be their painful duty to find him guilty. But if, on the other hand, they thought she fell in by accident, they would then return a verdict of acquittal it had been proved by several respectable witnesses, that the prisoner was seen with the child going in the direction of the pit, about the time she was lost; and it was also proved that he returned without it.

The Jury then retired, and in about 10 minutes returned in Court with a verdict of *Guilty*. The most death-like silence at this moment reigned throughout the Court.

The jury, when they delivered their verdict, said it was their unanimous wish to recommend the prisoner to mercy.

Mr. Justice Park – In a conviction for murder, Gentlemen, I can receive no recommendation for mercy; there can be no mercy in this world.

The Learned Judge then addressed the prisoner, expressing his perfect acquiescence in the propriety of the verdict. The finger of Providence had pointed out his guilt as strongly as if the deed had been witnessed by human eyes. He had behaved most cruelly to the women whom he was about to make his wife – he had behaved most cruelly to her innocent child. "I entreat you therefore; during the short time the law of England allows you to live, to spend it in prayer and supplication for mercy. You have committed a crime for which, in a few hours, you must be cut off from the land of the living. You have but a few hours to live; let me beg of you, then, to ask for mercy; be earnest in your entreaties and you may yet find it. Knock with penitence at the gates of Heaven and they may still

The Lime Kilns footpath still exists, as shown in the picture above, but now only leads to factory units and is known as the Hayes Business Park. It was said years ago that on certain nights the crying of a young child could be heard and many people would not walk the path after dark. It was probably only a rumour, or the wind in the trees.

be opened to you, for with God there is plenteous redemption. [It is at this point that the black cap, (a square of 9 inches of black silky material) would be placed upon the Judge's head. Execution would follow within days of this sentence.]

It only now remains for me to pass upon you the dread sentence of the law, which is, that you be taken to the place from whence you came and on Friday next, the 30th of July, be taken to a place of execution, and there be hung by the neck until you are dead; and that afterwards your body be given to the Surgeons for dissection, and may the Lord God of Mercy have mercy on your soul."

Worcester, 5 August 1830

EXECUTION.– The execution of *Charles Wall*, aged 23, convicted of the murder of Sally Chance, aged 5, by throwing her (on the 16th of May) into a lime stone pit at Hay's Hill, in the parish of Oldswinford, took place at six o'clock on Friday afternoon. The body of the wretched being was very promptly given to Mr. Downing, surgeon, Stourbridge, in order that it might be dissected in the immediate neighbourhood where the crime was committed. The body was most skilfully dissected by Mr. Hill and Mr. Hayes, two of Mr. Downing's pupils, and

immense crowds of both sexes and all ages came from the Lye Waste and all the surrounding places to see the body.

It is a melancholy fact that this is the second execution within six months for murder committed in the same neighbourhood, and under similar circumstances. Upon the trial much surprise was expressed that the prisoner appeared to have committed the crime without any motive.

But after his conviction it became known that *Wall* had been engaged in many robberies, with which the child (whose mother *Wall* was about to marry) was acquainted, and had mentioned them to some persons. *Wall*, therefore, to get her out of the way, had recourse to the dreadful crime for which he as justly forfeited his life.

The pit where the body was found was at the Hayes, in Lye, where the body of Ann Cook was also found, but not necessarily in the same pit. The Swan Inn in Lye Waste was where both bodies were taken. The Hayes (from the word Hay, or Haga, a Saxon term for boundary or artificial enclosure) has been an important crossroads for many years. It was on the boundary of Lye and Cradley, which was also the boundary between the ancient parish of Oldswinford and Cradley parish.

The area in 1699 was owned by the Foleys who were followed by Doctor Richard Phillips, a surgeon and apothecary of Droitwich, who was the principal landowner in the area in 1782. Harry Court's map of 1782 shows the 'Hayes Farm' with other buildings nearby. The road running east to west was originally cut through a hillock of limestone, which was excavated and used for building and other purposes. During the late nineteenth and early twentieth centuries the area was occupied by Mobberley & Perry Brickmakers, who sunk various pits in the area to obtain coal, clay and limestone.

# MURDER OF JONATHAN WALL

Robert Lilly, aged fifty, was a buttonmaker of Bromsgrove. He was a mild-tempered man and inoffensive, but had a nasty temper when provoked or under the influence of drink. He was an ex-army man who had served time in India and was said to have received a serious head wound, which affected his temperament. On the night of 5 November 1833, he called at a public house on his way home, where he had three pints of beer. Having left the public house, slightly inebriated, he was set upon by a group of boys who threw fireworks and mud at him. Being a Catholic he took this as a personal insult. On reaching home about eight o'clock, he was in a vile temper, and verbally abused his wife and stepdaughter, who set his supper of bread and cheese before him, which he ate using his pocketknife. He became more abusive, cursing his wife and threatening her, causing her and her daughter to run out of the door shouting Murder.

Jonathan Wall, who was a friend, a neighbour and also his landlord, went to see what the fuss was about and was immediately stabbed in the stomach. By now James King, a police constable arrived and tried to calm him down and was threatened with the knife, at which he drew his staff and struck him two blows, bringing him down and causing the knife to fall from his hand. Meanwhile, Wall was taken to a Doctor, but died later.

*Berrow's Worcester Journal*, 18 March 1834

MONDAY MARCH 10.– Before Justice Park.

WILFUL MURDER *Robt. Lilly* was charged with the wilful murder of Jonathan Wall, at Bromsgrove, on the 5th of November last. The verdict of the coroner's jury was "manslaughter," but the grand Jury returned a bill of wilful murder.

Mr. Alexander having opened the case called Anne Wise, the daughter of the prisoner's wife. This witness stated that his back was all over mud when he came

in, and complained that mud had been thrown at him, and appeared in a great passion [rage or temper] and called his wife a whore, saying he would stick her, and held up a knife.

Charlotte Gill, saw Wall run up stairs, which he did with a view to induce prisoner to be quiet; two minutes later he came down, the prisoner coming down behind him; Wall cried out, "Oh, somebody take me to the doctor – I am a dead man." Witness said to the prisoner, "you villain, you have killed him." He replied, "damn you, if you come within reach of this knife, I'll serve you the same."

James King constable, deposed, that he arrested Lilly and produced the knife, which was a common pocket knife; it was covered with blood. King stated that Lilly was very quiet when sober, but very violent when in liquor.

Mr. Horton, surgeon, deposed, that Wall was wounded on the left side of the belly; the wound was 5 or 6 inches deep, and the intestines were exposed; the knife produced, might have caused such a wound; Wall died of the wound 35 hours after it was inflicted.

Mr. Lee, on behalf of the prisoner, pleaded provocation, and should be deemed manslaughter only.

Mr. Sanders stated, that the prisoner had been in his employ since 1825, as a button-maker, and had borne the character of a quiet, inoffensive man.

In his charge to the Jury, the Learned Judge said, the prisoner at the bar stood charged with wilful murder in having caused the death of Jonathan Wall. The Coroner's Inquest had charged the prisoner with manslaughter; but he had stated before the Grand Jury, that this must be murder or nothing.

A defence had been made, and very properly, by the learned counsel, and some cases had been referred to, to prove that this might be only a case of man-slaughter. His Lordship wished that he could find anything on the face of the evidence, which could justify him in so directing the Jury. A great deal had been said on the subject of malice aforethought, but he must tell the Jury, that every putting to death of a fellow-creature was murder, unless the party accused could show any circumstances of aggravation or defence; this he must show by his own witnesses, or must deduce from the evidence of his accuser. The indictment charged the prisoner with malice aforethought; no one from the evidence could infer that there was malice before hand in this case; but any man guilty of murder, by giving a wound with some deadly weapon, was to be considered as influenced by hostility against the whole race of men – it is therefore malice – not aforethought in this case indeed, the deceased himself released from any ill will to him. But the question that arose was, whether there was not malice, which might be deduced from the acts of the prisoner. The prisoner, in his defence, said he had been drinking and the constable had said that though quiet when sober, he was outrageous when in beer. But his Lordship could not find in law that this was any excuse.

The Jury deliberated for about 10 minutes and then returned a verdict of *Guilty.*

The Judge then assumed the black cap, and proceeded to pass sentence in the following terms.

The next part of the proceedings was known as the 'Admonitory Speech', or to the criminal fraternity as the 'Dismal Ditty':

"Robert Lilly, after a very long and very impartial trial, and assisted as you have been in your defence by a very able counsel who has argued every point, that could possibly tend to further your cause, the Jury have come to the conclusion, that you have been found guilty of murder, in taking away the life of a fellow-creature. If the Jury had found any other verdict it would have astonished all who have heard the evidence and however painful it must be for them, that verdict is perfectly satisfactory to me, as it is in accordance with that which justice demands. I should indeed have been pleased, if I could have found any ground on which to recommend any other course. A kind, peaceful neighbour comes into your house, with the most anxious and kind intention to compose your differences, and in a moment you stab him with a mortal weapon, not in madness or fury of a man who is not conscious of his actions, but you dealt out your blows on every hand, and called upon everyone to come on and you would serve them the same. This is a case of direct and wilful murder, and how the Coroner's Jury could bring in a verdict of manslaughter I cannot conceive. There must have been some misdirection by the Coroner, for the principle he laid down is subversive of all law; he supposes that there must be malice aforethought, or there would be no murder; but where life is violently taken away, the law supposes malice, unless some circumstances can be brought forward to justify or alleviate the act.

No such circumstances have been produced, and in your case I dare not hold out to you the slightest hope of mercy, for God hath said nothing can cleanse the land from blood that is shed but the blood of him that shed it. I dare not, as I respect the laws of God and man, afford you the hope of pardon from an earthly judge, but I can direct you where you may find that mercy which an earthly judge dare not vouchsafe, from the God you have offended, even through the merits and mediation of his adorable Son. Your time must be very short, and I therefore exhort you to apply to some spiritual instructor, and with earnestness of soul seek for that forgiveness – from God, which cannot be extended to you by man. Ask and it may be given you, seek and you may find, knock I entreat you at mercy's door and it may even now be opened to you, and it shall be my fervent prayer for you that it may. (Here the venerable Judge was deeply affected, and paused, overcome by his feelings.) The sentence of the Court is, that you, Robert Lilly, be taken back to the place from whence you came, and on the 12th Wednesday, be taken to the place of execution, and there be hanged by the neck until you are dead – your body afterwards to be buried in the ground contiguous to the place

of execution, and may God in his great mercy have pity on your guilty soul!" [Execution was often carried out within two or three days of sentencing and generally on market days, in order to attract a larger crowd.]

The solemn address of the venerable Judge, and deep emotion which he exhibited, while passing the sentence, caused a strong feeling throughout the Court. The prisoner was firm, but shed tears while the sentence was being passed, affected apparently more by the Judge's manner than by the fear of death. Throughout the trial he was composed, and there was nothing in his countenance, which betokened a man capable of deliberately shedding the blood of a fellow creature.

EXECUTION OF ROBT. LILLEY.– This malefactor was executed at the drop over the entrance of the County Gaol, at 12 o'clock this day. After his condemnation, he expressed himself perfectly resigned to his fate adding that he truthfully forgave all who were concerned in prosecuting him. He also said that he had been on bad terms with his wife, but he bore no enmity to her. His wife visited him on Monday.– His whole demeanour was very becoming. Being a Roman Catholic, he has not since coming to the prison attended the chapel, but has had the assistance of the Rev. Mr. Tristram, Pastor of the Catholic congregation in this City, who has closely attended upon him, and yesterday administered the sacrament. At the above hour, Lilly attended by Mr. Tristram, left his cell and ascended the scaffold. When all the preparations were made, the drop fell; he did not appear to suffer much. After hanging the usual time, the body was buried, without funeral rites, in the ground adjoining the gaol. The crowd was very great and as usual, there was a majority of females. [Women were the highest proportion of onlookers. Children were often lifted onto parents' shoulders so they could get a better view.]

The dreadful act for which Lilly suffered was committed when he was in a state of intoxication; it appears that though a very quiet, unoffending man while sober, he was, after having a small quantity of liquor, a mere madman; this violent effect is attributable to an injury on the head he sustained while serving in the army in India. Upon the night of the murder his passion was peculiarly roused by boys pelting him, as a Roman Catholic, and it being the 5th of November.

The gaol had 170 cells each normally housing one prisoner, but at times of greater demand, each cell often held three. There was also a Governor's house. Most prisoners, once arrested and charged with a crime, were held here until the time of their trial at the Assizes, the fortunate ones were found 'Not Guilty' and released. The prisoners found 'Guilty' of a capital crime returned here and were publicly executed in front of the gaol.

After building the Gate House, executions were carried out on the roof of the gaol, watched by hundreds of spectators who gathered to witness the scene. Others who avoided execution, received sentences of transportation to the Australian

Colonies for 7, 10, 15, 20 or 25 years and sometimes for 'the rest of their natural life'. Punishments for minor crimes were also administered here in public in the form of whipping, standing at the pillory or burning in the hand.

Shorter terms of imprisonment and periods of solitary confinement would be served within the gaol. Later executions were carried out within the prison and the bodies buried in the prison in unmarked graves and without ceremony. The last public execution held here took place on 2 January 1863 when William Ockold, aged sixty-nine of Oldbury (then in Worcestershire), was hung for the murder of his wife. After execution bodies were often sent to the Royal Worcester Infirmary for dissection and Phrenology*. Plaster casts of the head would first be made. The casts would then be examined by an expert in this scientific subject looking for mis-shapes, large or small, to give a scientific answer for the behaviour of the prisoner in committing his particular crime.

* *Phrenology was the so-called science having for its basis the supposition that mental facilities and traits of character can be gauged from the shape and size of the skull (New Universal Encyclopaedia).*

A pencil sketch of Worcester Gaol, known as the 'Castle', in Castle Street, with the iron railings, normally mounted on the dwarf wall, removed.

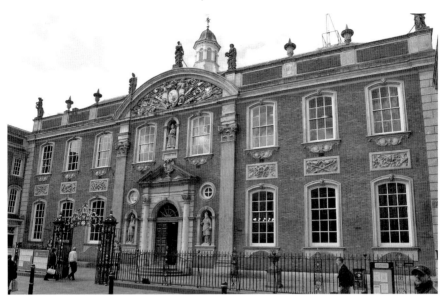

The Guildhall Worcester was built in 1724 and served as the Town Hall and also the civic and criminal courts for the Assizes up till about 1835, when the County Courts moved to the Shire Hall. The cells (resembling dungeons) still exist in the basement, where prisoners waited before being brought up into the court room and put before the bar, to face the judge and Jury. Most were found guilty and returned to the cells, with the final words of the learned Judge still ringing in their ears.

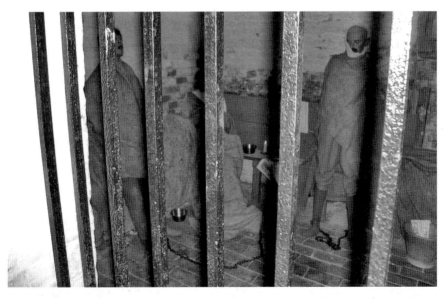

Prisoners shown here in the basement cells are awaiting their trial in the courtroom above their heads. Some may have already received sentence and are pondering over their future and that of their families'. The date of the scene is late eighteenth century. The prisoners also have shackles on their ankles.

# MURDER OF JOSEPH HAWKINGS

Joseph Hawkins owned a small grocery shop in the village of Areley Kings. He had not been seen since Thursday 8 September 1836, so the local police officer who was informed, obtained a ladder and entered the house and found the building had been ransacked. On entering the brewhouse he found the body of Hawkins on the floor covered in blood. He had a gunshot wound to the stomach and his brain was protruding from his skull. On the floor lay a coal hammer and a leg broken from a table, both covered in blood and hair. A local man named William Lightband was known to own a shotgun and had recently been to Stourport, where he had purchased powder, shot and caps. On this information William Merrefield, a police inspector, searched his house and found a percussion gun barrel, which smelt of powder, as if it had been recently fired. He likewise discovered in a basket, a roll of tobacco, a bag of raisins, a bag of currants and some sugar. Subsequently he searched the suspect and found on him two sovereigns, one half-sovereign, seven shillings in silver and a watch, the possession for which he could not give a satisfactory account.

*Berrow's Worcester Journal*, Thursday 9 March 1837
TRIAL OF WM. LIGHTBAND FOR MURDER
WEDNESDAY MORNING
The Court was thronged at an early hour this morning, great anxiety prevailing to hear the trial of *William Lightband* for the wilful murder of Joseph Hawkins, at Areley Kings, in this county.

Shortly after nine o'clock Mr. BARON PARKE took his seat on the bench and the prisoner was placed at the bar. He did not appear to feel his awful situation; and when called upon to plead to the indictment, he threw up his hand with the utmost confidence, and lowly explained "Not Guilty". [Justice Baron Parke was known as a 'Hanging Judge' and criminals to be tried by him could expect little or no mercy.]

Mr. Lee and Mr. Beadon were counsel for the prosecution and Mr. Curwood appeared for the prisoner.

Mr. Lee opened the proceedings.

Mr. Kendrick Watson the surgeon, stated that he had extracted 12 shots from the stomach of the deceased and that his ribs were fractured and his breastbone broken and his liver lacerated. He said the cause of death was concussion of the brain, although either the laceration of the liver, or the wound from the gun, would eventually have occasioned death.

William Merrefield, Inspector of Police, Kidderminster, described his visit to the prisoner's house and what he found there. He then detailed in the most clear and satisfactory manner the prisoner's confession, which was put in and read to the court.

"I, William Lightband, do declare, in the presence of Wm. Merrefield and Wm. Dickins, that I bought half an ounce of powder on Monday evening, at Mr. Griffin's, in York-street; the shot I had at Mr. Broadfield's, opposite the Market-house; the powder and shot cost me 2*d*. From there I went to Mr. Busby's, and bought a halfpenny worth of caps; I then had 2½*d*. in my pocket left. I watched my opportunity, and at about half-past six o'clock I went into Hawkin's with the gun, and asked him to serve me with half a pound of cheese; and while he was weighing it I put the gun across the counter thinking to shoot him, and the cap went off; it miss fired; he considered it as a joke, and laughed at me. On the Thursday morning my wife asked me if I was going to work; I said yes; she told me I should be too late. I left to go to work – she left to go hop picking; I concealed myself, and returned to the house to work on the gun stock, and finished it, I drew the charge that was in it, put it all together, and reloaded the gun with about two thimbles full of shot. About a half past five o'clock the same evening I went to Hawkin's and asked him for half a pound of sugar, and while doing so I shot him he fell. I afterwards struck him with the stock of the gun on the head, when the stock broke; I afterwards dragged him to the back room, and he made a little noise; I found a coal-hammer, and struck him twice on the breast; I was then going to leave him and he began to groan; I took hold of the leg of the table that has been produced to-day and with that struck him in the same place that I had struck him with the gun stock. I laid hold of him and turned him over and then left him. I went into the shop; I took about 2*s*. 6*d*. in copper, and some silver; in all, copper and silver, about 20*s*. 10*d*. I fastened the door with the key, and came out. On Friday morning I went in again, about a quarter past six o'clock, and found him dead; I then went upstairs and opened his box, but found nothing; but in an old basket in the room, in removing some old rags, I found 5 sovereigns and a 5*l*. note; the things that were produced by Mr. Merrefield were taken by me from the shop, I mean the currants, plums, sugar, and tobacco. I declare in the presence of God that what is here is all true, and I am the only person concerned. The gun stock I burnt."

During the reading of the above horrible detail, which was heard with breathless attention and anxiety by the whole court, the prisoner alone stood unmoved; he displayed no symptoms of feeling or contrition, but leaned with his hands on the front of the dock, and stared around him like an unconcerned spectator.

Two or three questions were put to Merrefield by Mr. Curwood as to the sanity of the prisoner.– Witness stated however that he never had to deal with a more cool and collected man in his life.

Mrs. Meredeth was returning from Kidderminster Market on the 8th of Sept., and had passed the house of the deceased about 160 yards when she heard the report of a gun; it was about half-past five in the evening.

William Bickerton, watchmaker, knew the prisoner, stated that on the 10th September he enquired about the prices of some watches; he purchased one at 25s., for which he tendered two sovereigns.

Matthew Grainger, an assistant to Mr. Yates, Stourport said the prisoner, on the 9th September, purchased a hat at 4s. 6d. in which witness wrote "William Lightband." The prisoner also purchased other articles, to the amount of 14s.

John Parsons, clerk to Mr. Winnall, Stourport, had waited upon the prisoner several times for rent that was due; on the 9th September he called at the office of Mr. Winnall, and paid three sovereigns, leaving due 1l., 17s. and 6d.

This closed the case for the prosecution.

Mr. Curwood briefly addressed the Jury on behalf of the prisoner, observing that he had not wasted the time of the Court by any cross-examination, because he considered it would be doing the unhappy man no service; he thought it the most discreet course to leave it in the hands of the Judge.

Mr. Baron Parke summed up, and while his Lordship was addressing the jury the prisoner occasionally drew a heavy sigh, and seemed to feel his situation very acutely; tears flowed profusely down his cheeks before his Lordship concluded.

The Jury, after a few minutes' consultation, returned a verdict of *Guilty*. The prisoner when asked why sentence of death should not be passed on him gave no answer.– The Judge then put on the black cap, and in a most solemn tone pronounced the awful sentence, remarking that he had never during the whole course of his life heard of a more deliberate and cruel murder than that of which the prisoner had been found guilty.

His Lordship concluded, "You will return to the Gaol from whence you came, and then be conveyed to the usual place of execution, there to be hung by the neck until your body be dead; and may the Lord have mercy on your soul!"

Worcester, Thursday 30 March 1837
EXECUTION OF WILLIAM LIGHTBAND.
On Thursday last, soon after twelve o'clock, this culprit was executed in front of the County Gaol, for the murder of Joseph Hawkins, at Areley Kings. He

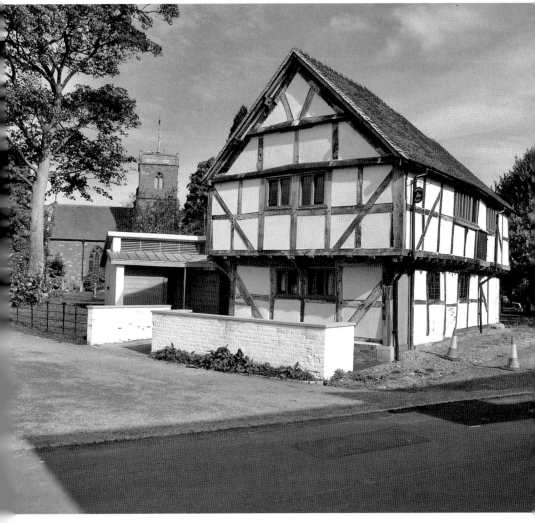

Church House at Areley Kings, built in 1536 to hold celebrations known as 'Church Ales', was restored in 2006. The Parish Church of St Bartholomew and its churchyard, seen in the background, is where Joseph Hawkins was buried, 13 September 1836, aged seventy.

acknowledged that his sentence was just. From the time of his condemnation the Rev. J. Addlington, the chaplain and the Rev. John Davies Rector of St. Clement's gave him the utmost religious instruction and consolation. The prisoner said he was not afraid of that death that kills the body, but of that which cometh afterwards, and kills the soul. On entering the prison he was ignorant of the alphabet; but before his execution he was able to read a chapter in the Bible. The Rev. J. Addlington, preached on Sunday se'nnight the condemned sermon, taking his text from the 32nd chapter of Numbers, part of the 23rd verse: "Be sure your

sin will find you out." The discourse, which was very impressive one, greatly affected the unhappy man. In quitting the room, to be delivered up to Mr Under-sheriff Gillam, who was in attendance, he shook hands with the governor of the gaol – "Good by, and may God bless you for your kindness to me!" He tottered on, shedding tears profusely and accompanied by the Under-sheriff and his officers, to the portal of the gaol. The prisoners in the meantime were drawn out, the debtors in the yard on the right, and the felons on the left, to be spectators of the distressing scene which was approaching.

At the portal of the gaol, during the process of being pinioned, his emotion and trembling were such that he was near falling, when the Rev. J. Davies approaching him, whispered some words of spiritual consolation, and he recovered his firmness. He then shook hands with two of the turnkeys, and steadily ascended the steps to the top of the building. When he was on the scaffold, while the fatal noose was being fixed, he trembled violently, crying out "Oh Lord! Oh Lord! Have mercy upon my soul," and shed a profusion of tears. He shook hands convulsively with a friend who had visited, and paid many attentions to him while in prison, and said "God bless you!" The cap was then drawn over his face; the Rev. Chaplain read the solemn and impressive service for the occasion, and in a few minutes the fatal bolt was drawn. He fell apparently dead, but in about half a minute a convulsive movement of his whole frame excited a cry of horror from the crowd, which covered every visible spot of ground. A few struggles, as if gasping for breath, followed, and in a few minutes he ceased to live.– Wm. Lightband was about 20 years old, and of rather short stature. There was wildness in his look and nothing ferocious about it. He was by trade a carpenter, and he told his reverend attendant and also one of the visiting magistrates, that he could obtain near 30s. per week by his labour, but having fallen in with profligate and vicious associates, he was seduced into the habits of intemperance and idleness that he left his own fire side and family to be in the companion of the drunkards in the ale house; and having thus imbibed a disinclination to follow his regular labour, the dreadful idea of committing the horrid deed for which his life had been forfeited entered his mind – was there fostered by the degeneracy into which he had fallen step by step and he was induced to spend the last money he possessed in the world, (5d.) in purchasing the shot and powder with which to murder his helpless victim Hawkins, and the rest (2½ d.) on a pint of ale.

Such is the lesson he has left behind him. May it be a lasting and useful one to those who are following a similar course of life, in rioting and drunkenness!

# MURDER OF MARY ANN STAIGHT

*Berrow's Worcester Journal*, 15 March 1849

Mary Ann Staight, aged 15, was brought up from the age of 9 by her aunt, and lived in the village of Drake's Broughton, Pershore, where she had lived after the death of her parents. On Tuesday the 5th December, 1848, about four o'clock in the afternoon she was sent by her aunt to Mrs. Tyler's shop, about a mile away to buy grocery, near a place called the 'Two Elms', known locally as the 'Two Sisters'. By the time she reached the shop, it was getting dark. She made her purchases and stayed talking for a while before leaving with her goods but failed to return home that evening. On Wednesday the 6th December, her body was found in a ditch by Frederick Turvey, a boy of eight. He immediately fetched his mother who recognised the body as that of Mary Ann Staight, it was clear from her injuries that her death had been a very violent one, caused by being beaten about the head with some heavy object. On the following Saturday a heavy stick was found in a nearby ditch, which could have produced the injuries, with human hairs still attached, matching those of Mary Ann Staight.

The Surgeon who carried out the Post Mortem matched the stick to the injuries produced. The stick was identified as belonging to Mr. Panter, which he lost some time ago, after employing a man called Pulley to do some work for him.

Robert Pulley, a local man, was immediately suspected, who it appeared had a grievance against Mary Ann and expressed aversion and ill will to the poor girl, and had made various threats to kill her, which was said to have originated from his failure to win her affections and favours.

On the day of the murder he had been seen near her aunt's house at the time she left to fetch the grocery, and had made insulting remarks as she passed by. He was also seen following her along the turnpike road. He used the same language towards the girl when he met another person. He was also seen near the elm trees close to the spot she was murdered as if waiting for her. He was identified as

wearing a smock frock and breeches, and a black hat.

Elizabeth Richards, aunt of Mary Ann Straight, who sent her to Mrs. Tyler's, stated she heard prisoner say to deceased in August last, that "She wanted her b----y head broke." The girl, myself, and prisoner were present and talking about a woman at whom he had thrown a bean hook. Mary Ann and I said it was a shameful thing to serve a woman so, and the prisoner said to her "What was it to you, you want your b----y head broke?" When he said that, I asked him why he should use such abusive language? He replied "Well, woman, I don't know, I am such a one." For the last three or four years he had slept out, and burnt his tools last harvest.

Hannah Tyler keeps a hucksters shop, Mary Ann came to her shop on Tuesday 5th December about five o'clock and bought groceries and a farthing's worth of pins. She knew prisoner, and said he would not work even if he had it to do. Nothing was missing except the pins.

About 4 o'clock, on the 5th of December James Savage was talking to Pulley near Pigeon House Lane, as Mary Ann passed by and Pulley asked her "Are you going off again tonight, you were seen in the lane one night with your clothes up around your middle?" he said Irish Molly had told him so. She never replied, but just went on her way. He told me he was at her aunt's house sitting by the fire with her aunt and her, and were talking about girls taking to bad ways, when he told her he hoped she would never do so. Her aunt answered, "if she did, it was to herself, and it wasn't any difference to any one". I told him I was in a hurry, and wanted to go on my journey; but he called me back and said, "She was a d----d whore. He would as soon spread her brains about the road as he'd move that bit of dirt about," – (at the same time scraping the dirt with his foot). I then left him. He had a wallet on his shoulder, but nothing in his hands. I live in the neighbourhood, and know the deceased to have been a tidy, well-conducted girl. She passed and took no notice of the prisoner. He called her his whore and told her to haste back it would be dark before she got back to the hovel. He said she'd been telling the people of Broughton that he was jealous of her and if he could catch hold of her he would tell her whether he was or not. He went about the country, and slept in barns and other places. He was a wicked talking man at times, but though he talked about spreading deceased's brains about, I was not alarmed, I did not know that he had broken up his tools last harvest till after the murder. He used to work at odd jobs, he hardly talked rational, he always talked in a curious sort of way, so people took no notice of what he said. I believe it was all vanity and silly talk. I saw the way the girl went, and Pulley followed her.

At the time of the murder he was near the Two Elms, at half past 4 to 5 it would be quite dark. He often carried a wallet over his shoulder (a wallet, a bag for carrying personal belongings in, and often consisted of a rolled blanket tied at both ends.) On Thursday morning the 7th December Superintendent William Harris found Pulley in a barn at Pinvin about a mile from Pershore. He had two

smock frocks on and on the outside one there were spots of blood from the wrist band up to the collar and also at the bottom between the gaiters. The Learned Judge and Counsellors minutely examined both frocks, there were smears of blood down the inside frock and he had two clean shirts on. On the way to the station he met a person on the road to whom he said, "Well, Jack, I am going to be hanged." He told the Superintendent he did not do it. He was searched and a knife was found in his pocket. A wallet was found in the barn with blood round the mouth of it, and some broken victuals.

She was murdered by a ferocious attack; a plea of insanity was made by the defence counsel on his behalf.

She rejected a love offer on his part. She was 15 years of age and he was an old man of 49, maintained by the charity of others, he therefore had nothing to offer her as an inducement. Plunder was not the object of ferociously killing her, all her property was untouched except for a paper of pins, which was missing, but could not be found upon him. His Lordship then summed up the case. He told the jury they would have to be satisfied in the first place that the murder was the act of the prisoner; and satisfied of that, whether he was in a state of mind to be responsible for a criminal act. It was no idle words or absurdity of speech that would establish a defence of this kind. None of the witnesses had intimated that the prisoner was at all regarded as a lunatic in his neighbourhood, though his conduct in going about and saying what that he intended to do was certainly not like that of a sane man. His Lordship having read over the whole of the evidence left the case with the jury.

The jury then turned round to consider their verdict, and after an interval of about ten minutes the foreman said – "We find the prisoner GUILTY OF WILFUL MURDER."

Considerable sensation was now apparent in every part of the Court. The prisoner on being called upon to say why he should not receive sentence to die, made no answer. His Lordship assumed the black cap, and, proclamation of silence having been made, proceeded to pass the awful sentence of death as follows:–

Prisoner at the bar, you have been convicted upon the clearest evidence of this cruel murder. What motive could have operated upon your mind to induce you to kill this innocent young person, just starting into life, it is known only to yourself; to me or anyone else it must be a mere matter of speculation. For some reason or other you appear to have cherished a malice feeling towards this young person, who you have now deprived of life, and it is vain to speculate upon your motives. You appear to have been utterly careless of the consequences so long as you could gratify the ill-feeling that existed in you bosom. I hope that you may make use of the time you have yet to remain on earth in making your peace with the God whom you have offended by this act of outrageous murder. I hope that by the assistance of the pious gentleman whose duty it is to offer you instruction,

The top picture is Mrs Tyler's shop, where Mary Ann went for her groceries and was last seen alive. It no longer has the enamelled signs, as it did in 1952–3, advertising the likes of Colman's Mustard, Starch, Typhoo Tea, Cherry Blossom Boot Polish, Brasso and others... as the author remembers it, having passed it many times as a young National Service Man stationed at Tewkesbury, going home on weekend leave.

The Plough & Harrow is on the main road from Pershore to Worcester, the Twin Elms were said to have been within a short distance of this public house. Almost opposite, on the other side of the road, is a lane with a no entry sign, which leads to Windmill Hill. The Sister Elms were said to be next to it.

and who will, I have no doubt, perform that duty consciously, and efficiently, you may, receive all the consolation which your circumstances will admit of, and that you may be brought into a fitting frame of mind to meet that state which you must so shortly enter. It now only remains for me to pass upon you the sentence of the law, which is, that you be taken from the place where you stand to the common gaol in the County; that you be taken thence to the place of execution, there to be hanged by the neck until you are dead, and that your body be buried within the precincts of the gaol, and may the Lord have mercy on you soul.

The prisoner, who, throughout the trial, had exhibited the greatest possible indifference, was then removed, apparently with very little concern.

THE CONVICT PULLEY. – Since our last publication we understand that a memorial to the Home Secretary in favour of a commutation of the sentence most righteously passed upon this wretched man has been got up in this city and forwarded to the City Members for presentation. We must confess that although we share the common repugnance, which all men of well regulated minds must entertain against the public spectacle of a execution, yet we have no sympathy with the trading humanity-mongers who systematically oppose the punishment of death for all offences. Their officious interference on all such occasions is dictated by a morbid and unhealthy sentiment, and in the present case their memorial is based upon fallacious allegations. The convict is no more insane than are the memorialists; on the contrary, although unlettered he is remarkable shrewd and intelligent – much more so than the generality of men in his rank of life, and is tolerably well acquainted with the scriptures.

We are authorised to state that unless a reprieve should arrive, the execution of Pulley will take place on Monday next, at twelve o'clock, at the County Gaol.

Whitehall, 22 March 1849. A reprieve was refused.
Execution of Robert Pulley for the Murder of Mary Ann Staight.
This wretched culprit underwent the extreme sentence of the law on Monday last 26th March 1849, on the roof of the County Gaol, in this City, between the Infirmary Tower and the Gateway, immediately opposite the Infirmary Walk.

THE EXECUTION. By the early part of the morning the scaffold was completed and painted black and the surrounding railing covered with a black cloth drape, and by five o'clock many people were beginning to assemble outside the Gaol, and began to take up the most favourable positions they could find in the Infirmary Walk and its vicinity. As the morning wore on, the crowd increased, and by seven o'clock a large concourse had assembled. During the whole of the morning, which was fine, although somewhat cold, vast number of persons in every available vehicle were continually arriving, especially from the Pershore district. Cart after cart brought its load of human beings, and as the time fixed for the execution drew near, every place from whence a glimpse of the scaffold could

be obtained was completely crowded. Very large numbers had also arrived from Birmingham. With the exception of a few of the very lowest class of persons the mass behaved very orderly; but, we fear from the levity which we witnessed that the moral effect of the scene was quite lost upon the multitude, who eventually had came to look upon it as a spectacle, or a matter of amusement and curiosity, and were actuated by the same feeling as if they were witnessing a theatrical entertainment. Among the crowd, although not surprised, we were grieved to see many apparently respectable females, and so powerful was the incentive which brought them there, that numbers of them who could find no one to take care of their children at home actually brought them with them. Hundreds of women with children in their arms stood for hours exposed to all the boisterousness and

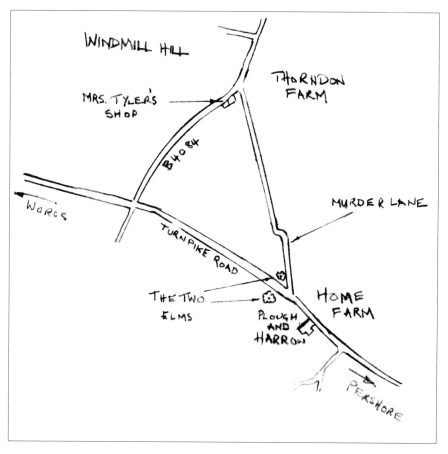

The spot where the murder took place is difficult to pinpoint, as the two elm trees known as the 'Twin Sisters' no longer exist. They were cut down in the 1970s as a result of Dutch Elm disease. The road branching off nearby has been identified as the lane where Mary Ann was murdered and is known locally as 'Bob Pulley Lane', which leads to Mrs Tyler's shop at Windmill Hill.

ribaldry of a mob, composed of some of the very worst specimens of humanity. But out of feeling of propriety were still further outraged by seeing among the spectators a great number of females, who, from their dress and demeanour appeared to belong to a more respectable class in society.

About twelve o'clock, the whole of the male felons were brought out into the debtors yard, and arranged in rows to witness the execution. The female prisoners also, were taken into another enclosed yard, from which they could observe the painful spectacle.

The prisoner arrived at the first gate and was met by the Executioner. This dread personage was enveloped from head to foot in a dark gloomy coloured cloak, which entirely covered the whole of his person. The lower part of his face was muffled in a capacious handkerchief, and a cap slouched down over his ears and eyes, most effectually disguised his countenance. He walked by the side of Pulley, with the Governor and Chief Constable behind, followed by the Javelin men and gaol officials. And the gaol bell commenced tolling. They mounted the flight of stairs leading to the press room, where the executioner proceeded to untie his neck cloth and pinion his hands and arms to his body. On reaching the platform he was positioned beneath the beam and the cap positioned over his head. The executioner then soaped the rope well with soft soap, and positioned it over the prisoner's head. Everything being ready the drop was released, and Robert Pulley was no more. After hanging the normal time his body was removed and placed in a coffin and later buried within the precincts of the prison without ceremony.

Pulley was of short stature, strongly built, thick neck, and broad expansive shoulders. He traced his ruin to habits of idleness and drinking, and the crime for which he suffered, was a powerful illustration of the evil of giving way to unbound passions; fortunately he left no wife or children behind. He did not make a full confession, but admitted that the sentence was a just one.

The spot where the murder took place is difficult to pinpoint, as the two elm trees known as the Twin Sisters, no longer exist, cut down in the 1970s, due to Dutch Elm disease, the road branching off, near by, as been identified as the lane where Mary Ann was murdered, and is known locally as 'Bob Pulley Lane', which leads to Mrs Tyler's shop at Windmill Hill.

# MURDER OF LUCY RICHARDS

*Worcester Herald Supplement*, Saturday 24 July 1852

Worcester Assizes, 21st July 1852 Before Mr Justice Cresswell.
MURDER OF A CHILD BY ITS MOTHER AT OLDSWINFORD
ROBINS, MARY, alias RICHARDS, MARY ANN, aged 25, single woman, was charged with the wilful murder of her infant, Lucy Richards, at the parish of Oldswinford. [Here is another reference to the parish of Oldswinford of a murder which took place in the parish of Lye by throwing the victim into a pit at the Hayes which makes three murders in all. All the bodies were taken to the Swan Inn in Lye Waste where the inquests were held.]

Mr. Whitmore and Mr. Best appeared for the prosecution. Mr. Huddleston for the defence.

The prisoner, who had a vulgar set of features, and a dull look, appeared much distressed and feeble. She wept occasionally during the trial, and now and then exclaimed in a low tone, "My child! My child!" she was allowed to sit during the whole of the proceedings.

Alfred Knowles examined by Mr. Best. – I am a miner. I know the Hayes fire clay pit, I was at work there on 23rd June, I found the body of a child. There was about two inches of water over the child when I found it. I delivered the body to Police-constable Selley. The mouth of the pit was left open. There were clothes on the child. The pit was about thirty yards from the footpath. We began to draw the water at seven o'clock that morning. The track by the pit leads to Netherend and Cradley. It is the shortest way across to those places.

By the Court. – The pit was forty yards deep, and had a five feet diameter at the mouth.

The footpath mentioned was the ancient path that once ran from the Hayes, from opposite Wood Street to Hayes Lane, known as the 'Lime Kilns'. It continued on by

a further footpath, a little lower down Hayes Lane, which went to Netherend and Cradley and would probably be the shortest distance on foot to both Netherend and Cradley. Neither exist today having been built over by factory units.

Police–constable Selley examined by Mr. Best.– I received the body of a child from the last witness. I took it to the Swan at the Lye.

The child was dressed. I know the poor girl's mother; I hear the girl has been subject to fits, but I don't know it. I have heard she is considered soft, but I don't know it of my own knowledge.

Henry Burton, superintendent of police, examined by Mr. Whitmore – I apprehended the prisoner on the 23th June. I asked her if she had been confined lately. She said she had not had a child for the last two years. A surgeon of the name of Wilson was then brought to her. He examined her breasts and declared she had recently had a child. I then charged her with the murder of the child found in the pit. She said – "I'll tell you the truth, Mr. Burton. I have had a child born at Mary Ann Banister's, at Bilston, but it died after being put in a warm bath, and was buried with the man who died of the fever at Bilston." I know Beach and Manley. They are employed at the Wolverhampton Union Workhouse. They were brought to Stourbridge police station on the following Saturday, the 26th.

Cross-examined.– It was on the Wednesday I took her into custody, but left her in the charge of officers at her own house until the next day. She had a fit of hysterics when I returned to the house with the doctor on the Wednesday. She was so ill I thought it advisable to leave her at home. I took her to the station-house the following morning, and she was put to bed. I have known the girl for years, and I do not consider her of bright and clear intellect.

Edward Moore, examined by Mr. Best. – I am a surgeon at Halesowen. On the 24th June last, I examined a dead child at the Swan Inn, Lye Waste. I found that the substance of the brain was smashed. The injuries were sufficient to cause the death of the child; they were such as would be produced by a fall into a pit. The stomach contained a considerable quantity of milk. There was no discolouration of the scalp. Usually we should find discolouration of the scalp when wounds are inflicted during life. We do not usually find it when breaking of a bone or contusion takes place after death. In this case I found a small quantity of mucus in the lungs, the left side of the heart empty, the lungs slightly congested, and the brain also, but it was difficult to say to what extent, in consequence of the injuries done to it. The brain was much congested. I have had much experience in cases of midwifery. I have seen instances where the mother at a period after the birth has been deprived of her reason for a short time. We may have puerperal fever, which generally comes on in three or four days, or rather before that, when secretion of milk comes. It may occur a fortnight after, but seldom does. It may occur at any period after confinement, but the most frequent period is before the

secretion of the milk is established. It may come on a fortnight or three weeks after, or even later. The fact of a person being subject to fits might most probably give a predisposition to it.

By the Court. –The *post-mortem* appearances do not enable me either to affirm or deny that the child had convulsions. The injuries are consistent with the supposition that the child had been thrown down either before death or immediately after death.

Mr. Wilson, surgeon, Stourbridge, examined by Mr. Best. – On the night of Wednesday, June 23, about ten o'clock, I examined the prisoner's breasts and found them full of milk. I was of opinion she had recently suckled. She was in a very hysterical state, but was not labouring under puerperal fever or mania at the time.

Ann Beach, examined by Mr. Best. – I am assistant nurse at the Wolverhampton Union Workhouse. I attend to the lying-in ward. I remember the prisoner being admitted, but I can't say the day of the month. She was confined there and stayed a fortnight afterwards. The child was a female; I was present when it was baptised; it was named Lucy Richards. The prisoner went in the Union by the name of Mary Ann Richards. It was a healthy child. The prisoner left the house on the 19th about half-past twelve in the day with her child. (The witness here described the clothes in which the child was dressed.) I saw the child dead at Stourbridge, on the following Saturday, and also the prisoner at the station. As soon as she saw me she fainted. I afterwards asked her how she could think of making away her child. She said the devil had tempted her to make it away.

Cross-examined. Mrs. Turner and another woman were in the room. It was about an hour after she fainted that I began to talk to her. It was as soon as she got better. She fainted in the yard and was carried to bed. She was crying very badly when I went into the room, and I asked her this question whilst she was crying. I know the child had had fits at the workhouse, perhaps two or three in the day. It was subject to them. The night before the child left the workhouse it was put into a warm bath for the convulsion fits by the doctor's order.

By Mr. Best. – It was pretty well when it left.

Ann Manley, of the Wolverhampton workhouse, I went into the cell, and asked her how she could be so unfeeling a mother to murder her own child. She said in reply, she sat down and suckled the child; the child had a fit, and she threw it into the pit.

Mary Turner examined.– I am the wife of John Turner, of Stourbridge, and live at the police station. The prisoner was in my charge on Saturday 26th. I remember Beach and Manley coming to the police station on that day. I was in the cell when Manley came in. The prisoner said "Oh, Manley, I did throw my child into the pit." Manley said, "How could you be such a cruel mother?" The prisoner said, "Oh! The devil tempted me, and I threw it into the pit." She cried a good deal, and said the child had a fit; she suckled the child; then it recovered, and she threw it in the pit.

James Everett, shoemaker, Lye, said he saw the prisoner on the evening of the 19th coming from the direction of the Hayes' pits, towards her own home, and about two hundred yards from the pits. She had nothing with her.

This concluded the case for the prosecution.

Mr. Huddleston said, that cases of this kind were the most painful they had to decide. They sat as judges on matters affecting the life of a fellow creature upon most fallible evidence, and that fellow-creature a young woman not possessed of a clear intellect, and subject to fits. It was quite clear that if the child was taken with a fit by the side of the pit and died, and the mother in agony of the moment threw it down into the pit, it would not be murder. The appearances that the doctor found were such as allowed, the supposition that the child died before it was thrown in. Then it was a singular fact in the case that there was no discolouration on the body. A violent blow after death produced no discolouration. This showed the probability of the suggestion that the child was thrown down after death. Would the Jury dare to affirm upon their oaths, in a matter affecting the life of a fellow creature, what the doctor who examined the body dared not say. The child was subjected to convulsions as the evidence plainly proved, and the probability was that it was taken with one those mysterious visitations to which all are subject and by which its life was destroyed, and that the mother in her misery had removed from her sight the painful object by throwing it down the pit. He concluded by observing the serious nature of the charge, and the necessity that the Jury should be satisfied beyond all doubt, before giving a verdict of guilty, that the child was thrown into the pit alive by the prisoner with the wicked intention of putting an end to its existence.

His Lordship commenced his address to the Jury upon the evidence by remarking upon the solemnity of the duty they had to discharge in this case, and calling upon them to exercise their judgement freely and fearlessly upon the facts, regardless of the consequences which might result from their verdict. He then proceeded to comment upon the evidence, which he read at length. There was no doubt he remarked, that the prisoner had made a false statement in the first instance to Burton, when she denied the fact that she had been recently confined of a child, and again when she said she had been confined at Bilston. With respect to the other expressions said to be made use of by the prisoner in the hearing of the female witnesses, the Jury must be cautious in the extent to which they received them, because it was extremely difficult, even under the most favourable circumstances, to repeat from memory the exact words used by a person, after any considerable lapse of time. The Jury had, as had been remarked, an instance of the difficulty of describing correctly expressions of another. By leaving out a few words, or not describing the words in the correct order, the meaning of an individual might easily be perverted or obscured. He expressed his opinion that there was no reason to doubt that the girl had thrown the child into the pit, but the Jury must decide from the facts whether the child was alive

or dead at the time. There were three points to which he should particular direct the attention of the Jury. The first was that the child was thrown into the pit with its clothes on, and it might be supposed that a person who wished to commit murder would be more careful to destroy the means of identifying the body in case it should be discovered, by removing the clothes. The second was that the pit was being worked and that any person in the neighbourhood, used to the appearances at the pit mouths, would be able to know that such was the case. The prisoner lived near the pits, and it must be supposed would be well aware that the body would soon be discovered. The third point for their consideration was whether, supposing the woman threw the child into the pit alive, she was in a sound state of mind? The law inferred that every person was in possession of sufficient reason to be accountable for his actions unless the contrary was proved. What proof to the contrary was given here? There had been some talk about puerperal fever and mania, but the learned Counsel did not press that point. None of the witnesses who could speak to the prisoner being attacked by anything of the kind had been asked the question. The mother of the girl could have been called if the girl had shown any symptoms of unsoundness of mind on her return home. It would be straining the matter too far to assume that the prisoner was not in possession of sufficient reasoning faculties at the time this was done. The main question would be whether the child was alive when thrown into the pit, and was wilfully thrown down for the purpose of destroying its life.

The Jury after some minutes spent in consultation, requested liberty to retire and they were accordingly removed under the usual protection from communication with others. In half an hour they returned; their verdict was that the prisoner was guilty of wilfully throwing the child alive into the pit, but they recommended her to mercy.

His Lordship enquired upon what grounds the recommendation was founded. A juryman replied – "We think her sufficiently sound in mind to be responsible for her actions, but we think she was not sufficiently so to resist the temptation."

His Lordship having put on the black cap proceeded to pass sentence, the prisoner meanwhile exhibiting much alarm and agitation. He said –The Jury have, after a careful consideration of the evidence, convicted you of the crime laid to your charge; nor can I come to any other conclusion than that you have been, as was said to you by some of the witnesses, that cruel mother capable of destroying your own offspring. The Jury consider you to be a person of sufficient intellect to be responsible for your own actions, and have found you guilty, but not enjoying the same amount of understanding bestowed upon the majority of mankind, have thought fit to recommend you to mercy, and that recommendation shall, of course, be duly forwarded to her Majesty's advisers; but I should be sadly misleading you if I instructed you to hope that the terrible sentence I shall have to pronounce will not be fully carried into effect. (The prisoner here threw herself upon the shoulder of a female who was attending

her and hid her face.) On the contrary, I am bound to tell you it is extremely probable. At present I see no reason to doubt it – that the dread sentence of the law will be executed. [Sensation] You are indeed in a fearful position. It is a dreadful thing to see a young woman in the very prime of life and apparently in full health, now standing before me, who yet within a few short weeks must suffer a violent death. I know not whether you are now calm enough to listen to what I have to say – it shall be but little. I have no authority – no commission to tell you what to fear or what to hope for in the future – to hope for beyond the grave. (The learned Justice appeared too much affected to proceed without frequent pauses.) Here, I have told you, you have little hope; but if you have never listened to religious instruction, I pray you to do it now. There is always a person appointed to administer such instruction to persons in your situation and to afford hope and consolation to such as are truly penitent. To his care I resign you during the remainder of your days, trusting you will fully profit by the teachings he will, according to his sacred office, be authorised to give. I will not make any observations upon the dreadful crime you have committed. It is unnecessary that I should try to excite detestation of your crime in the mind of anyone here. No one can fail to be impressed with the horrible nature of the offence – that of wilfully destroying your own off spring. I trust your sad fate will be a lesson to all who depart from the course of virtue. We here see the terrible consequences, which result in one false step, and the terrible temptation, which result. The sentence of the Court is, that you be taken hence to the place whence you came, thence to the place of execution, and that there you be hanged by the neck until you are dead; after you are dead, that your body be buried within the precincts of the prison in which you are confined, and may the Lord have mercy on your soul.

The impressive manner in which this sentence was delivered by his Lordship had a visible effect upon every one present. There were no female spectators to give way to violent grief, but tearful eyes and serious looks amongst the rougher sex who formed the audience, indicated the presence of excited feelings throughout the Court. The prisoner being insensible towards the conclusion of his Lordship's address and at its termination was carried below in the arms of a stout officer of the gaol.

*Worcester Herald*, Saturday 31 July 1852

THE CONVICT MARY ROBINS. – Since our last, a petition to the Queen praying for mercy for this unhappy creature has been extensively signed by Magistrates of this county and city, Clergy, and citizens generally. The petition was also signed by the High Sheriff, who kindly undertook the duty of transmitting it to the Home Secretary, and it is to be hoped that the benevolent object of the petitioners will be attained. There is no marked change in the demeanour of the

wretched woman; she remains apparently under a proper apprehension of her awful position, and she does not deny her guilt, but says the deed was done in a state of distraction, not knowing what she did.

The following letter has been addressed to us by a gentleman intimately versant in the administration of the criminal law, and one of the last persons, we should say, to write as he does accept under a deep conviction that there are mitigating circumstances in this miserable woman's case, which, if they do not entitle her to mercy, yet ought to justify its extension to her, even in the eyes of those who deem the example of public executions as of a salutary tendency:–

TO THE EDITOR OF THE WORCESTER HERALD.

Sir, – I am induced to address you in reference to the case of the female under sentence of death in our county gaol, and upon whom the law is, at present, left to take its course.

The facts in reference to the dreadful crime she committed are soon told. In fourteen or fifteen days after her confinement in a Union workhouse she was allowed to depart in a very weak state of health, in body and mind, as proved on her trial, with her infant, which was subject to convulsions. Having in this weak state travelled on *foot* a distance of ten or twelve miles, she sits down, *fatigued and exhausted*; her infant's convulsions returned; she had no place to go to, her father having declared he would not receive her; and thus driven to despair, and no doubt distressed in mind determined to pursue a course which would prevent her infant sharing her sorrows and difficulties. Either a Union workhouse or the open air was the alternative, and the latter with no means of support!! This was her position! In the sorrowful, difficult, and distracted state of mind she committed the dreadful crime for which she is sentenced to die.

I ask whether under such circumstances a public execution of this poor wretched woman will create any other feeling than that of sympathy in the public mind? Are not the circumstances stated of a mitigating character? Are they not stronger, or at least as strong, as those, which have operated in modern times to save the lives of those who have been convicted of similar crimes? (No doubt you could supply instances.) Why then should this poor wretch be made an *exception* from that clemency which has of late prevailed in similar cases where such circumstances of mitigation appeared? Of late Judges have interposed their influence to save the forfeited lives of poor wretches convicted before them, and who have been driven to desperation in the same way as this wretched woman was; and in this case the JURY RECOMMENDED HER TO MERCY.

After what has of late been done in cases like the present – the lives of the culprits spared – it would seem to be something like *caprice* to hang this wretched woman. Surely, therefore, an immediate application should be made to Mr. Justice Cresswell (who is not wanting in feeling of humanity), before whom she was tried, in furtherance of a petition to the Queen, already forwarded, and signed by several county and city Magistrates and others who have expressed

# THE
# Sorrowful Lamentation !

*Of Mary Robins, 25, under the Sentence of Death in Worcester Gaol, for the murder of her infant at Kingswinford, June 21st. 1852,*

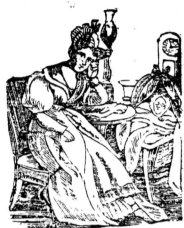

Ye tender hearted Christians all,
  Come listen unto me.
While I relate a tale of woe —
  Which ends my misery.
Mary Robins is my name,
  And dreadful it is known :
For the murder of my infant child,
  Would melt a heart of stone,

Murder is my awful crime.
  And is denounced by heaven,
And on my head my infants blood,
  I hope to be forgiven.
So I was apprehended,
  To Worcester sent with speed,
And now I'm doom'd to suffer,
  all for this dreadful deed.

At the last Worcester assizes,
  I was placed at the bar,
That I was guilty of the deed
  the Jury did declare !

The Judge the sentence passed on me.
  and then to me did say —
" For the murder of your infant child,
  " You must die upon the tree ! "

In a dungeon dark, in irons bound.
  I bitterly do weep,
The midnight bell, the thoughts of death
  deprive me of my sleep.
The ghastly form of my infant babe.
  appears fresh before my sight,
Strikes terror to my guilty soul,
  amidst the shades of night.

My old companions all I pray,
  take warning by my fate.
Beware of murdering's fatal sway,
  before it is to late.
For in good thought you all must keep,
  and shun such wicked ways,
The thoughts of death makes me to weep
  in these my latter days

My life is forfeit to the laws,
  For the deed that I have done,
Good people all — pray for me.
  When I am dead and gone.
May the Lord have mercy on my soul,
  Have mercy Lord, I pray,
When I appear before thy throne,
  On the Judgement Day !

Wright. Printer, Birmingham.

The original source of this poem is unknown, it was discovered at Worcester Record Office. It is definitely about the same Mary Robins mentioned on the previous pages, except it is inaccurate, in-so-much, she did not kill her daughter, Lucy, at Kingswinford. The author has probably mixed up his Oldswinford with his Kingswinford, when in fact the murder took place at the Hayes in Lye, which was previously in the parish of Oldswinford.

their opinion, and who see no good in taking the life of this wretched woman.

Do not suppose, Mr. Editor that I desire this malefactor to go unpunished, or that I feel anything short of abhorrence in reference to her crime; no such thing. I feel strongly that her execution will only create sympathy, as her present position does very generally, and will have no beneficial effect by way of warning; that her case contains circumstances of great mitigation; that effect ought to be given to the recommendation of the Jury; therefore that her life ought to be spared, especially as it would only be consistent with what has been done in many similar cases.

I hope the feeling of the citizens of Worcester and its neighbourhood will be roused and expressed to the learned Judge in this case, and I feel assured that that course is the only effectual one to be pursued.

I am, Sir, Your obedient Servant.        C. July 28

A number of similar letters can be found in the newspapers of this time relating to the same subject.

*Worcester*, Saturday 7 August 1852
The Convict Mary Robins. – It is with heartfelt satisfaction that we now state that the High Sheriff received a despatch from the Home Office on Thursday morning, intimating that her Majesty had been graciously pleased to grant commutation of this wretched creature to Transportation for Life. Intelligence of this great change in her position was communicated to the convict. The community of this city and of this county owe a heavy debt of gratitude, for their escape from the disgrace, which would have been entailed by the public execution of such a woman.

In the last Herald it was stated that a partition to the Queen for mercy, signed by the Magistrates, Clergy and others, had been transmitted to her Majesty by the High Sheriff; it was pointed out that the Judge who tried the convict should be appealed to, setting forth the circumstances existing in her case and we now add that after the proceedings were adapted, they have happily proved successful.

On Friday Mr. Curtler went to Stourbridge to investigate the case, and there communicated with Mr. Robins the committing Magistrate, Supt. Burton, of the police, the surgeon who had examined the convict and the Magistrates who usually act for the district. Mr. Robins had on Monday previous, written to the Home Secretary, representing how useless the execution would be in point of example, from the general feeling of sympathy that existed in her favour.

[William Robins, no relation to Mary, was a Stourbridge Banker in partnership with Hill and Bate, owning the Old Bank on the corner of Coventry Street and High Street, known as 'Hill, Bate and Robins'. He was also High Sheriff of Worcestershire in 1843.]

His opinion may be inferred from the following passage in his letter: – "When the unfortunate girl was brought before me for examination, she appeared

to be very weak in intellect, and had it been my province to try her instead of committing her for trial, I should have felt indisposed to hold her responsible for her conduct." Supt. Burton stated that he had known her for years, she was of weak intellect, a "very soft one", not able to resist any persuasion, or to form any judgement of her own. He did not believe she premeditated the murder, or else she would not have carried the child twelve miles to a place within sight of her father's door. His Lordship recommended that the memorial presented to him from the citizens of Worcester, should be transmitted to the Home Secretary, which was done on Tuesday; and we only to add, that eventually these efforts have resulted in the extension of mercy to the unhappy woman.

Above is the convict ship the *William Bryan*, which carried female convicts to Australia. It was built in Southampton in 1816, weighing 302 tons. It sailed on 4 July 1833 from London to Hobart, Van Dieman's Land, taking 111 days and carrying 130 female convicts. Photograph by kind permission of the Archives Office of Tasmania. Reference 30/403.

Mary Robins sailed from Woolwich on 27 November 1852, bound for Van Diemen's Land (Tasmania), on board the *Duchess of Northumberland* together with a further 218 female convicts. After 144 days, they arrived at Hobart on 21 April 1853.

Above is the Convict Record of Mary Robins, it is printed here with the kind permission of The Archives Office of Tasmania, who are the copyright owners. It states she was tried at Worcester ASS. 17th July 1852 – Life S. Arrived 21/4/53. Wesleyan Re. Transported for Wilful Murder of – Single 2 children, Stated this offence. Destroying my own Child 14 days old. Sentenced to Die but was reprieved Single 2 children. Surgeons report good. Described as a Needle Woman, 4/11¼ tall, aged 26, hair light and blue eyes. Native place – Worcestershire.

Remarks – Left wrist burnt – Subject to hysteria. Ticket of Leave 13/1/57. Conditional Pardon 27th Sept 1859. Her Record states she had got two children. Children were not normally transported with parents.

She married Edward Wells, at Launceston 27 September 1854, a convict sentenced to 7 years for embezzling £8-6-0 at Nottingham. They had three children, all boys. Edward died at Kingston in 1861.

Mary married William Turfrey, a widower, also a convict, sentenced to ten years, at Oxford for burglary, by whom she had two children, one a girl she called Lucy. Mary Turfrey (Robins) died at Ranelagh near Hobart, 21 November 1903, aged seventy-six years. Her daughter Lucy married Charles Brown in 1881 and Ernest Wagg in 1899. She died in 1943.

Burns of the above nature would suggest she was a nailer, back in Lye. A Conditional Pardon, allowed her to freely move around the colonies of Australia, but not to return home to England.

# MURDER OF MARY ANN MASON

*Berrow's Worcester Journal*, 21 July 1855

MEADOWS, Joseph, aged twenty-three, whitesmith, was indicted for the wilful murder of Mary Ann Mason, [who was said to be 17 years of age] at Dudley on 12th May.

The prisoner was a short, thick-set man, about 5 feet 4 inches in height, with a pale complexion, no whiskers, and a wild restless eye. When called as to how he pleaded, he said "Not guilty."

Mr. Huddleston prosecuted, and very briefly stated the facts of the case. The prisoner had been anxious to pay his addresses to a young woman, a domestic servant, named Mason; but circumstances having come to her knowledge not very creditable to his character, she declined his acquaintance, and took a situation at some distance away in order to avoid him. He however found her out, that she was in service at the "Sailor's Return Inn", Kate's Hill, near Dudley, and paid her several visits there, but without effecting any change in her determination. Early on the morning of the 12th May, the prisoner, actuated either by jealousy or revenge, obtained a gun from the house of his master, loaded it and proceeded to the Sailor's Return. There was some other men in the kitchen at the time, while the deceased and her mistress were cleaning the room; the prisoner took the opportunity of the temporary absence of the mistress and the inattention of the men in the room to fire the fatal shot, which almost instantly took away the young woman's life.

Mr. Cresswell, who was with Mr. Huddleston, then called.–

William Ingram. – I am a miner at Kate's-hill, near Dudley. On the 12th May, between seven and eight in the morning, I was at the Sailor's Return, with William Robinson. Prisoner was there, sitting in a corner between a window and the fire-place, the mistress and the servant were mopping the house at the time. The report of a carbine arrested my attention. I went to prisoner and said "Oh, you rogue, you have murdered that wench; you have shot her." The girl had fallen on

the floor, and prisoner was in the corner; he said "I have got another revolver in my pocket," I remained with him, and sent for a policeman.

Cross-examined by Mr. Kettle for the defence.– It was after eight o'clock when we first went into the house. We went into the kitchen. The prisoner had a cup of ale by the side of the fireplace. The mistress had just left the kitchen when the carbine was fired. I was perhaps about half an hour in the house before the carbine was fired. I had not seen the carbine before.

Mary Hunt, wife of the landlord of the Sailor's Return.– Prisoner was at our house on the 11th May, about ten at night. Mary Ann Mason was in my service. She passed as his sister, and had been nearly seven weeks in my service. When he came in on Friday evening she went on with her work, and did not speak to him. On Saturday morning, shortly after seven, he was in the kitchen, and had a pint of ale. I had been helping to clean the kitchen with Mason. I went out of the kitchen for a bucket of water, and when I came to the door I saw the prisoner levelling a carbine, and the flash came in my face. Prisoner was standing at the time. I called the master. The girl fell towards me, and breathed about 13 minutes, and then died. The shot had struck her under the left ear. My husband came in and collared the prisoner. The only words I heard the prisoner say were, "Now I am satisfied."

William Robinson was at the Sailor's Return between eight and nine o'clock. I sat against the window in the tap-room. The mistress, the servant, and the prisoner were there. I was about a yard from him. I heard a report, and turning round saw the girl fall. The carbine was on the floor by me. Prisoner picked it up, and I took it from him. When I took the carbine from him he said, "she should have given me an answer."

Cross-examined.– Deceased was in a stooping position, mopping the room. When the shot was fired, he was about six or seven feet away.

Joseph Jewkes, Police superintendant at Dudley, was called in by Robinson on the morning in question. Took prisoner into custody, and saw that the girl had received some shot wounds near her ear. Mr. Meredith, surgeon, was in attendance. I produced the carbine and charged the prisoner with having shot his sister. He said "I did. I've had my revenge; I've heard 'em say revenge is sweet. I left home for that purpose; I've done it, and now I'm satisfied." I searched him and found a shot and powder flask, on the road to the station he said, "It's not my sister; it's a young woman I followed for about ten months. I was determined if I couldn't have her no one else should." I said "It's a pity you were not prevented, there being two men in the kitchen." He said "They hadn't a chance; I pulled the carbine from behind my back and fired it off in an instance; I threw it down to pick the girl up, but I was prevented."

William Hunt, landlord of the Sailor's Return, deposed that the prisoner first entered the house about ten minutes before seven. When witness heard the report, he ran into the kitchen and collared the prisoner who said, "I've done what I intended to do."

Cross-examined.– Saw nothing peculiar in the prisoner's conduct on the previous night. When something was wanted in the kitchen, the girl asked her mistress to go in instead of her, as she did not want to see her brother, who had caused her parents many a score of hours of uneasiness. I said he was the biggest sawny [a simpleton] I had ever seen; he would not drink out of the glass I took him, but wanted a larger one. I saw nothing mad about him. He drank his ale, and asked me to drink with him.

Joseph Rann.– I am a whitesmith at Round Oak. Prisoner was articled to me for four years, of which two years are expired. On the Friday night he did not come home until two on Saturday morning, when he seemed intoxicated. I left him on the sofa. Next morning I went downstairs at seven, and he was gone. Afterwards I went to the gaol, and saw him. I said, "You've done for yourself now," and he said, "I intended to do it before I started." The carbine is mine, and so are the powder-flask and shot case.

This was the case for the prosecution.

Mr. Kettle then addressed the jury at some length, and with much earnestness for the defence. He was certain they would feel a manly thankfulness to him if he showed them a path by which they might escape from giving a verdict, which would consign the prisoner to a painful and ignominious death. For this end, he begged them to accompany him through his analysis of the evidence. The testimony divided itself into two kinds – first, of words spoken, and then of deeds done. There were no words spoken until after the flash of the gun, but he would consider the words first. Having commented on Mrs. Hunt's being called now for the first time as a most serious disadvantage to the prisoner. On the night before, the prisoner was in such a state of idiotic inebriety that he could not find the way to his own bed. He had a drink again at seven o'clock in the morning and was as if his life depended on his drunken utterances that morning. There was no evidence that there was any extraordinary attachment on the part of the prisoner to the deceased girl. But if that was so, there certainly were evidences that that attachment was reciprocated. She was a well-conducted girl, and as such could only have deceived her master by representing herself as the prisoner's sister for the sake of having favoured interviews with him. The prisoner took the carbine not loaded but with the ammunition and caps for loading it, not for the purpose of assassination, but with the intention of loading the gun before the girl and threatening in his drunkenness to shoot himself for the purpose of obtaining, as he said to one of the witnesses, an answer from her.

Up to the very commission of the act everything tended to show that he did not intend to take away the life of his sweetheart. On this theory he left the matter to the jury.

The learned Judge then digested the evidence. His Lordship then went through *seriatim* the whole of the evidence of the various witnesses, remarking that there was no proof of any acts or words on the part of the prisoner that indicated insanity. There appeared to be no doubt of the prisoner having fired the gun,

and it was for the jury to say whether that act had been done wilfully and by deliberate intention.

His Lordship's address entirely removed every prop of defence – weak as it necessarily was – from the case, and in about one minute after its close the jury returned a verdict of GUILTY.

The Judge then put on the black cap and said – "Joseph Meadows, you have been charged with the dreadful murder of Mary Ann Mason, to whom you appear to have been for some months attached. You have been defended by the ability and eloquence of learned counsel. You have at last been convicted by an attentive and impartial jury; and I will only say it is one of the clearest cases which, according to all experience I have ever had, or by my reading become acquainted with, that ever appeared for decision in a criminal court. You appear to have taken offence at some part of the conduct of that poor girl. It may be that the expressions that were dropped to the relative to the payment of a weekly sum by you towards your illegitimate child may throw some light on what has occurred in this sad transaction. It may be that, on her becoming acquainted with that part of your conduct of which she had been previously ignorant, she may have expressed a determination, which led you to do this deed. There can be little doubt that you were set on this dreadful course the night before the event happened. You rose in the morning, and proceeding from your master's house, armed with a deadly weapon, you took the opportunity when the mistress was absent and the two guests in the kitchen inattentive, and you fired the fatal shot which in a few moments deprived her of existence. It only remains for me to pass on you the awful sentence of the law, and that is, that you be taken to the place from whence you came, and from thence to the place of execution, where you will be hanged by the neck until you are dead; and that your body shall be afterwards interred within the prison where you shall have last been confined previously to your execution."

The prisoner, on hearing his awful fate, displayed no emotion; he turned and rapidly disappeared down the stairs to his cell.

The Court rose before six o'clock.

Worcester, 11 August 1855

Execution of Joseph Meadows for the Murder of Ann Mason

During the week the excitement remained, with the space in front of the prison being daily thronged like a fair with idle and curious people.

Eight o'clock on Saturday morning was fixed for the execution. Soon after daylight, people began to assemble in the space in front of the gaol and in the Infirmary Walk. Some of these had evidently come from the country, but the most were plainly residents in the city. By seven o'clock about a thousand had congregated, and from that time a continued influx of spectators arrived until eight, but the crowd was not so great as on the former occasions, and to the last there was plenty of room on the gaol side of the road for persons to pass freely along.

The middle and opposite side of the road, however, were crowded, and every spot commanding a view of the dismal drop was occupied. From the roof of the prison, when the fatal moment drew near, the scene was strangely peculiar. In every direction the ground was covered with people with their faces directed towards the scaffold in anxious anticipation. The concourse was chiefly made up of males of the working class, and militiamen, the red coats of the latter glaring very distinctly amongst the darker attire of their neighbours. Several individuals were pointed out to us as having come from distant parts of the county and remained perseveringly in attendance in Salt Lane [old name for Castle Street] day after day, in order to be present at the execution. Within the gaol, the prisoners, male and female would be drawn up in lines in exercising yards that commanded a view of the drop, all having their eyes riveted upon that gloomy looking instrument of death.

The place of execution was the roof of the gaol between the front entrance tower and the tower at the eastern corner. Access was gained to it by stairs to the top of the entrance tower, and an inclined plane of planking from the top of that tower down to the lower roof, on which the platform was built. During the Friday night the drop was erected upon this platform, and now stood out against the summer sky a most melancholy and dreary looking object.

The convict since his sentence had been confined in one of the day rooms in the centre of the prison, securely ironed by the legs to a strong column of brickwork that supports the roof. His chain permitted him a few yards of movement about the area. A warder remained with him night and day, and towards the latter end of the week two were present nightly in the cell. His last night of life was passed upon his bed, but sleeplessly. At five o'clock the next morning he took a breakfast of tea and bread and butter, with a good appetite. About half past six he was visited by the chaplain, with whom he conversed upon his approaching end, and prayer was offered up. The minister then retired for a short time, and at a few minutes to eight he again went into the room to deliver the last words of exhortation and hope. The prisoner never expressed any feeling of assurance that his sins had been forgiven, but he seemed to hope confidently for the reception of mercy through the merits of Christ. He frequently uttered the words, "Jesus, Son of David, have mercy upon me!"

A few minutes before eight o'clock, the convict was led from his cell into the yard. He was pale, calm and collected and dressed in a brown vicuna coat, a grey cloth cap, a pair of black cloth trousers and waistcoat, black woollen gloves and blucher boots. The lower buttons of his coat were buttoned. With one hand he supported the fetters with which his ankles were bound, and with the other he held a dark silk handkerchief before his mouth and the lower part of his nose. A procession was then formed, a number of javelin men in front; Mr. Walker, of Upton, the Under Sheriff, and Mr. Tymbs, of this city, acting Under Sheriff, bearing wands, following next. Mr. Stables, the governor of the gaol carrying a wand, followed, and the Chaplain in his gown, reading sentences from the burial service. Immediately behind the Chaplain

came the prisoner, with a prison officer on each side and two more officers closed the train. The prisoner walked with a firm steady step. On arriving at the entrance tower, the persons composing the procession proceeded, singly up the narrow stairs of the tower until they arrived at a landing, which is called "the pinioning room".

Here Calcraft, the executioner, was waiting to receive the culprit. The prisoner was motioned to sit down upon a folding stool, and on his immediately complying; the officers of the gaol unlocked and removed the irons from his legs. Then Calcraft went behind the prisoner and pinioned his arms behind him with a strap. Next he removed the prisoner's neck tie, and thrust it inside the wretched man's coat. These preparations made, he was conducted in the same manner as before to the top of the entrance tower. Whilst ascending the steps he requested Calcraft to be as quick as he could be over the work, and walked on as steadily and composed as before. Calcraft replied that it should not take a minute. As soon as the spectators outside caught sight of the criminal, a loud murmur of conversation arose, which almost instantly subsided and the crowd remained nearly silent, every eye fixed upon one object. The Chaplain accompanied his charge to the foot of the drop and then retired from the platform. The prisoner scarcely glanced at the crowd, but mounted the steps of the scaffold firmly by the side of Calcraft, who went up between the prisoner and the outside spectators. Then he placed the doomed man under the beam, and quickly performed the usual duties. Calcraft receiving from the prisoner another request that he would make it as short a business as possible, shook hands with him, descended from the drop drew the bolt and ended the life of the unfortunate culprit. Amongst the crowd there were some suppressed screams and moans and great sympathy was shown by the female prisoners within the walls. It was as near as possible to eight o'clock when the drop fell and in a few seconds all signs of life had departed from the body. Scarcely a struggle could be seen and it is supposed that his death was instantaneous. Calcraft reported that when at the last moment he shook hands with the convict, he could detect no weakness or tremor in him, and is of the opinion that the convict felt less agitation and excited than many of those whose duty brought them to the scaffold to see the law carried out.

The body remained suspended an hour, at the end of which period it was taken down and placed in a coffin without removing the clothing and during the day was buried within the precincts of the gaol, immediately by the side of Pulley, the last person hung at this gallows.

The crowd, which had behaved with the greatest propriety during the whole period of the gathering, quietly dispersed as soon as the body was removed from the beam.

When Meadows was old enough to go to work, he came to Worcestershire, where he found employment at a Mr. Hill's shoeing smith at Netherton near Dudley, with whom he stayed some time. Next he obtained a situation with Messrs. Keep and Watkins, spade makers, Stourbridge. During his residence in

Stourbridge he formed an acquaintance with a young woman named Kimberley, the result of which was an illegitimate child. Sometime after the birth of this child, Meadows was summoned before the Magistrates as the father, and he was ordered to pay 1s.9d. per week towards the maintenance of the child. Subsequently he neglected to comply with this order and a warrant having been obtained against him by Kimberley, he was taken into custody and committed to the County gaol for a month. When he obtained his 21st year he articled himself for four years to Mr. Rann, a white smith at Round Oak, and made considerable progress in the business. He lived in his master's house and was well treated, but his habits were dissipated and irregular and he frequently stayed out late at night. It was during his stay with Mr. Rann that he became acquainted with Mary Ann Mason, a young woman then in the service of Mr. Comoli, at Dudley. The acquaintance soon ripened into courtship, though it is probable that the woman's affection was checked in its development by discovery that the disposition and habits of her lover were not as would lead to happiness in the married state.

Mary Ann Mason, towards the latter end of April last, moved from her situation to another at the "Sailor's Return", Kate's Hill, near Dudley, probably with the intention of avoiding his visits. Meadows, however, followed her to this house and visited her several times. On such occasions he passed himself off as her brother, the woman herself assisting in the deception. At length, perhaps from receiving indubitable intelligence of his former *liaison* with the female at Stourbridge, she evinced a determination to break off the courtship. This conduct on her part appears to have produced a powerful effect upon his mind and having brooded upon the matter until disappointed love and jealousy rendered him furious and utterly contemptuous of life, he sought her presence and committed that foul deed for which he has now suffered so shocking expiation. The Sailor's Return is a very respectable house in the best quarter of the district called Kate's Hill.

ERECTED
BY
VOLUNTARY SUBSCRIPTION
To the memory of
MARY ANN MASON
*who was murdered by Joseph Meadows*
*on the 12th of May 1855.*
Aged 17 Years.

The grave of Mary Ann Mason can be found in the graveyard of St John the Evangelist Church, at Kate's Hill. It is said that it is the only known grave in England of a murder victim that names the murderer.

# MURDER OF SOPHIE OCKOLD

*Berrow's Worcester Journal*, 20 December 1862

The Commission for the holding of the Winter Assizes for the city and county of Worcester was opened on Wednesday last by Mr. Justice Mellor, the Judge who takes the Oxford Circuit. His Lordship reached the Shrub-hill Railway Station by the afternoon train, from Shrewsbury and at the station was received by the High Sheriff of the county, Sir E. H. Lechmere, Bart. The learned Judge then entered the High Sheriff's carriage, and, escorted by the javelin men, proceeded to the Shirehall, where he lunched and robed. He then opened the commission for the county and afterwards drove to the Guildhall.

## WIFE MURDER AT OLDBURY

*William Ockold*, aged 69, tailor, a white-headed old man, was placed upon his trial, charged with the wilful murder of his wife, Sophie Ockold, on the 8th November, 1862, at Oldbury.

Mr. Richards, in opening the case, for the prosecution, said the prisoner at the bar stood charged with the wilful murder of his wife Sophie and that he (the learned counsel) was quite sure that the jury would therefore give the case their best consideration.

The first witness was then called.

Maria Grazebrook, stated I know the prisoner and I know his wife Sophie. On Friday, the 7th November, I went to their house, and saw the deceased. She was sitting on the floor with her head on the bench. She was groaning very much and appeared to be in very great pain. I asked her if she could take a cup of tea or some broth, and she said no. The prisoner said "No, she does not want a drink, she wants to go to bed so that she may lie groaning and keep me awake again as she did last night, but she shan't again tonight."

On the following (Saturday) morning, about twenty minutes to nine o'clock,

I again went to their house with Mrs. Woodall. Prisoner was sitting on the table sewing. I said "good morning grandfather, how is grandmother this morning." He said, "I don't know." I asked him where she was, and he said, "I don't know." When he said that, I noticed his hand was bruised and stained with blood. I then said what's that. He studied a little while and then said "its from giving her a punch in her mouth." I said, "giving her a punch in the mouth, whatever did you do that for, she was ill enough without you doing that." He said, "For going off and getting drunk with that Jack Hadley." I said, "Why you know she was not able to walk across the house, let alone go and get drunk." He said, "Well her was quite drunk, and I didn't know about it until this morning." I then said, "Where is she?" and he said, "I don't know." I said, "Is she in bed?" he replied, "I don't know." I went towards the stairs, he said, "You ban't a going upstairs," and I said, "I don't want to." I then called "grandmother" four times, but received no answer. I then ran upstairs, but when I got to the top of the stairs, I saw Mrs. Ockold lying on the floor. Her face was covered with blood. She lay on her back, with her face uppermost. Her right arm was bruised very much, and the skin was off it. The blood upon her face was getting dry. When I got down, I saw the prisoner, who was sitting on the table, and I said, "You old brute, you have killed that old woman." He said "Her ain't dead, is er?" and I said, "She is, though." He said "Her is not dead, her's only asleep" I said, "Yes, her is quite dead." He replied, "Her's only asleep." And I said, "She'll never wake up again." The prisoner then went upstairs and Mrs. Woodall and I heard something dragging along the floor. I then fetched Simmons, the policeman, and Mr. Cooper the surgeon, and just before Mr. Cooper's coming I went upstairs again with Simmons and we saw the body lying on the bed. I picked up some grey hairs, like the old lady's. Simmons, took the prisoner into custody. On the table where the prisoner was sitting, I saw part of a mopstick. It had the appearance of having been split off recently. It was the part of the stick where the mop had been attached.

Thomas Ockold, stated: I am the prisoner's son. I went to my father's house on Friday evening, the 7th of November. It was about seven o'clock when I got there. I saw my mother, sitting on the bench; she appeared to be very ill. My father was getting her a cup of tea. I supported her head while she had a cup of tea as she could not hold it up herself, deceased said something about having had a stroke. I carried her upstairs, and put her to bed, she could not walk, and I carried her upstairs quite easily. I then went downstairs. Prisoner was standing by the fire, and he said if her lived to the 3rd of May they would have been married fifty years. The following morning I was fetched to the house, and got there about nine o'clock, my mother was lying on the bed dead. On the Friday evening the prisoner seemed kind in his manner to deceased, and he said he hoped she would get better.

Lavina Woodall stated: I went on Saturday morning, the 8th of November, to prisoner's house with Maria Grazebrook. Prisoner was standing by the fire and

I asked him if we could go up and see the old lady and he said "Yes, you may go up if you like." I saw Maria Grazebrook pick up some hair. It was woman's hair. She gave me the hair, and I gave it to Mrs. Weston. The hair resembled the old lady's. There was blood on the steps. I observed that there was a severe blow on deceased's temple. There was blood upon one of her arms and the skin was off, I saw part of a mop's stale on the table, which appeared to have been freshly broken.

Hannah Forrester, landlady of the Royal Oak public-house, Oldbury, said: I know the prisoner and I knew his wife, on Friday night, the 7th at about ten o'clock, he came to my house and had some beer. He said, "You know that my old woman is very ill." I said, "No," and he said, "Yes, she is very bad indeed. He finished his drink and went away. The next morning, at about twenty minutes to eight he came to our house again, and I asked him how the old lady was. He said, "Oh, I have laid her straight upon the floor." I replied, "She is not dead, is she?" He said, "No, but I've give it her." I said, "What for?" and he said, "Why, bad as she was yesterday afternoon, she got up and dressed herself, and went off along with that Jack Hadley and she got so drunk she could not find her way home, and when she was at home she did not know where she was." I said, "Oh, you should not have done that."

P.C. Daniel Hutchins said: I was on duty on the night of the 7th and morning of the 8th of November, in Halesowen-street. As I passed by prisoner's house I heard him downstairs cursing and swearing and making a great noise and he seemed to be cursing at someone upstairs. I heard groans upstairs. I went away and in about 10 minutes returned, when I heard someone whom I believe to be the prisoner, go to the foot of stairs. I listened and heard prisoner mock at the groan. He said, "You ---- old cat; you are very bad I daresay; but I never knew you when you were any good," adding "D--- your old eyes, if you don't come down stairs I will ----," but the rest of the sentence I did not hear.

Jerimiah Bradley, a labourer, said: I live in Furnace-road, Oldbury and about four o'clock on the morning of Saturday, the 8th November, I was at my stables. I heard a noise, which came from prisoner's house and I went to the door of the house. I heard prisoner using very bad language to the old lady. He called her an old ---- The old lady appeared to be downstairs, and I heard her say "Oh, Bill, don't kill me, for my head is ready to split." She said that as many as three or four times. The words the old woman used were "Oh, Bill, don't kill me."

P.S. Samuel Simmons said: that on the 8th November I went to the prisoner's house about nine in the morning. The house was full of people, and I said to Ockold, "This is a bad job," and he said, "it is." I went upstairs and saw deceased lying on the bed. She appeared to be dead, and the face was covered with blood. I came down stairs, and took the prisoner into custody. I then removed him to the station and charged him with wilfully murdering his wife. He said "I only struck her once." I then made an examination of his person, and saw that there

was some skin off the forefinger of the right hand, and before I had spoken he said "I did that against her teeth." I observed the mouth of the old woman, and saw that she had not got any teeth. I then examined his shirt and trousers and found blood on both. I went back to the house and examined the stairs and found blood upon them. There were large patches of blood on four or five of the steps. In the pantry I found part of a mop stale. There was blood on the bosom of the shirt, and on the shoulder. In the station the prisoner said his wife had been drinking along with Jack Hadley, that she had come home drunk, that she would not get up to get him any breakfast and that he had been at work all night. He said she had been drinking at James's. I think he repeated more than once that he did not do it wilfully.

Mr. Thomas Richard Cooper said: I am a surgeon at Oldbury, during November last I was attending Mrs. Ockold for disease of the kidneys. I remember being fetched to Ockold's house about nine on the morning of the 8th November. When I got to the house I saw the deceased who was quite dead, but the body was warm. I should say she was 74 to 75, from her appearance. On Monday the 10th I made a *post mortem* examination of the body. On removing the scalp from the skull I found several patches of congestion there was also a slight quantity on the right side. On opening the head I found a clot of blood on the left side of the surface of the brain. There was about an ounce of blood. I found the arch of the cheek bone broken. The other cheek bone was healthy. In my opinion the injury to the arch of the cheek bone could not have been caused by a fall. Part of a mop stale would inflict the injuries. I think the deceased was struck more than once. The injury to the right cheek certainly could not have been caused by a blow from the fist. The heart was healthy and the lungs slightly congested. There was an abscess in the kidneys. The cause of death was pressure upon the brain, from an oozing of blood from a ruptured vessel, ruptured by a blow from some heavy blunt substance. I should say that when I first saw the body deceased had been dead three of four hours. A less degree of violence might be required to break the cheekbone of a person of deceased's age than that of the young person. I am quite sure deceased had no teeth. I think the blow on the cheek would cause death. It would cause the rupture of a vessel in the brain. I think such a blow on the cheek on anyone would be likely to cause death. The injury to the temple may have been caused by falling downstairs, but certainly not the injuries to the cheek. The injuries to the cheek might have been caused by a heavy fall against a sharp post. It is possible that a person flung from a higher to a lower level might meet with such an injury.

This was the case for the prosecution.

Mr. Benson then replied for the defence, and in the course of an eloquent address, claimed the sympathy of the jury in the arduous and responsible task that had fallen to his lot. He asked their indulgence to all the suggestions, which he should make to them on behalf of the unfortunate old man whose life was in

their hands, but in the interests of justice he called upon them not to be led away from the right path by the thrilling tale of horror, which his learned friend had brought before them. The law was jealous of life, and the law, if wilful murder be the verdict, was inexorable in demanding a life for a life. He contended, however, that in the eye of the law there had been, in this case, no murder. Let them look over the facts of the case, not as they had been brought before them on the part of the Crown, where everything had been done to blacken the evidence against the prisoner, and to conceal that which would speak in his favour – but in a fair and impartial way – not that he blamed the counsel for the Crown, for they had but followed out their instructions. There was always a motive for a murder, but what was it here? Why there was none, positively none, for the death of the poor old woman would absolutely tend to deprive the prisoner of his means of livelihood, for as they had heard from one of the witnesses, the old woman did half his work. He did not ask them, as sensible and reasoning men, to disbelieve that the poor old woman met her death at the hand of this wretched old man, but what he sought to prove was, that he had done no murder. The learned counsel then proceeded to go through the whole of the evidence minutely, criticising every portion of it, and putting it to the jury whether, supposing the prisoner knew he had killed the deceased, it was not extraordinary that he made no attempt at concealment, or that he did not prevent the witness, Maria Grazebrook, from going up into the bedroom, when he must have known that that battered corpse of the poor old woman was lying there. In conclusion, Mr. Benson said the old man now prayed him to make the same assertion as to his innocence of murder that he did when he was first charged with the offence. There might have been a sudden struggle in the dark in the bedroom, when in a moment of blind rage prisoner struck his wife and had gone down stairs in ignorance of the awful result. In that case their verdict would be manslaughter only.

The Learned Judge, in summing up, said the jury had already been told by the learned counsel engaged in the case, that a charge of wilful murder was one which required their most careful and attentive consideration. The killing by one person by another was a *prima facie* murder, unless the circumstances accompanying the transaction, or from evidence given on the part of the accused, was such as to reduce the crime to manslaughter. In deciding upon their verdict they must consider the provocation given not by words only but by the struggle, which might have taken place between the parties. But if the violence used was entirely on one side, it was murder. He quite agreed with the learned counsel for the defence who had conducted his case so ably, and who had exerted every faculty which man could use, that they must be very careful how they determined as to whether there was any act on the part of the woman. If there had been neither struggle nor contact, and the death blow was given by the prisoner, then their verdict would be one of wilful murder. They must take care not to jump to a conclusion so fatal to the prisoner to say that he was guilty of wilful murder, unless they were satisfied that

there was no conduct on the part of the wife, no struggle or contact so as to induce him to commit an act so deadly as that which he stood charged. The present was about the most important transaction that men could be engaged in, and the jury must deal with the matter fairly and according to the oath they had taken. On the one hand they must not be led away by any feeling of compassion, which might be excited for the prisoner, nor on the other hand, by any feeling of indignation. In his concluding remarks, the Learned Judge said he did not know that he had ever heard a case which was surrounded by more extraordinary circumstances and he then referred to the fact that when the dead body of the woman was first seen by Grazebrook, the prisoner was quietly sewing. If they believed that the violence used on the night that the woman met her death was not brought about by her in any way they would convict the prisoner of wilful murder; but, if, on the other hand, they were of opinion that the deceased's death was brought about by violence on the part of the prisoner with provocation, such provocation amounting to a struggle or a blow, or if death was the result of accident, such as a blow received in a fall, it would reduce the crime to manslaughter.

At half past three, the jury retired from the court to consider the verdict.

After an absence of more than an hour, the jury returned to the Court, amid the deep silence that prevailed.

The Clerk said, gentlemen are you agreed upon your verdict. How say you: Do you find the prisoner, William Ockold, guilty or not guilty.

The Chairman: Guilty.

Silence in Court having been proclaimed.

His Lordship assumed the black cap, and said, "William Ockold, you have been found guilty of the dreadful crime of murdering your own wife, to whom you have been married, by your own account, near upon fifty years. It is a most painful thing indeed to see a man at your advanced period of life convicted of such a crime – a crime against the wife whom you had sworn to love and cherish. The jury have recommended you to mercy and I shall take care that the recommendation is transmitted to the proper quarter; but I have no power to hold out any hope to you. That power is absolutely vested in the person of the Sovereign. It is only from her clemency that any possible mitigation of your sentence can proceed. Whatever will be the course taken it is not for me to say and I should be deceiving you if I held out any hopes of a remission of your sentence. I beseech you, therefore to be penitent and by prayer, to apply yourself to the throne of mercy, where you may obtain that mercy which you denied to your poor, ailing and unfortunate wife; and that the short remainder of your days may be spent in preparing yourself for that doom which awaits you, when you must appear before that Judge before whom you must at last stand. The sentence, which I shall have to pass on you, is the sentence of the law. It is that you be taken hence to the place from whence you came and that from thence you be taken to the place of execution, and that then you be hanged by the neck

until your body is dead, and that your body be buried within the precincts of the prison where you were last confined, according to the provisions of the statute. May God, in His infinite mercy, have mercy upon your soul.

On receiving his sentence, he walked from the dock with a firm step.

Worcester, 3 January 1863

THE PUNISHMENT.

The gallows was erected on the roof area between the east and central tower of the gaol, and as it stood immediately opposite the Infirmary-walk, it was in the best position it could occupy to give room for the crowd of spectators at the execution. The apparatus was of the usual description, consisting of a platform and gangway and drop. Standing out against the grey sky at midnight on Thursday, the profile of the machine was revealed in all its hideousness. The night was a fearful one for the wind and rain and no doubt the weather had its affect in limiting the number of spectators from a distance, which on this occasion was considerably smaller than usual. By their appearance it may be inferred that the great bulk of those who came from a distance were residents at Dudley, Oldbury and the neighbourhood in which the murder was committed.

It was not until six o'clock this (Friday) morning that the spectators began to assemble, and as the morning wore on, the arrivals became more numerous and towards eight o'clock persons of all ages came pouring up in continuous streams. At its greatest the mob – for so we must call it, in the entire absence of any respectable person – consisted of between 4,000 and 5,000 persons and was remarkable for the number of women and children in it, being a far greater proportion than we ever before saw at an execution. To make the matter worse, many women and men too, had brought infants and children of tender years in their arms to witness the horrid spectacle.

Between six and seven this (Friday) morning, the condemned man rose from his bed for the last time and at the usual hour partook of a good meal of tea and bread and butter. Afterwards he was visited by the Chaplain, who remained with him for nearly an hour, exalting him to remember how soon he was to render up his account of all his earthly deeds. All the preparations for the execution being complete, at half-past eight the prisoner was brought forth from his cell to his death, outwardly he had the same quiet self-possessed air about him which he had all along borne. Very few who have outraged the laws of the country as he had done and who have had to suffer the stern but righteous sentence which awards a life for a life, have conducted themselves more firmly on the way of death. On the procession moving, the Chaplain commenced reading the burial service, which was continued until the eastern central tower was reached, by which means access was had to the gallows. The pinioning room was a chamber just over the gate warden's lodge and here a halt was made and the prisoner pinioned by Calcraft, the executioner.

About eight o'clock the attention of the spectators was arrested by the appearance of the Governor of the Gaol and the executioner on the scaffold, the death bell in the gaol, began to give out its mournful sounds. At half-past eight a few javelin men, took their position on the platform, and in a few minutes after the procession appeared. Ockold, followed closely by the executioner, walked with a firm step across the platform to the steps leading to the drop and when he turned his face towards the spectators a shudder seemed to run through all who looked upon him, the feeling found relief in a few smothered groans. The sight of this aged man, with his hard featured and pale face, white hair and whiskers and spare form, steadily ascending to the drop and then taking his place underneath the gallows, appeared to have an impressive effect upon the crowd.

The executioner at once proceeded to adjust the rope, and with some difficulty, owing to its tightness, drew the cap over Ockold's face. He then shook hands with him and the criminal's last words to him were, "I suppose I'm going now." As the executioner was descending the steps the sound of a groan from the convict's lips reached the crowd, and there was a cry of "hush" – the stillness of the grave followed. The sounds which issued from the wretched man's mouth and to those who were near took the shape of "Oh, Lord, have mercy on my soul! Oh, Lord, have mercy on me! Oh, dear! Oh, dear!" The bolt was drawn and the body fell with a sharp rebound; a hoarse murmur ran through the crowd and after a very slight movement of the legs and hands, the body settled into its position, death being almost instantaneous.

The culprit died very easily, but it was found when the body was removed that the halter had cut right through the skin of the neck.

The execution of the William Ockold in 1863 was the last public execution at Worcester, and all public executions ended in 1868. Execution was still the ultimate penalty for murder, which then took place out of sight of the public, within the precincts of the Gaol.

# MURDER OF CATHERINE GULLIVER

John Butler, aged sixty-two, had been the head lock keeper at Holt on the River Severn for almost twenty years and lived in the lockkeeper's house nearby. He had lost his wife some time ago and decided to engage the service of Mrs Catherine Gulliver as his housekeeper. At first they got on reasonably well together, but the relationship gradually deteriorated until they were outwardly hostile to each other, even when in the company of other people. On the night of Saturday 13 August 1864 Mrs Gulliver had been to the village to obtain groceries and beer and had spoken to a number of people about her poor relationship with Mr Butler. Later the same night shouts and screams of murder were heard coming from the direction of the lock.

The next day Mrs Gulliver was nowhere to be found and on questioning Butler he stated that she had probably gone to friends at Worcester. On 17 August a body was found below the lock and identified as that of Mrs Gulliver and carried marks of physical violence. He was arrested later the same day by police sergeant Matthews of Ombersley and confined to the lock-up there. He had previously threatened to put Mrs Gulliver in the lock (13 feet deep) and was charged with her wilful murder on the evening of 17 August 1864.

On 15 December John Butler appeared at the Worcester Assizes before Mr Justice Byles on a charge of wilful murder of Catherine Gulliver and pleaded not guilty. After a lengthy trial the jury brought in a verdict of guilty. The evidence given by the surgeon was inconclusive, did she drown or was she beaten to death before being put in the water? The only compelling evidence against John Butler was that there was bad blood between them and he had threatened to put her in the lock, but was it John Butler who did the wicked deed, or did she meet someone else that fatal night?

*Berrow's Worcester Journal*, 17 December 1864

## THE MURDER AT HOLT – SENTENCE OF DEATH PASSED.

Winter Assizes – Shire Hall, *John Butler*, 62, lockkeeper, was placed on his trial for the wilful murder of Catherine Gulliver, at Holt, on 13th August last. Mr. Richards and Mr. J. G. Watkins, were counsel for the Crown and Mr. Motteram was for the defence. On being arraigned, the prisoner pleaded not guilty in a firm voice. He was a hale looking man and was dressed in a white smock frock. [The Winter Assizes were additional to the Assizes held in March and July, and were only commissioned when extra work demanded them.]

Mr. Richards for the prosecution begged the jury to give this case, their most serious consideration, ignoring all what they might have previously heard.

The first witness called was. – .Wm. Ewers, boat-man, of Holt Fleet: on Sunday morning, 14th August about a quarter past five, I was below the lock, when I saw prisoner drawing up the bottom paddle of the lower gate. He drew it up 16 or 18 inches, as near as I could guess. The inside top gate was open. The raising up of the paddle would draw anything out of the lock that was in. A body would pass through the paddle hole. Witness had passed through a smaller one.

Henry Ewers, fisherman of Holt Fleet dragged the river below the lock on the morning of the 17th of August on the instruction of Police Sergeant Matthews, and found the body by the shore, 20 yards below the lock. He recognised it as that of Mr. Butler's housekeeper. He also noted she had a black eye and other bruises.

Mr. C. E. Busigny, surgeon, of Ombersley, said: he knew Mrs. Gulliver and he saw her body on Wednesday the 17th August. I examined the body externally and found there was a blow over and under the right eye, surrounding the eye. There was a bump the size of a walnut in the centre of the forehead. The right lower jaw was swollen and discoloured and might have been the result of a blow. With regard to the blow on the right eye, I believe it to have been caused before death. As to the other bruises I cannot give a positive opinion whether they were caused before or after death. The state of the lungs was congested. I found nothing in the air passages; not a trace of water, sand, or mud. Supposing a person to enter the water while there was the power of breathing left, there might or might not be water in the air passages. We should know there had been water from the frothy mucous. It is not essential we should find water in the stomach. In my opinion the cause of death was an injury arising from concussion and immersion in the water, producing immediate suffocation.

When cross-examined: he stated to have been in practice five or six years and there was no trace of beer or water in the stomach and supposed that if she had taken beer half an hour before her death he would have found traces of it. I hardly believed she could have had any. If it should be proved she did so drink beer his theory would not be upset, because she might have voided it. His

notion was the blow on the forehead produced a stunning effect. From the fact of there being no water in the air passage, and no frothy mucous, he was of the opinion that deceased did not breath after being immersed in water. If the subject was taken out with the head downwards, the water passing out might remove and obliterate the frothy appearance. The blow to the forehead might have been produced by deceased falling against some solid substance. If the person had fallen from the bank and was stunned by hitting against some hard substance, stupefaction would ensue and the glotis being closed, no water would pass in after immersion. Every mark except the black eye might have been produced after death. Numerous witnesses testified to seeing her between nine and ten o'clock on the night of the 13th, as she went from the grocery shop to the beer house, including the beer shop-keeper, who said she had a glass of beer, he said she was cheerful and unmarked. He saw her again about eleven o'clock and so did Mr. Thrupp, all said she was sober and appeared to be fit and well, but complaining about Mr. Butler.

Many of the local ladies were concerned about her disappearance and questioned John Butler as to where she had gone, to which he gave feeble excuses for her absence, which did not satisfy their curiosity. Many witnesses had heard her screams and shouts of murder from the direction of the lock and were willing to testify against Mr. Butler, but all seemed unwilling to go to her assistance.

John Harris, under-lock keeper, called and examined: My house is between 30 and 40 yards from prisoner's house. I sleep in the front room of my cottage. Have been under-lock keeper at Holt twelve months and have known prisoner thirty years. On the evening of the 13th August, prisoner was at home. I went to bed about half-past nine o'clock and was awoke by the voice of Mrs. Gulliver, who cried out, "Wha, wha," and said, "You d----- old scamp, you d----- old villain." The noise was from below our house and our window was open. I saw Butler about half-past ten, I saw no smoke from the house and I said, "Where is Mrs. Gulliver, has not her come back yet?" He said, "She have not John." I asked, "Was it not Mrs. Gulliver I heard in the night?" He said, "Yes, I was laid down in my bed with my clothes on, and she came to the door towards the middle of the night, and I went to open the door and undone it. She came in, in a dreadful passion and I think she seemed in drink. She threw the basket down, and the groceries went all over the place. On the night of the 13th, the lock was full, and the following morning it was full. During the twelve months, I have heard prisoner and Mrs. Gulliver have words lots of times. One night last winter I heard Mrs. Gulliver call out "Murder," and on running out, she said in the hearing of the prisoner, "The old devil has been beating me and I hallo'd murder to make him ashamed of himself."

Police Sergeant Matthews deposed that on 1st July, deceased came to my station and made a complaint. It was nine at night, I went straight down to the prisoner's house and said, "Butler, your housekeeper has been to my station and

has made a complaint that you have threatened to drown her in the lock." He answered, "If you will see her and ask her to forgive me, I will never threaten her again." P.S. Matthews continued that on the night of 17th August he went to the house of the prisoner, about nine o'clock. Prisoner, when he saw witness, said, "Oh dear, oh!" I then told him he was charged with the murder of his housekeeper and took him to the lock-up at Ombersley

This was the case for the prosecution.

Mr. Motteram then addressed the jury for the defence and said in a case like this it was quite unnecessary for him to invite their serious attention; while on behalf of the prisoner he made such observations as he thought necessary, in order to show them prisoner was not guilty at the charge laid to his door. He should not have to draw their attention more than once to the high character borne by the prisoner and the station of trust he had so long held, but he would say Butler was an old man, upwards of 60 years of age, who for more than 20 years had been in the service of the Severn Improvement Commissioners. He (the learned counsel) had no cause to complain of the way in which the case had been opened, but he should show that the evidence which had been adduced was not all conclusive and that it was by no means of that character upon which either they, or any other jury should be called upon to convict. No person had been examined to show by whose hand the deceased lost her life, neither had any witness been called to tell them the means by which she died. In the first place he should have to call their attention to the evidence of the surgeon, and the opinions he had expressed and without meaning any offence he must say it would have been far more satisfactory if that gentleman, before he had ventured upon that which he (Mr. Motteram) thought was a hasty opinion, he had instructed himself better on the matter he was examined about. Then they had no evidence as to the manner in which the deceased met her death and yet they were asked, on the opinion of one medical man, to consign ignominy and death to the old man at the bar. He should show that the opinion of the Surgeon expressed in cross-examination was widely different from that he expressed when examined. Then as to the motive by which prisoner could have been actuated? One of the principal things they looked for in cases of this kind was motive for the act, but his learned friend had not ventured to assign a motive. It had not been hinted by any one that any improper intimacy existed between the prisoner and the woman. No evidence had been adduced on the point and their duty was to believe that no such intimacy existed. Let them be assured that if there had been any evidence to that effect they would have heard of it. The woman was merely his housekeeper, who had no claim on him; and, if he wished to get rid of her, all he had to do was to give her a month's wages and send her away. There was not motive therefore; and, could it be supposed that he, an old man verging on three score years and ten, would imbrue his hands in the blood of the woman without a cause? In the first place the jury must be satisfied as to the manner in

which deceased met her death and that she met her end from the violence of the prisoner with malice forethought. Now, had they any reliable evidence of the way in which she died? The theory of the prosecution was, that deceased was beaten by the prisoner, stunned by a blow, and then thrown into the water and that theory was gone upon in order that they might not come to the conclusion that she died by accidental drowning.

The Surgeon said she received a blow that was mortal, before being put in the water, but he had propounded opinions, which he was not able to maintain in accordance with a received scientific medical work and the only medical evidence against him, was such as they could not rely upon, it was, in fact beneath them. They did not know that the woman was murdered at all, for her death might have been caused by her own act or by accident, and yet they were asked to say the old man at the bar was her murderer! He asked them to disbelieve that she was thrown into the lock; the prosecution did not believe it, for they had said they thought she was thrown into the water lower down, supposing that it was thrown in there at all? Well might the prosecution give up that theory and suggest that the deceased was thrown in below the lock. Then, what evidence was there, that deceased was ever in Butler's company after she left Green's beer-shop for the last time? He then proceeded to remark, that the answers given by the prisoner to Mrs. Green and the other "busy bodies," were answers that under the circumstances he might be expected to make. He did not ask the jury to believe that the prisoner was insane, they must give their verdict upon the evidence before them and that alone and seeing what that evidence was, he thought there could be little doubt what their verdict would be; and after calling before them the evidence he had to give of the prisoner's excellent character, he would conclude by praying fervently in the language of the law, that "God may send him a speedy deliverance."

At the conclusion of the address, which lasted a considerable time, there was some applause but this unseemly exhibition was at once repressed.

His Lordship then proceeded to sum up. He reminded the jury of their deep responsibility, and said it was their duty to acquit the prisoner or find him guilty of wilful murder, for upon the evidence there was no third alternative.

He read over the evidence to them at length, because in such a case he dare not trust to his own resume of it. He felt very much relieved by the address of the Learned counsel for the defence, who had urged everything that could be urged on behalf of the prisoner and they would give that address, as well as the speech of the learned counsel for the prosecution, the weight they thought they were entitled to. There was no doubt the unhappy woman Catherine Gulliver, met her death at the place indicated, then and there and whether she was stunned before she was put in the water so as to be unable to inhale, or whether she was put into the lock alive and in the full possession of her powers, did not appear to him to be of so much importance as had been supposed, for he thought that in going

through the evidence they would see that the time and place of death were pretty clear and that she met her death either by injury upon the person and immersion in the water, or by drowning alone. He then came to the question, who was the author of her death? And he again begged to show that, in his opinion, this was a case of murder or nothing; and so he said also there was nothing to judge between right and wrong. Then if they accepted the police sergeant's Matthews evidence, the jury would probably be of the opinion that threats had been used by the prisoner, the nature of which, they might gather from the officer's testimony, which was not the only evidence upon the point.

In cases of assassination, where the facts were clear, previous good character amounted to nothing, but if the jury had any doubts they would, of course, give such evidence due consideration. The questions for their consideration were: Was this a case of murder or was it not? On that point they had heard the observation of the learned counsel. Next, when and where did this woman meet her death?

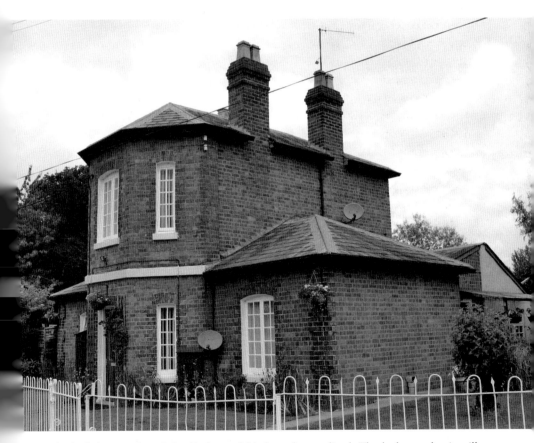

The lock house where John Butler and his housekeeper lived. The lock, nearby, is still manually controlled, but the lock gates are electronically operated.

And whether she was stunned before she got in the lock and so lost her life from the joint effects of stunning and drowning, or whether she was drowned, they would he supposed, have no doubt that between the two she received her death near where her body was found. They did not know exactly where the spot she met her death was, but the learned counsel for the prosecution thought it was below the lock. The next question was when did she die? After eleven o'clock she was seen alive and evidently between that hour and half-past five the next morning she met her death. Had she gone to bed? It seemed not. When she was found dead, she had on the same clothes she was last seen alive in. When was it, then, she died? Was it, or was it not, at the time when the Harrises and the other witnesses heard the cries and the words, "You old scamp, you d------ old villain." It would be for the jury to say whether that evidence did, or did not fix the time of death, was the prisoner present at the time? If she had jumped in would he have allowed her to remain in the water without making an effort to save her? Such a supposition would be very unfavourable to him. Could they say she fell in, or jumped in and that he took no part to save her? If she did not fall in, or jump in, then the case was one of murder. If so, by whom was the murder committed? The prosecution had called evidence of previous misunderstandings between the two people, and of threats, especially that uttered in July by the prisoner. Another point to be considered was that the woman leaves suddenly and that for three days prisoner says nothing about any accident having happened to her. If she had come by her death accidentally in his presence, could he not have given the best possible information? He did not do that, but said she had gone away, and would return shortly and that the prosecution urged, was a strong fact against him. They also said another strong point was that when charged with the murder he made no reply. The absence of motive had been dwelt upon by the counsel for the defence, but if the crime was committed by a person in a fit of passion, it still amounted to murder in the eye of the law. It was suggested by the prosecution that the act was committed in a sudden transport of rage.

These are the facts of the case, and he entreated the jury to remember that if they were of the opinion deceased met her death accidentally they must find the prisoner not guilty. If they believed she was murdered then they must say who the murderer. Those were the two points they had to inquire into. If they believed murder was committed, they must consider who did it if the prisoner did not. After telling the jury to give the prisoner the full benefit of any doubt, his Lordship concluded by saying that if they thought prisoner was the guilty person they must say so, however painful it might be to do so, for the lives of all people depended on the honest and fearless way in which juries discharged their duties, however painful those duties might be.

The jury then retired, and after being absent about 50 minutes, returned to the Court. When they re-entered the box every eye was turned on their faces, and from their saddened countenances it was almost obvious what their decision

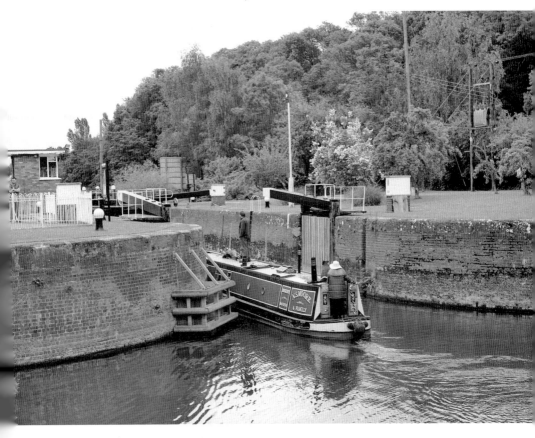

The lock at Holt Fleet.

was. There was profound silence, and after being called on in the usual way, the Foreman said, "We find the prisoner *Guilty*, but recommend him to mercy on account of his age and previous good character."

The prisoner was then challenged, asking him whether he had anything to say why the sentence of death should not be passed on him in the usual way. Prisoner made no reply.

Silence, whilst sentence of death was passed, was then proclaimed.

The Learned Judge put on the black cap, and, amid deep silence said: John Butler, you have been convicted upon very clear evidence of the crime of wilful murder. The jury have accompanied that verdict with a recommendation to the mercy of the Crown, on the ground of your advanced age and previous good character. All I can say is that I will forward that recommendation to the proper quarter, but I fear any hopes founded upon it will prove delusive. I recommend you to pay attention to the religious instruction you will receive, for so alone can you meet your impeding fate with any degree of resignation, tranquillity, or

hope. The sentence of the law is that you be taken hence to the place whence you came, and from thence to the place of execution and that you be hanged by the neck until you be dead; and that your body be buried within the precincts of the prison. May the Lord have mercy on your soul.

The prisoner who behaved with great composure was then led away.

THE CONVICT BUTLER.– This wretched man, we understand maintains the same apparent indifference to his fate as he did when on his trial, and although attentive to the exhortations of the Chaplain he seems to take but little notice of anything going on around him. No confession has been made; indeed he continues to assert his innocence and we never remember in our long experience any case where so general and so strong a believe existed that the convict had no confession to make, because he was innocent, there having been a fearful mistake of justice in his conviction. There is no doubt, as we are informed, of the jury having found a verdict of guilty against the unhappy man under a wrong impression of their own functions and those of the Judge. It is stated that 11 out of 12 jurymen believed that it was their duty to accept and act upon the Judge's opinion of the prisoner's guilt and that they believed his Lordship to intimate in his summing-up that the prisoner was guilty because it was impossible to tell. If Butler was not guilty, who then murdered the woman?

We remain of the opinion expressed last week, viz., that the convict's guilt was not proved and that there was not even that amount of evidence tending to his crimination which leaves no moral doubt in a discriminating mind of the guilt, although it fails to satisfy all the requisite legal conditions. Nevertheless, we fear greatly that the horror of another execution of a witless man awaits this city, which horror will now be aggravated by an appalling dread that the doomed man was wrongly convicted. We question if ever any one was convicted and executed in Great Britain, since the introduction of trial by jury, on evidence so utterly shadowy and unsubstantial; and yet, as we have said, we greatly fear that such a horror now awaits Worcestershire and this city, for the Home Secretary is not likely to commute the sentence without this the concurrence of the Learned Judge and the latter declared in passing sentence that the verdict was founded upon very clear evidence! A memorial from the county praying for a commutation of the sentence is now in course of signature. Supposing every effort to have failed, the execution will take place on the 5th January, but not on top of the gaol as usual owing to the insecurity of that site. At the last execution (William Ockold on 2nd January 1863) Calcraft (the Executioner) complained that he would have been unable to carry the law into effect if the boisterous wind of the previous day had continued, the platform of the drop having to be erected on the ridge of the roof, which rendered it peculiarly susceptible of the action of high winds. The platform will be erected between the wall of the gaol and the perimeter iron railings, and about half way between the main entrance door and

the corner of Love's grove; it will be about 9 ft. high and a wooden partition will be raised to about the same height, so as to shut out from view everything except the actual death of the culprit.

Worcester, 7 January 1865

**Reprieve of John Butler**

Sir, I am to signify to you the Queen's command that the execution of the sentence of death passed upon John Butler, now in the Worcester County gaol, be respited until further signification of Her Majesty's pleasure.

I, am Sir, Your obedient servant, G. Grey.

The Mayor also received an official communication from the Home secretary's office, in which Sir George Grey intimated that, "after a very careful consideration of the case and after full communication with the learned Judge (Mr. Justice Byles) he (Sir George) had felt that it will not be inconsistent with his duty to recommend that the capital sentence shall be commuted to *penal servitude for life*." The great change in his fate was immediately communicated to the unhappy man, and he was then removed from the condemned cell, and is now placed in the same wards as those prisoners who are sentenced to penal servitude

Up to 1853, a reprieve would mean transportation for life to the Australian Colonies, but with the introduction of the Penal Servitude Act in 1853, reprieved convicts sentenced to Penal Servitude served a life sentence of hard labour in this country.

The 1851 census for Ombersley shows John Butler Lock Keeper, aged forty-eight, his wife Frances, aged forty-six and Frances Taylor, niece, aged fourteen. The 1861 census shows John Butler, now fifty-nine and Mary Taylor, niece, housekeeper aged twenty-two.

# MURDER OF MARIA HOLMES

Charles Holmes, aged thirty-eight and a labourer at the gravel pits, lived at Eachway near the Lickley Hills, Bromsgrove with his wife Maria who was twenty-five years old and a nailer. She was his second wife, (they had been married for four years), and they lived together with their son Arthur, aged four and Charles' son from a previous marriage who was called Alfred and was nine years old.

On Thursday 7 March 1872, Charles was drinking at the Rose and Crown when an argument had taken place and another man wanted to fight him. About this same time Maria came to fetch him home, which upset him so he turned and vented his anger upon her, threatening to put her in a coffin. Maria, a headstrong and obstinate young woman was not going to be dictated to in this way by her domineering husband, who expected her to attend to his every whim. She had a restless night and by the next morning decided she could not go on with things as they were – it was not good for her or her little boy – so she thought it best if she left him. The next day Holmes went to work as normal and in his absence, Maria packed her bags and some clothes for Arthur and went to her mother's house, arriving around noon. She had previously done the same thing before and was away for eleven weeks, before returning to her husband.

At dinnertime Charles returned home, expecting to find his dinner to be on the table, only to find the house empty and his wife gone, together with his little lad. He immediately went to his mother-in-law's house, arriving around two o'clock, where he found his wife and requested her to come home, which she refused to do. After pleading and begging her to return home a number of times, to which each time she refused, he left. On his second visit, he took his wife's best shoes and again begged her to come home, but again she refused. On the third occasion he took with him his razor off the shelf in his pocket and again begged her to come home and be comfortable, but again she refused. He then asked her to let the little boy come home with him, but again she said no. On offering his little boy money for sweets, she again refused to let him have it. Charles, now deeply hurt, grabbed

her round the neck and bringing the razor from his pocket, slit her throat and immediately left the house. Maria Holmes fell to the floor with blood gushing from her throat and died within minutes.

Meanwhile, Charles made his way to his father's house and told his parents what he had done, asking them to look after Alfred, his elder child from his first marriage. He then made his way to Selly Oak to his brother's house, where police sergeant Workman found him.

He thought the world of his son and was heartbroken when he found his wife had taken him to his mother-in-law's, who he considered was a bad influence on his wife, as she always interfered when they had a squabble – naturally taking her daughter's part and providing a home for his wife and their son.

The impact of seeing her own daughter killed in such a heinous manner before her eyes was all too much for Mrs Mary James, who was a widow and a feeble old woman. She took to her bed and managed to make a statement to the police describing how her daughter was killed, but she died a few days later.

Charles was tried at Worcester Assizes on 22 July 1872 before Mr Justice Grove, for the murder of his wife on 8 March 1872. He never denied that he had killed her and was resigned to meet his fate. The Counsel for his defence, Mr Motteram, pleaded provocation and said the murder was not premeditated. But if that was the case, why did he pick up the razor and put it in his pocket? Or was that just an impulse while in a passion?

Police sergeant Workman arrived at Selly Oak just after midnight. His knock on the door brought James, the brother of Charles, from his bed to the front door at the same time that Charles took the razor from his pocket and cut his own throat, but it was not sufficient to cause death. A doctor was sent for and he was stitched up – he wasn't going to be allowed to cheat the hangman. In his statement he said, 'I was determined if she did not live along with me she shouldn't live along with someone else.' He had subjected her to both verbal and physical abuse, the whole of their married life.

The Judge in his summing up stated it was his jealousy that had denied them a happy married life and, the woman he should have loved and cherished, he had brutally murdered. The jury never left the jury box and reached a verdict of guilty within a few minutes. The judge then put on the black cap, and gave the usual pathetic admonitory speech, overwhelmed with emotion, making frequent pauses and at times his voice hardly audible, finally pronouncing the death sentence. 'You will be taken from here to the place from whence you came and thence to the place of execution and there you will be hung by the neck until you are dead and your body buried in the precincts of the gaol, and may God have mercy upon your soul.'

On 12 August 1872, Charles Holmes went into the record book as being the first man to be executed within the precincts of Worcester prison; all previous executions had been held in public on the roof or outside the prison before

hundreds of spectators. This change in the law was introduced in May 1867. The last man to be hung nine years previously was William Ockold of Oldbury, who was a seventy-year-old wife murderer. Whilst the execution system had changed only slightly, the Executioner of Ockold was the same for Holmes, namely William Calcraft, now a grey-haired man and the executioner from 1829 to 1874. He was known as the 'finisher' and was estimated to have executed up to 450 culprits.

The fact Holmes was hung in private meant that the execution did not draw the usual crowds. The usual public officials and the press were present, however, to see the execution was carried out in accordance with the law and none of the public were admitted. A small assembly gathered outside the gates as the time of the execution drew near, but there was none of the atmosphere of the old-style executions. What was once the ultimate public deterrent had gone for good.

Holmes slept soundly the night before his execution and ate a hearty breakfast the next day. The prison bell began to toll at 7.45 a.m. and a few minutes later Calcraft entered his cell and pinioned his arms. He walked unassisted to the scaffold, but required some assistance climbing the stairs onto the platform of the scaffold, as the stairs were steep and his hands tied. On reaching the top he was positioned beneath the beam. Calcraft then produced a white cap which he placed over his head and face and positioned the rope. Throwing the slack over the beam, Calcraft drew the bolt, the drop fell and Charles Holmes was no more. The black flag was then raised over the prison. After hanging the usual time, his body was removed and placed in an elm coffin and buried near the prison outer wall without a ceremony.

# TRIPLE MURDER

John Harris was a twenty-seven-year-old collier, who worked at a pit in Old Hill. He was a man of small statute and of untidy appearance and had been married to Amelia Jones his wife for some time. They had two children, the eldest Alice, who was about six years old and Eva who was about two years old. They all lived with his wife's father and mother at their house at Coombes Wood Hill, Halesowen. In the summer of 1877 he was attacked by some disease and taken to Birmingham General Hospital, where his mind became affected, leading to symptoms of insanity. He was transferred to Winson Green Asylum and then moved to the Asylum at Powick, where he remained until 1 October 1877 at which time he returned home on trial. He then returned to the Asylum for a short time, but was later discharged as recovered and was sent home. This would prove to be one of the biggest mistakes ever made!

Shortly after he returned home, malicious gossip was being circulated about his wife and it came to his knowledge that she had been unfaithful to him in his absence. Upon challenging his wife, she naturally denied such conduct. This led to quarrelling and bickering and a change in his attitude and affection towards her and their children, even though there was no evidence to support such gossip. On returning home on 4 February 1878, the argument between them was renewed and continued after bedtime and midnight.

The next morning his father-in-law got up at his usual time of 6 a.m. to go to work and called to John, who was still in bed. He got no answer from him, so went off to work on his own. John Harris got up about 8.20 a.m. and sat in the kitchen nursing Eva, his youngest daughter. At 8.30 a.m. his mother-in-law left the house to take her husband's breakfast, her daughter wished her goodbye and said 'don't be long'. She returned about 9 a.m. to find her daughter, Amelia, lying on the kitchen floor in a pool of blood, hacked around the head with a sharp instrument. Lying alongside her was the body of Eva, her daughter, covered in blood and in a similar condition; both were dead. She picked up the child, thinking she was still alive and

carried her out of the house to get assistance. Alice, the eldest girl was later found upstairs on the bed bleeding from her wounds but still alive – she died the next day. John Harris, meanwhile, was seen running from the house by a small boy called James Jones, who was his nephew. James was told not to go into the house.

Later, Harris was found casually walking towards his home, as if without a care in the world. With his hands in his pockets he was totally unconcerned and, appearing not to know what had taken place, he was unaware of the atrocious crime he had committed on his own family. When found, his clothes were saturated with blood. He was grabbed by some men who were out searching for him and handed over to the police, but on being questioned, he denied any knowledge of the murders.

The doctor who conducted the post mortem stated that the wounds inflicted upon the victims were far in excess of that required to kill either of them, more force being used than what was necessary. They carried the hallmarks of a mad man in a frenzied attack suffering delusions of his wife's infidelity – a form of today's modern description of schizophrenia.

His father and mother-in-law always took the side of their daughter when arguments arose often reminding him, rather unkindly, that he had been in a lunatic asylum. They suggested that was where he ought to be now, which may have contributed to his state of mind on the day of the murder.

The axe used in the attack was found in the house. It was usually used for cutting firewood and it was wet as if an attempt had been made to wash it, but it still carried incriminating evidence and was still spotted with blood. For a man to be cuddling his two-year-old daughter at 8.20 a.m. and by 9 a.m. hacking her to death with an axe could only be the work of a mad man.

But was he mad? In some respects the murder was premeditated, he must have given things a lot of thought after their argument the night before and lay awake considered what his next step would be. He lay in bed the next morning waiting for his father-in-law to go to work and later for his mother-in-law to leave the house to take her husband's breakfast, a practice he was well aware of – she had done it every morning for years – which gave him the opportunity to put his plan into operation once she was out of the way.

Worcester, 16 March 1878.

He was tried at Worcester Assizes at the Shire Hall on Thursday, 14th March, at 11.30 by Lord Justice R. Baggally, with Mr. Selfe for the prosecution and Mr. Plowden for the defence.

He was charged with the wilful murder of his wife Amelia, on 5th February when asked how he pleaded, he stated he did not know what he was doing on the day of the murder and that his wife was unfaithful.

The doctor from Powick Asylum stated that a patient who returned to madness was suspicious of people around him and had an impulse to injure or kill them,

an impulse he described as uncontrollable and he considered Harris had such impulses before he was released, and continued by saying that a person who had been held in an asylum was five times more likely to return to madness than someone who had never been inside one.

The surgeon at Worcester gaol said he found no signs of insanity and when he spoke to him their conversation was quite normal.

A plea of insanity was made by the defence, which was supported by the Judge and other evidence from other Doctors.

The jury, after a short discussion, returned a verdict of not guilty due to insanity and that the prisoner should be detained until 'Her Majesty's pleasure be known'.

Harris was returned to the lunatic asylum at Powick but this would probably only be for a short time as killers of his kind would be normally transferred to specialised secure units like Broadmoor. Broadmoor was designed to accommodate 700 criminal lunatics who would be a threat to the public if ever they got loose.

# MURDER OF ALFRED MEREDITH

Enoch Whiston, a respectable twenty-one-year-old man, employed as a groom by a large firm of iron masters at Woodside, had been paying his address for about six months to a young lady aged twenty-three who went by the name of Mary Terry of Commonside, Pensnett. They had saved about £30 and he had promised her another £25. They were considering marriage on Christmas Eve 1878.

Alfred Meredith, aged twenty-four, was a clerk to the Company of Hill & Smith Ironmasters, also of Woodside. Every Friday, at the same time, between 2 p.m. and 3 p.m., Alfred took a cheque to the value of about £280 (the weekly wages), to the Birmingham, Dudley and District Bank in the High Street, Dudley. Every week he returned with the cash in a black leather bag with the name Messrs. Hill & Smith of Brierley Hill printed on the side.

On Friday 6 December 1878, about 2 p.m., Enoch Whiston stood in the 'Junction Inn' having a drink, preoccupied with looking through the window. At about three o'clock he left the public house and was seen by a number of witnesses to be closely following a man carrying a black leather bag. At about 3.30 p.m. a pistol shot was heard by a number of people who looked in the direction from which it came and saw a man struggling on the ground and another running away through a field carrying a black bag.

Police Constable Stains also heard the report from the firearm attended to Mr Meredith, who could not speak as his mouth was full of blood from a wound beneath the right ear. He was rushed to Dudley Guest Hospital.

The bag, now in Whiston's possession, contained about £280 consisting of 164 sovereigns, 90 half-sovereigns, £5 notes and silver and copper, which he hid in various places as he made his way to Mary Terry's house at Commonside. At approximately 4.30 p.m., a knock on the front door was answered by Enoch Whiston, who was confronted by two policemen. He immediately turned and rushed to his coat to obtain his loaded pistol. He was seized and secured and charged with Highway robbery by Police Superintendent Burton and detained at

Brierley Hill Police Station. The money was later recovered.

On 12 December Mr Alfred Meredith died from wounds caused by three lead slugs and an inquest held at Dudley Town Hall brought in a verdict of wilful murder by Enoch Whiston, who stated he did not intend to kill him. It was clearly a robbery that had gone wrong and in the struggle to obtain the bag he shot him. Nevertheless, it was murder. Whiston was then committed to appear at the Worcester Assizes, where he appeared at the Crown Court before Justice Huddlestone and was charged with the wilful murder of Alfred Meredith. A plea of insanity was made, supported by a statement from his girl friend who said he had frequent headaches and the counsel for his defence gave instances of his insanity. The jury retired and returned after 20 minutes with a verdict of guilty. The learned Judge then read out the sentence of death.

Whinston was executed behind the walls of Worcester Prison at 8 a.m. on 10 February 1879 by William Marwood, a man of about fifty, in accordance with the Private Execution Act, witnessed only by Officials. Members of the press were excluded.

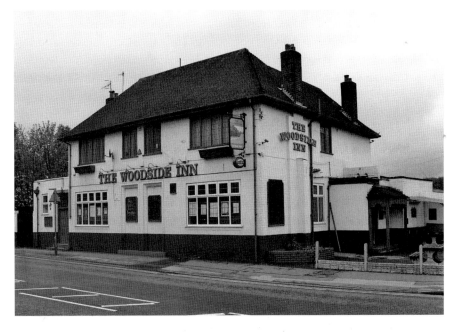

The Woodside Inn is an old established public house at Woodside, which in early times provided refreshment for the iron workers from the nearby iron works, where the murdered man and his murderer were employed. Most of the old works have now gone and new industries have sprung up in their place, but their workers continue to frequent the house.

# THE BRUTAL MURDER
# OF PC DAVIES

Police Constable James Davies was thirty-three years old when he was violently killed by a poacher, who stabbed him to death in a frenzied attack in a country lane known as Eaglesfield Lane, Weatheroak, Beoley.

A local man was suspected of stealing fowl and a special patrol had been mounted to keep watch on the farms in the area of Beoley, where he was well known for his poaching activities. Such activities were considered relatively harmless, but he had turned his hand to stealing fowl from local farms, which was considered a more serious matter. He was also known to be violent. The police were called in and had been keeping a special look out for suspects, hoping to catch them red handed. The patrols consisted of a number of officers who had to cover certain sections of the land, linking up with each other at a given check points and at a given time. On Friday 27 February, it was a moonlit night and PC Davies started his patrol at 11.30 p.m. He had to meet up with PC Whitehouse at 1 a.m. at the Portway, who was on duty patrolling the adjoining section.

They met at 1 a.m. on Saturday morning 28 February as planned, opposite the Rose and Crown and went into a shed, where they stayed about an hour, keeping a careful watch for intruders. They checked their watches and parted company at 2 a.m., PC Davies heading in the direction of Weatheroak Hill Farm, where he was to meet PC Sheppard of Alvechurch at Seechem Farm at 4 p.m. They did not meet up, however, as PC Sheppard was ill. At 8.30 a.m. the same day, the body of PC Davies was found in Eaglesfield Lane, he had been savagely killed. There was evidence of an extreme struggle or fight having taken place, with footprints all around. The officer was covered in blood from a series of stab and slash wounds to the neck and upper parts of his body including his hands and arms, which he must have raised to protect himself. His helmet and staff lay nearby, which he had probably drawn.

The doctor, who examined the body of PC Davies, said several of the wounds, in themselves could have caused his death. The footprints were easily distinguishable

as being of two differing kinds. The imprints made by the officer were made by the boots still on his feet and had hobnails in them. The others were large and plain soled and went towards Beoley. There were two sets of foot prints coming towards where the murder was committed, from the direction of Weatheroak Hill Farm (the farm was owned by Mr Fisher, from where it was later reported some poultry had been stolen), but only one set going away towards Beoley. It was found that the officer's watch and chain was missing from his fob pocket. On checking at Weatheroak Hill Farm, footprints the same as those of the plain sole boots were found in the fold yard. The soil in the surrounding area was of red clay.

As soon as the murder was discovered, Moses Shrimpton, a local poacher, with a criminal record including assault, became the immediate suspect and the loss of the fowl was further proof.

Superintendent Tyler of Kings Heath stated that on the afternoon of the murder he went to Birmingham in search of Shrimpton, who he had known for eleven years. He saw him in Banbury Street and followed him to a house in Bartholomew Street. Later he went with four additional police officers to where Shrimpton lodged and found him in bed with a woman. He jumped out of bed and said 'Hullo what's up?' He was immediately seized by the arms by two police officers and handcuffed and told he was being arrested on suspicion of the murder of Police Constable Davies, which he denied. He then turned to the female and told her she was also under arrest. The room was searched and a knife was found in the dress of the woman, which Shrimpton admitted was his. Fresh injuries were found on Shrimpton, some of them still bleeding and some covered with sticking plaster, as if he had recently been in a fight. Upon being asked how he got them; he said he had fell down drunk last week. On examining his clothes they were found to be covered with blood, although attempts had been made to wash them and a bucket was found containing reddish brown water and a bottom covered with a sandy gritty deposit. His boots were examined and found to have been recently cleaned. They were later taken and tried in the footprints and found to be a perfect fit. Plaster casts of the footprints and of the impressions made by the boots were identical.

A bulge on the side of one of the boots matched the plaster cast made of the footprint at the scene of the murder, which was a compelling piece of evidence. Shrimpton, upon being examined by a doctor, was asked how he had got his injuries. He stated he had run into a lamppost last Monday whilst he was drunk. The doctor, who examined him on 28 February, said the wounds had been received within the last twenty-four hours.

On 2 March, Shrimpton was charged with the murder of PC Davies and stealing his watch. He said that on the night in question he was rabbiting at Yardley and could prove it, but was unable to name anyone to support his story.

On 6 March five fowl were discovered at Woodland Farm and nearby similar footprints to those at Weatheroak Hill Farm were found, which were identical

to those where the murder was committed. On 7 March, two more fowl were discovered at Seechem Farm, together with further footprints matching those previously found. All seven fowls had been taken from Weatheroak Hill Farm.

The knife found was a double-bladed clasp knife, with a buck horn handle, which Shrimpton said was his. It was a long strong pocket knife with dagger like points on the blades. Although a similar knife could have inflicted the wounds, it still had bloodstains upon it, even after it had been cleaned.

Shrimpton was a regular at the White Lion at Portway, often accompanied by Mary Moreton. One day he looked though the window and saw PC Davis go by and was heard to say, 'There goes the teetotal, if ever I was to meet him I would be more than a match for him.'

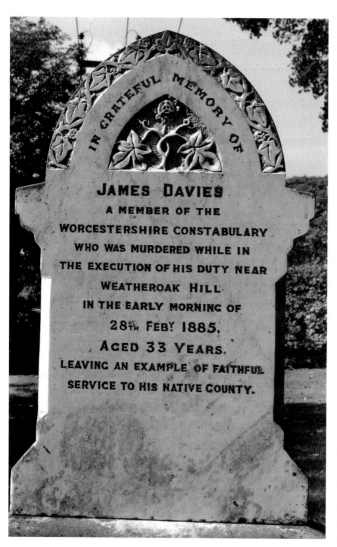

IN GRATEFUL MEMORY OF

JAMES DAVIES
A MEMBER OF THE
WORCESTERSHIRE CONSTABULARY
WHO WAS MURDERED WHILE IN
THE EXECUTION OF HIS DUTY NEAR
WEATHEROAK HILL
IN THE EARLY MORNING OF
28TH FEBY 1885,
AGED 33 YEARS.
LEAVING AN EXAMPLE OF FAITHFUL
SERVICE TO HIS NATIVE COUNTY.

The grave of PC Davies. He was the only Worcestershire Police Constable to be killed on duty. He was buried here on 5 March in the graveyard of St Leonard's church, Beoley, where he lived, with the police equivalent to full military honours. The cortege was led by the Birmingham Police Band, with eighty uniformed officers following behind and hundreds of people lining the route of about a mile from Beoley to the Church. PC Davies left a wife and four small children.

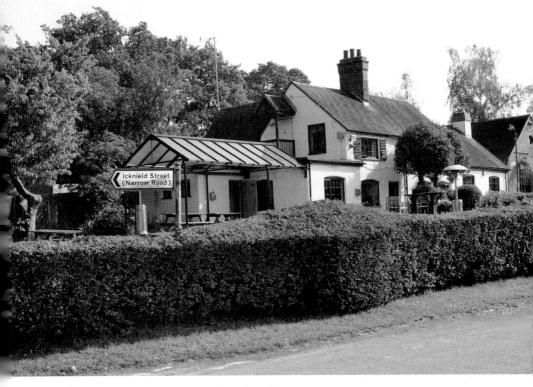

The Coach and Horses Inn at Weatheroak Hill.

Icknield Street referred to by the newspapers in 1885 as Eaglesfield Street.

This stone, with the initials J. D. is imbedded in the roadside bank and marks the place where PC James Davies was so viciously attacked and died. It can be found in Icknield Street, a long narrow road, originally built by the Romans, along which can be found a number of farms. The stone is about 100 yards on the left, past the entrance to Alcott Farm, coming from the Coach and Horses Inn at Weatheroak Hill.

The trial of Moses Shrimpton took place at Worcester Assizes on Wednesday 9 May 1885 before Justice Baron Huddlestone, where there was a great public interest. All the seats in the Court were taken and a large crowd remained outside. He was about sixty-six and respectably dressed. His hair was greying, he was wearing spectacles and he was described as a needlemaker. He was defended by Mr Daniel, and pleaded not guilty.

Mary Moreton, the woman Shrimpton was living with, was aged about forty-nine and was described as a charwoman. She was charged with harbouring and maintaining Shrimpton, knowing him to have committed murder and also as being an accessory. On making enquiries about the watch it was discovered that she had taken it to Mrs Facer's on the Saturday morning, who was a woman she worked for. She said Moses Shrimpton had given her the watch, telling her he had bought it. She had asked him for money, but he said he had none and gave her the watch instead. She asked Mrs Facer for two shillings in exchange for the watch, which she refused and instead gave her one shilling.

Fellow lodgers said Shrimpton was out on the night in question. Hannah Brogden occupied the ground floor of the building and Shrimpton and Moreton occupied the top floor as Mr and Mrs Jackson and had been there about five weeks. She saw him on 27 February when he was not marked by any injuries,

which were clearly evident when she saw him on 28 February covered with bits of sticking plaster. Eleanor Allen of Bartholomew Street also saw Shrimpton on 27 February at about 6 p.m. without any injuries and saw him again on the 28th with injuries to his face.

The Judge was an hour and three quarters in his summing up. On completion the jury retired and was absent for about five minutes, they returned with a verdict of guilty.

The result was a foregone conclusion; the evidence was stacked against him. Moses Shrimpton was found guilty, any other verdict would have been a miscarriage of justice. When asked if he had anything to say, he replied, 'I am not guilty, but I am ready to die.' The Judge then put on the black cap and passed the dreaded sentence of death. In passing sentence, the Judge mentioned the criminal record of Shrimpton, it was extensive and included a previous assault on a police constable, for which he served a sentence of five years penal servitude, these he said were insignificant crimes to that of the deed for which he had now been found guilty. He was caught in the act of stealing fowl and had barbarously murdered the police constable who caught him in order to resist arrest.

Mary Moreton was found not guilty and was discharged.

Moses Shrimpton was executed on Whit Monday 25 May 1885, three Sundays after he was convicted (this being the normal period allowed at this time).

The Execution

At a 7.45 a.m. the prisoner was prepared in his prison dress. His hands were pinioned and the prison bell began its monotonous toll. A few minutes later the first words of the burial service were uttered by the prison chaplain and the procession began to move across the prison yard towards the treadmill house, where the apparatus of death was housed. He paused momentarily on entering and was directed and positioned beneath the beam, directly over the trap, where the executioner strapped his legs and then positioned the noose. At the stroke of eight the trap fell, the bell ceased to boom and the black flag was raised. The crowd outside the prison, estimated as being 3–4,000 people, gasped and said, 'He's gone! Shrimpton's gone!' A few minutes later they began to drift away to their homes, satisfied that justice had been done and Shrimpton had paid the extreme penalty. When his job was completed, James Berry, the executioner, left to catch the train to the north.

After hanging for an hour the body was removed and the inquest held and a formal declaration posted on the prison door stating, 'That in accordance with the law, Moses Shrimpton has this day been executed.' On examination it was discovered that the head had been almost severed from the body, suggesting that the executioner had got his calculation wrong and set the drop too deep in relation to his weight.

The History of Shrimpton

Moses Shrimpton was born in about 1820. His criminal career ranged over a period of at least fifty years. His first recorded crime was stealing apples at the age of fifteen, for which he received a sentence of one month in prison. There may have been earlier crimes as a juvenile, which went unrecorded. His record shows twenty-five known convictions and each received a sentence from a minimum of three weeks for illegal fishing to the maximum of five years penal servitude for assaulting PC Haynes at Tardebigge in 1868. This point tended to be the climax of his criminal career, ending with the murder of PC Davies for which he paid the ultimate price of his life.

His crimes were mainly poaching, amounting to sixteen charges, two of illegal fishing, one of stealing a sovereign, three of assault (not counting the murder), one of neglecting his family and one of stealing fowls. His favourite pastime, when not poaching, was drinking.

He was said to be a needlemaker, and at the age of twenty-five he moved to Headless Cross and spent most of his life, when not in gaol, at Redditch. All his life he had been a petty thief supplementing his wages by petty crime, until he finally gave up work and resorted to a life of crime. His total sentences added up to fifty-two months in gaol over a period of fifty years plus the five years Penal Servitude mentioned above and below. The final sentence was his execution at Worcester.

Worcester, 4 July 1868

Before R. P. Amphlett QC

Moses Shrimpton, aged fifty, a fish hook maker was charged with an assault on PC Haynes on the 26 June, 1868, with intent to do him bodily harm. The prisoner who was known to be a poacher was stopped at Tardebigge, by PC Haynes on suspicion of having something concealed beneath his coat. When asked what it was, Shrimpton refused to show him, so the officer proceeded to search him and found it was a gun, which he tried to take into his possession. Shrimpton resisted, and retaliated by striking the officer a number of times with the stock of the gun and the officer fell to the ground, bleeding from the nose and the mouth. Shrimpton then sat astride him and continued to strike him with the gun and threatened to kill him. The officer then called out for assistance and was aided by a member of the public, who saved him from further injury. For this offence Shrimpton was awarded five years penal servitude.

R. P. Amphlett QC is believed to be 'The Right Hon. Sir Richard Paul Amphlett', who in the 1881 census, was described as a 'Retired Judge of the Supreme Court of Appeal & Privy Counsel'. He was born at Quatt, Shropshire, in 1809, living at 32 Wimpole Street, London. He was the son of the Revd Richard Holmden Amphlett of Hadzor, who lived at Wychbold Hall, Dodderhill, where he died in 1842, the Hall passing to Sir Richard Paul Amphlett.

# MURDER OF LITTLE JIMMY WYRE

Worcester, 7 July 1888

On 1 June two men were cutting down trees at Highwood, near Wolverley, Kidderminster. It was warm work and they were thirsty. Nearby was an unoccupied cottage called Highwood, owned by a farmer named James Davies, which had been unoccupied for two years. In the garden was a well, covered with timber weighed down by an old heavy furnace, to prevent the cover being moved. The thirst of the men and the thought of the cool refreshing water made them remove the covers to get to the water. On looking into the well, which was about 30 feet deep, they noticed something floating in the water, which they thought was a human body. Their thirst was quickly quenched after realizing it was the decomposed body of a small child floating in the water which they were about to drink! They quickly replaced the covers and next day they told Henry Field, a local farmer and also Police Constable Edwards. A rope was obtained and a noose formed on the end, and together they fished out the partly dressed body of a small child, which was badly decomposed. The post mortem by Mr Howell, surgeon, said that it was a male child aged about four years and had been in the water at least three months, and it had a tooth missing from the lower jaw.

PC Walker who also assisted with the recovery of the body stated that the chemise the child had on had been identified by Mrs Roden who had given it to his mother, Mrs Wyre. On this information the child was identified as James Wyre, known as Jimmy, the son of Thomas Wyre and his wife. Mrs Roden was their next door neighbour.

PC Walker immediately went looking for Thomas Wyre and found him at Mamble on 4 June. He arrested him and took him to Kidderminster Police Station to lock him up and charge him on suspicion of causing the death of his son.

William Roden and his wife and children lived next door to the Wyre family at 'Bird's Barn', they had known them for five or six years, his wife had made the chemise. Jimmy had been last seen by Mr Roden, being carried with a shawl

around him by his father Thomas Wyre, at 5.30 a.m. on 3 March, who had said he was taking him to his grandmother at Kidderminster.

The wife of Wyre was a loose woman who had had a number of affairs and, due to her infidelity, they decided to split up. His wife would leave her little girl with a friend and go into service and Wyre would take his son aged four to his mother's at Kidderminster. Wyre, at the 'end of his tether', with no wife, no job and no future, was in a very confused state of mind with a young child to care for. At one point he was seen to be standing in the middle of the road as if he was lost and did not known what to do or where to go. They were living at 'Bird's Barn' when they had agreed to break up and at 5.30 a.m. on 3 March, he left home with his son. Intending to take him to his grandmother's, he had instead changed his mind and made his way to Highwood cottage where he uncovered the well.

The Wyre's were not very well off, they had two children, Jimmy and an older girl, who often played with Elizabeth Roden's children and she passed down some of her children's clothing to the Wyre's as they were 'bad off', and added that sometimes the children did not have enough to eat and she gave them food. They were a poverty stricken family receiving hand-me-downs and charity from others.

For about three months he stayed at the house of his sister in Kidderminster. He was found at Mamble on 4 June and on being asked where his son was, he said he was with his wife. It was only the chance discovery by the two thirsty timber cutters that the truth was known. His wife meanwhile had gone into service at Woverton. Thomas, now at a loose end, wandered about the neighbourhood doing nothing. The identification of the body was difficult due to the advanced state of decomposition and was beyond recognition; the mother could not be called as she could not give evidence against her husband.

### The Trial

It was suggested that poverty was the reason for the child's death or inconvenience to the parents who were splitting up. The Judge, in summing up, told the jury it was not for them to decide on a motive, as to if the child's death was due to poverty or other circumstances, or if he was just an inconvenience to his parents.

The jury retired at 5.15 and after half an hour returned a verdict of guilty. The Judge, after putting on the black cap, proceeded with the usual dismal ditty, concluding with the death sentence. The prisoner bowed his head and wept. A reprieve was applied for, but was denied.

### The Execution

Worcester, 21 July 1888

James Berry was the executioner, who had just hung Robert Upton at Oxford, for the murder of his wife. Many people came to see this infamous hangman when he arrived, out of morbid curiosity, he arrived two days before his services were required, at Foregate Street railway station, dressed in a black coat, silk top hat

and a flower in his buttonhole. The gallows was set up in the wheelhouse and on the day of the execution a crowd of about 150 to 200 people gathered outside the prison gates. The bell began to toll a few minutes before eight and the black flag was raised shortly afterwards.

Wyre apparently ate a hearty breakfast and was visited by the Chaplain, and a few minutes before eight Berry arrived at his cell and pinioned his hands. He was then escorted to the wheelhouse accompanied by the tolling of the bell, where the scaffold was assembled and positioned beneath the beam. Berry made everything ready, Wyre's ankles were strapped, the cap drawn over his face and the noose adjusted. On the stroke of eight the bolt was withdrawn and the drop fell and Wyre dropped into the abyss beneath his feet, his neck broken. After hanging the usual time he was cut down and placed in an elm coffin. Berry, his task now complete caught the 10.15 train from Foregate Street.

The confession of Wyre included the words 'I did it, but I don't know why'. He thought a lot of his wife, but admitted that one man was never enough for her. His wages were sent to him from the farmer who employed him at Mamble, less the sum of 10 pence for washing!

He talked to the Chaplain and unburdened his mind about the conduct of his wife, to who he had been married for six years and of the many men she had had liaisons with.

# MURDER OF JOHN WILLIS

Worcester, 24 November 1888

John Willis, aged fifty-five, lived with his wife Elizabeth (Bess) at the end of a row of ten houses called Church Terrace in Dodderhill, Droitwich, next to Crutch Lane. By trade he was a florist and a gardener and he was well known and well liked in the neighbourhood of Hill End. The plot of land he occupied was large, but suited his purpose of growing fruit and vegetables. His pride, in particular, was a pear tree known as 'Smokey Jennet' in which he took a special interest. It carried a good crop of pears, which ripened quite nicely and each day a number would fall from the tree. Each morning John collected the pears that had fallen overnight, which he sold at ten for a 1d. He looked forward to collecting them each day, but in recent days there were none at all, which led him to believe that someone was stealing them.

The garden gate was locked each night, but could easily be lifted off its hinges. The wall surrounding the garden could be easily scaled and was not really an obstacle, so on Wednesday 1 August he got up at 3.45 a.m. to keep watch for the culprit. He was not surprised to find a man by the name of Samuel Crowther gathering up the fruit and other vegetables and putting them into a 'frail' (a carpenter's tool bag). He knew Crowther. He was a poor man, seventy-one years of age and was severely disabled with a dislocated hip which caused him to walk with the aid of a stick. He was the local boot and shoemaker and repairer who lived about 40 or 50 yards away on the Bromsgrove road. He was known to be a bit light fingered!

Willis went out and challenged him. There was a struggle and he received a series of stab wounds in the chest from Crowther (one penetrating the heart), who carried a shoemaker's knife. Crowther then made off with the spoils. Willis managed to stagger to the back door of his house, where he called his wife for help, saying that Crowther had killed him. She helped him into a chair and then raised the alarm. Neighbours quickly came to her aid and the police and a doctor

The Church and Churchyard of St Augustine's of Dodderhill, where Crowther made his getaway and hid his pears and vegetables after killing Mr Willis. During the civil war the Church was occupied by the parliamentarians and attacked by the Royalists, resulting in some of it being burnt down.

were summoned, but by the time they arrived it was too late, John Willis was dead.

On the information of Mrs Willis the police went calling on Samuel Crowther, but found his house locked at the back and the front. After loudly knocking and receiving no answer, Police Sergeant Harrison broke a pane of glass to gain access and they found Crowther in bed apparently asleep. He said, 'What's up, what's the matter?' He was arrested and cautioned and taken to a cell in the town hall at Droitwich. It was noted he had bloodstains on the fingers of his right hand, which he said was jam that he had for breakfast. His clothes were examined and found to be spotted with blood and were taken away for further examination. His boots were also taken away and matched with the footprints left in the garden.

The area of the garden where the scuffle took place was examined and found to have the footprints of Crowther and the footprints of Willis, who was wearing slippers. Both prints were quite distinct. The footprints of Crowther were peculiar

due to the 'lameness' in his left leg and there were also holes made by the ferrule of his walking stick, which was badly worn on one side. Both the imprint of the stick and boot matched those belonging to Crowther.

Samuel Crowther was a resident of Droitwich, where he learned his trade of boot and shoemaking. He had been a police constable at Birmingham, but for some unknown reason had been dismissed and went to work in the Liverpool docks, where he had an accident which left him with a dislocated hip on his left side and a serious limp. Walking with a stoop and supported on a walking stick which he held at an angle to his body, he often left a distinct imprint wherever he walked. He maintained his balance by walking with his left hand on his hip. He was about 5 foot 6 inches tall, bald headed, almost stone deaf and had 'staring eyes'.

He was seen at about 4 a.m. on the morning of the murder, in Dodderhill Church yard carrying his frail over his shoulder. As he made his getaway he was recognised by a thirteen-year-old boy on his way to work at a salt mine, who spoke to him, but he did not reply. He was seen a little later by a woman who lived close to him before he entered his house at which point he was not carrying the frail. A search was made of the churchyard and a pile of pears, onions and carrots were found in a ditch. A bloodspotted frail was also discovered on the embankment of the railway below the churchyard. A search of his house, which was in a dirty condition, led them to discover about 3lbs of pears in a bedroom.

His wife had disappeared some time ago and was found drowned in the Salwarp River. He had a criminal record of petty theft, mainly of stealing vegetables, neglect of his children, and vagrancy for which he had received minor sentences of imprisonment. He was known locally as 'Blucher', the name of the famous Russian commander who joined forces with Wellington against Napoleon. It was also the name given to a type of boot and since Crowther was a boot and shoemaker he was given the same title. Crowther was a poor man. While being well known in the area of Dodderhill, he was not as well liked as Willis, possibly because of his disability, which made him resentful. With a scouring look and a difficulty in getting on with people, others took pity on him and gave him food and work to do.

## Worcester, 24 November 1888

Samuel Crowther was tried at the Winter Assizes, Worcester, on Wednesday 21 November for the murder of John Willis on August 1 last, before Mr Justice Field. Mr R. H. Amphlett and the Hon. Alfred Lyttelton appeared for the prosecution and Mr Owen and Mr R. Harington defended the accused.

The prisoner, bent almost double, made a most pathetic figure as he limped into court and was assisted into the dock and given a seat. He appeared to have recovered from his recent illness. A few weeks ago it was reported he was seriously ill in the Prison Infirmary suffering from dropsy. The charge was read out but he did

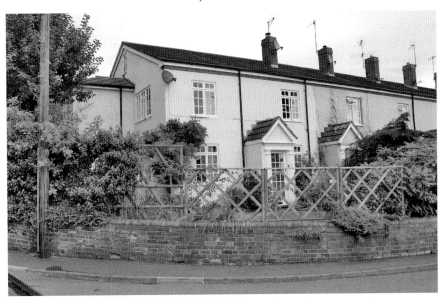

The house above is a photograph taken from Crutch Lane of No. 1 Church Terrace, where John Willis lived. The garden is now much smaller because of the extension on the left-hand side of the main building, where the pear tree stood and John Willis was murdered. The house as it stands is probably twice the size of the original cottage. There are ten cottages in all, which have been modernised. All have been rendered and painted covering the original brickwork, all have an identical porch and most have had replacement windows. The rear garden, which was quite extensive, has partly been used for housing.

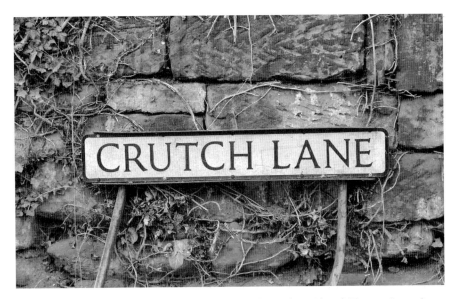

Crutch Lane was built by the Romans and is at a right angle to Church Terrace. It continues through a small housing estate, past Droitwich Golf Club to Crutch Farm and Crutch Hill, where there once was a Roman Hill Fort.

not appear to hear due to his deafness, a warder then repeated the question asking him if he was guilty or not guilty? To which he replied, 'No.' Various witnesses were called, and the evidence produced, proved beyond any reasonable doubt that Crowther was the culprit, he never denied the charge or gave an alibi, nor was there any witness called who spoke in his favour, even his daughter admitted that the frail was her father's and that he was in the habit of carrying his shoemaker's knife.

An appeal of manslaughter was made on behalf of the prisoner.

The Judge in his summing up of the case stated that the Jury must make their own judgment; it must not be made on feelings of sympathy. They must trust only the evidence; and if upon that evidence they were of opinion that the prisoner did murder Willis they must not be afraid to say so.

As to the difference between murder and manslaughter, he said, 'The law of England was that the sudden killing of one human being by another was if nothing more, murder. It was for the person accused to provide evidence, which would allow that crime to be reduced to manslaughter. They were not allowed to find a verdict of not guilty. They must make up their mind whether they found the prisoner guilty of murder or manslaughter.' The Jury retired and deliberated for 13 minutes before reaching a verdict of 'Guilty of Murder'.

The prisoner was then told 'You stand convicted of wilful murder; what have you to say why the Court should not give you judgement to die according to the law?'

Prisoner made no reply and he stood in the dock between two warders. One of the warders was asked to repeat the sentence to the prisoner.

The Judge, having assumed the black cap, said, 'Prisoner at the bar. The Jury have arrived at what, in my judgement, is the only correct conclusion in this case; and it is my duty now to pass upon you the sentence of the law. That is, that you be taken from hence to the place from whence you came, and from thence to the place of execution, and to be there hanged by the neck until you be dead, and that your body be afterwards buried within the precincts of the gaol in which you shall have been last confined before your execution. And may the Lord have mercy on your soul.'

The warder who repeated the sentence, for the benefit Crowther, was overcome with emotion. A petition on behalf of Crowther was sent to the Home Secretary begging for mercy and that his sentence be commuted to one of life imprisonment, on the grounds of his age and infirmity, and that the murder was not premeditated, also that the relationship between Mr Willis and Crowther had always been one of friendship, and that Mr Willis had shown acts of kindness, having lent him money and giving him food. The Home Secretary replied that he had studied the case carefully, and could find no reason to interfere with the course of the Law

### THE EXECUTION

The Execution was on 11 December; it was a cold and dank morning. Crowther was raised from his sleep early and ate a hearty breakfast. Shortly afterwards the Chaplain visited him to give him his last administrations and prepare him to the life beyond. From about 7.30 onwards the usual officials, press and witnesses arrived and were admitted through the main gates, observed by a small number of onlookers. It being a dull damp morning not many people had assembled outside the gates, the black flag hung limply at the bottom of its pole.

At 7.45 Crowther was brought from his cell accompanied by the Chaplain, Berry the executioner and his assistant joined the Governor and the warders as the prison bell began to toll its mournful tone, counting the remaining minutes left of the life of Crowther. The procession began to move towards the wheelhouse, as the Chaplain began reading the burial service and Berry and his assistant helping the poor wretch, almost bent double to walk with his stick. They paused at the doors of the wheelhouse, whilst Berry pinioned his hands. The doors opened revealing the hideous machine of death upon which he was about to suffer. He was helped by two warders who positioned him under the beam and over the pit. Berry fastened his ankles and adjusted the cord around his neck. He refused the white hood, which normally covered the face preferring to look directly into the faces of the officials in front of the gallows. On the stroke of eight, Berry withdrew the bolt and the drop fell and the bell ceased to toll. The drop was short, 3 foot 6 inches but effective, except it left his head and shoulders above the platform in a grotesque manner for all to observe. Death was quick and the calculated drop proved effective. The cost of one pennyworth of pears was paid for by the lives of two men.

The Chaplain later stated he had confessed his crime and had died penitent. There was no struggle and death was instantaneous. Outside, the black flag was raised and fluttered in the winter breeze. A cold shiver ran down the spine of many observing it, as they began to turn away, making their way back to the warmth and comfort of their homes at Dodderhill, Droitwich and other places.

It appears that Crowther in the last remaining days of his life, asked for some leather so he could make himself a new pair of boots to get hung in. It is not known if his wish was granted.

# MURDER OF FREDRICK STEPHENS

Worcester 22 February 1890

Joseph Boswell, aged 29, gardener, Samuel Boswell, aged 39, gardener, and Alfred Hill, aged 28, gardener, all from Evesham were charged with the murder of Fredrick Stephens, they were tried at the Winter Assizes held at the Shire Hall on 17th February. 1890.

The Judge was Mr Justice Hawkins who was met by the High Sheriff at Foregate Street station. The prosecuting counsel was R. H. Amphlett and Mr Jackson and Mr Cranstoun counsel for the defence.

They pleaded guilty to assault and not guilty to murder.

On Saturday 9 November 1889, the two Boswells and Hill were drinking at the 'Jolly Gardeners'. They were slightly inebriated and talkative and were in the company of others in a crowded smoky room. They were boasting that they were going poaching later that night, after they left the public house and said it would be hard luck on anyone who tried to stop them, or stood in their way of them achieving their purpose.

Joseph Boswell denied going with them and said he went home drunk and was not involved in the assault on Stephens.

Fredrick Stephens was an under gamekeeper for the Due d' Aumale at Lenchwick. On 9 November, he was on duty in Lenchwick woods, with George Bayliss, who was a fellow gamekeeper. It was a very light night. They started duty together at nine o'clock and split up about 2.30 a.m. and went their separate ways. Shortly afterwards he saw three men coming towards him, each carrying a bag that appeared to be quite full and each armed with a stick. They had two Lurcher dogs, which he identified as one brown and one white. As they got closer he recognised that the tallest of the trio was Joseph Boswell, who at that time he knew only by his surname, and described what he was wearing. He stated that it was Joseph Boswell who initiated the attack upon him by saying, 'Give it to

him lads'. They then closed in upon him and struck him heavy blows with their sticks and knocked him to the ground. They began to kick, punch and beat him about the head and shoulders and Joseph Boswell sat astride him and attempted to throttle him, so he bit his finger. In self-defence he struck one or two of them with his stick, before eventually becoming unconscious. He awoke, covered in blood, not knowing how long he had lain there. He got up and made his way to the house of Benjamin Wasley, the head keeper, who got out his horse and trap, and took him first to Evesham police station, where he made a statement to Police Sergeant Turner, naming and describing Joseph Boswell as one of his assailants and that he had bitten his finger. He then took him, accompanied by Sergeant Turner, to Dr Haynes who dressed his wounds, finally taking him home about 5 a.m.

On the information given by Stephens, Sergeant Turner and PC Brunton went to Littleworth Street and positioned themselves in a factory entrance opposite Joseph Boswell's house, where they could observe the house without being seen. About 4.15 a.m. Joseph Boswell came out of the house without a coat or shoes and looked up and down the road, as if to see if anyone was about.

He had a prison record for poaching, assault, stealing and drunkenness. PC Brunton crossed the road and said 'Good morning Joe, what brings you up at this time of the morning?' He replied, 'I was drunk last night and have slept on the couch and have come out for a breath of fresh air.' PC Brunton then asked him for a match and remarked that he did not know that he had lost part of his finger. Boswell then showed him his fingers.

He then turned his back on the constable and tried to shut the door in his face. This was prevented by Brunton, who held his stick in the door. At the same time Sergeant Turner approached and asked what the matter was, to which Joseph Boswell said he would open the door to him. Both officers then went into the house. Brunton suspected there was someone else in the house and thought he caught sight of someone leaving by the back door as they entered. As he went into the house he saw James Boswell's dog, a light coloured Lurcher with lots of white on it and also the dog belonging to Joseph Boswell, which was a dark coloured Lurcher. Both started to bark. He asked Joseph Boswell if he could see his shoes and was shown a pair of dry ones that had not been used for some time. Joseph Boswell then began to rave and shout and asked him for his search warrant and ordered him out of the house. Brunton saw a pair of boots under a table with fresh dirt on them.

Mary Ann Smith who lived in Littleworth Street said she saw Joseph Boswell go to his house about 10.30 and a few minutes later, saw Alfred Hill with his dog go towards Boswell house. She went on to say that she went to Joseph Boswell's house later on the ninth because she could hear the children crying. There was no one in, except the children and the dog was nowhere to be seen. Mrs Boswell returned and she stayed talking to her until 12.30, during that time she saw none of the Boswell males or their dogs. She went home to bed, but was awakened at

4.30 a.m. by dogs barking and loud talking. She looked out of the window and saw Joseph Boswell with two policemen.

Joseph Boswell was arrested and charged with assault and cautioned. He made a statement implicating the other two. 'Bonnie' (nickname of Samuel Boswell), was taken later, but Hill absconded to avoid arrest and went to his brother's house at Birmingham. A tip off was given to the police that a man answering the description of Hill was working at the Birmingham Gas Works. On 19 December PC Bayliss, who had previously lived at Evesham and knew Hill, went to the gas works disguised as a workman and observed him, but he was not absolutely sure. He got closer to him and said, 'Hello Lovely' (Hill's nickname). Hill's reaction was one of shock, horror and panic. The PC grabbed hold of him and told him he was arresting him on a charge of murder. He struggled and swore, but with the assistance of others he was secured. He made a statement, blaming the Boswells, adding that he only went along with them after being asked three or four times and only joined them at the last minute.

After the death of Stephens they were all charged with his murder and made statements to the affect that they were all involved in the assault. Each implicated the others but denied murder.

Benjamin Wasley in his evidence described how Stephens came to his house about 3 a.m. on Sunday the 10th, covered in blood and how he took him to the doctor's. About 6.30 a.m. the same day, he went with George Bayliss to the scene of the assault and examined the area, where the grass had been flattened and trampled, as if someone had been lying on it. They found Stephens's hat and stick and there was blood on the grass marking the spot where Stephens had lay unconscious.

Doctor Haynes described his wounds as mainly scalp wounds, bleeding freely and he had been knocked about a great deal. He dressed the wounds and sent him home. On the 12th he was slightly drowsy, but easily roused and checked by Dr Strange and Dr Haynes, who again examined him for fractures, but found none.

Two days later he was feeling a little better but on the 15th he was feverish and festering from his scalp wounds, which on examination he found a fracture. With the aid of his brother, also a surgeon, they performed an operation to remove some bone during which, they found other fractures.

On the 16th Dr Strange and Mr Bennett May, an imminent surgeon from Birmingham, were brought in for a second opinion and for further surgery, if necessary, which was carried out by them. He was seen on the 17th, 18th and 19th and his condition was said to be satisfactory. He was able to identify Joseph Boswell from a line up as being one of his assailants. On 23 November he was dead.

The post mortem said there were fractures all over his head and a particularly large one on the forehead. There were many other injuries to other parts of his body which they stated were probably caused by fists, kicks and sticks. They were

unable to diagnose the presence of the fractures at the onset and even if they had done, they would have known it was hopeless from the beginning. It was said to be remarkable that he had lived so long with such injuries. He was twenty-eight years old, very healthy looking and powerful.

Death was due to inflammation of the brain and the injuries were caused by heavy blows from kicks or sticks.

On the evidence of Stephens, Doctor Haynes examined Samuel Boswell on 17 November and Joseph Boswell on the 21st and found them to have various cuts, bruises and abrasions. The fact that Stephens did not die immediately after the assault, raised a point of law by the defence counsel as to how long the men could be 'held responsible for his death.' The Judge replied up to a year. There was also a second technicality, which arose due to treatment he had received from the doctors and surgeons, 'Could the doctors, by their treatment, have contributed to his death?' All were called to give evidence, but the post mortem stated he died from 'inflammation of the brain' and would have died anyway so it was hopeless from the start.

The judge found no single thing that was done by the surgeons that aggravated the injury. Dr Haynes stated he checked the wounds for fractures, but could not find any at the time, although he suspected there might be.

On 26 November, Joseph Boswell made a further statement, to which both Sergeant Turner and PC Brunton were witness. He was cautioned but admitted to being in Lenchwick Covert, with his brother Bonnie and Alfred Hill. Hill shot at a pheasant with a catapult and Stephens came up to them and struck his brother on the face and then struck Hill. In retaliation, Joseph Boswell then struck him in the face with his fist. They tussled together and Stephens bit his finger.

Joseph Beard, a gardener, said his yard overlooked that of Joseph Boswell's and that on 10 November about 4 a.m. he heard a noise. He looked through his window and saw Joseph Boswell, Samuel Boswell and Fredrick Hill and also Joseph Boswell's wife, who said, 'take the wall or you will be taken'. He then saw Samuel Boswell and Hill climb over the wall.

Elizabeth Boswell, wife of James Boswell of Bewdley Street, said that on 9 November, Joseph Boswell asked her husband 'if he was going to have a run out tonight'. He replied 'No'. Joseph said to her later 'we have nigh killed a keeper' and said they started throwing stones and then assaulted the keeper, who then bit his finger.

The Judge stated that the law was, 'If men were found in woods in the middle of the night with purpose of taking game, the keeper had a right to arrest them.' The Judge summed up telling the Jury it was for them to make their mind up. If he died within a year it was murder.

The jury returned in about an hour and the Clerk of the Assizes then asked the Foreman how they found in the case of each of the prisoners. After the name of each the Foreman answered 'Guilty' and added a strong recommendation to mercy.

The Clerk of the Assizes then asked the prisoners if they had anything to say why the sentence of death should not be passed on them according to law. Neither of the prisoners made any reply and his Lordship then proceeded to pass sentence of death.

The Judge assumed the black cap and, in a most pathetic admonitory speech, passed sentence upon the three convicted men saying they had been convicted by a jury of their own country men who 'have listened intently to the evidence put before them by their able learned counsel in their defence and have found you guilty of the crime of wilful murder, no evidence has been found to enable the charge to be reduced the crime to that of Manslaughter. You were found trespassing on land intending to commit a felony and when charged by a man employed to protect his master's property, you cowardly attacked him, three to one, beating him senseless and leaving him for dead. The law for murdering another person is death, a law not made by me, but administered by me, the jury have recommended you to mercy and I will pass that recommendation to those who are able give mercy. It only remains for me to pass the sentence of death upon you, that you will be taken from here to the place from whence you came, and there he hung by the neck until you are dead and your body buried within the precincts of the prison, and may the Lord have mercy upon your soul.'

The execution date was fixed for Tuesday the 11th. A petition, organised by the Vicar (Revd R. Straffen), supported by over 2500 signatures and begging for the three men's lives to be spared, was sent to the Home secretary. He replied by reprieving Hill and leaving the Boswells to suffer the course of the law. This immediately caused controversy for a number of reasons. All three men had been found guilty of wilful murder. All three had taken part in the assault, one was not less guilty than the others and it was even said that Hill was guiltier than the others in so much he had struck the fatal blow. But since this was on the evidence of Joseph Boswell it was ignored and medical evidence proved there was more than one fatal blow, which could have been struck by one, or all, of the culprits. At the time of the trial it was said that Samuel Boswell (Bonnie) was the lesser participant, yet he was left to hang along with his brother.

The only thing in Hill's favour was that he was not in the public house the evening before the murder, at the time when the two Boswells were boasting how they would serve anyone who interfered with their planned activities, later that night. This in effect made the murder pre-meditated and could not be reduced to manslaughter. In other words they stated they went with the intention of murdering anyone who stood in their way.

There was universal indignation amongst the population of Evesham, prompting the Revd R. Straffen, upon receiving the Home Secretary's reprieve of Hill, to write a letter of indignation of the Home Secretary's decision, begging him to reconsider his verdict. Not only did he send a letter, but he caught the early evening train to London to see the local MP and the Home Secretary. Due to the lateness of Hill's

reprieve, however, there was very little time left before the execution of the other two to look for fresh evidence and since the Home Secretary had already made his mind up, further protestations would be useless.

Many other letters were sent protesting to the Home Secretary's decision by groups and individuals who were outraged by his decision, begging him to reconsider and reprieve the other two guilty men. Some even wrote to his Royal Highness, the Prince of Wales asking Him to intervene and persuade the Home Secretary to change his mind. A reply from Whitehall on 10 March 1890 was to the effect that after careful consideration the sentence of Hill would be respited and commutated to penal servitude for life (hard labour). It was also stated that no reason could be found for intervening with the course of the law regarding Joseph Boswell and Samuel Boswell.

### The Execution of the Boswells

The execution took place on Tuesday 11 March inside Worcester Gaol. A small crowd of about fifty had gathered outside the prison mainly consisting of young boys. People gathered in groups, their main discussion being the Home Secretary's decision to reprieve Fredrick Hill. By 7.30 the crowd had increased to about 1200 and all eyes were concentrated on the flagpole. At 8.05 the flag rose above the prison wall indicating the Boswells had paid their debt to the society, and the crowd began to disperse.

Both prisoners ate a hearty breakfast and the Chaplain joined them shortly afterwards. The two men listened intently to his administrations. They were both very penitent and signed a letter addressed to Mrs Stephens, widow of Alfred, expressing their contrition for having deprived her of her life companion. It was also signed by Hill who was in a cell in another part of the gaol, about to start a life of hard labour under the terms of his reprieve. The press was admitted about 7.30 and at 7.45 the prison bell began its dismal toll, each strike counting the last remaining minutes of their lives, reminding the two offenders that their time in this world was drawing to a close. At the same time it reminded Hill who was in another cell that he was not to share the forthcoming fate of his partners in crime. Also at this time, the reporters and witnesses were admitted into the wheelhouse, where the apparatus of death stood waiting to receive its victims.

James Berry double-checked to see that the trap door was working efficiently and responding when the fatal bolt would be drawn. Beneath the doors was a pit measuring 7 feet 6 inches long by 5 feet wide and 10 feet deep. Originally the beam had been prepared to receive three men, with three rings for the ropes to pass through, but now only two would be used. By five-to-eight Berry had completed all the preparation and left the wheelhouse and made his way to the cells, holding in his hands the straps for pinioning the hands of his victims. He first pinioned Joseph and positioned a white cap on his forehead and left him in the care of his assistant and a warder. He then made his way to Samuel's cell and carried out the same operation.

The prisoners then joined the procession of dignitaries, witnesses, warders, Berry and the Chaplain, as they made their way towards the gallows house and halted momentarily at the doors. The caps were then fully drawn down over the eyes and face, the doors were opened and they were led inside and positioned beneath the beam by a warder on each side of them supporting and directing them. They were positioned on the two white chalked crosses marked on the traps, being all the time oblivious to the scene which had normally confronted previous victims. Berry's assistant strapped their legs, whilst Berry did the final adjustments to the ropes. Both men murmured 'Oh Lord have mercy upon us.' The bolt was drawn and the drop fell. The sudden jolt, as the bodies fell to their maximum limit permitted by the slack rope, tensioned the ropes making them quiver.

Wood Norton Hall was owned by the BBC from 1939, when it was used for sending and receiving messages from Europe during the Second World War. It was later used for training BBC personnel. It has been used as a hotel in recent times, and at the moment it is closed, but is said to be reopening sometime in the future as a hotel. The BBC still owns a large part of the estate. It is on the A44, about 2 miles west of Twyford.

The woods where the assault upon Fredrick Stephens took place, is on the Wood Norton Hall Estate. It was bought by the Due d'Aumale in 1872, who had been previously living there for some time. He was the fourth son of the King of France and he died in 1897.

# THE BARBAROUS MURDER OF CHARLOTTE PEARCEY

Worcester, 21 July 1893

Joseph Pearcey, aged sixty-nine and his wife Charlotte, aged seventy-one, lived comfortably together on their own, at Long Eye, Lickey End, Bromsgrove, on the road leading to Burcot, where they owned a small shop selling groceries and other things including coal, fruit vegetables, and sweets. On Monday 9 January, 1893, a hawker called at their shop who was selling writing paper, which he carried in a black box. He seemed to have difficulty expressing himself as to what his business was about, producing a card which stated he was deaf and dumb, and was signed by Charlie Westmorland. Mr Pearcey, partly out of sympathy for the man, purchased a few sheets and the man reciprocated by buying an apple for a halfpenny, which Mrs Pearcey put in a tin that was kept for money taken in the shop. The gentleman then left and continued to visit most of the houses remaining in the neighbourhood, selling his writing paper.

On Friday 13 January, Mr Pearcey was not feeling very well, and decided to spend the day in bed and sent for the doctor and left his wife to attend to the shop. At about 10 o'clock he heard footsteps coming upstairs and a man suddenly came into the bedroom. Mr Pearcey was not alarmed by the appearance of a strange man, as he was expecting the doctor or his assistant to call, so he said nothing, but he was concerned when the man started to rifle through three boxes that were kept in the room, in which they kept their belongings, but he did not appear to take anything. The man suddenly realised he was being observed by Mr Pearcey lying in the bed and quickly turned and went down the stairs, Mr Pearcey jumped out of bed to follow him only to see him disappeared out of the front door and locking it behind him. Suddenly Mr Pearcey became very uneasy, something was amiss and he started calling for his wife. On receiving no reply, he franticly started to search for her and found her lying behind the counter with a great gash on her head with blood pouring out, She died at about 4 o'clock in the afternoon; he looked at the clock and noted it was now twenty minutes past ten. Upon trying to open

the front door to get help, he found he was locked in. Having obtained a hammer and chisel he forced the lock, opened the door and called for help. Ellen Noakes, a young woman who lived at Long Eye, who had this same morning bought some coal, was returning the wheelbarrow when she heard the lock being forced and the cry for help. Together with Jane Adams, who was passing by, she went for a policeman. On his arrival, Mr Pearcey checked the boxes upstairs and the cash tin to see if anything was missing. There seemed to be nothing missing, but he did find a blood stained axe with grey hair attached to it in one of the boxes, which he took down stairs and gave to the police constable. Mabel Sanders, who was their nearest neighbour and often did celaning for them, witnessed this. She came to the shop after hearing Mr Pearcey's cry for help, but stated she had never seen the axe before. She came into the shop and saw Mrs Pearcey lying on the floor with the deep wound on her head and stayed with her until she died the same afternoon. The axe was the type used by carpenters and joiners, and had the name H. Daly stamped on the head. The grey hair on it matched that of Mrs Pearcey.

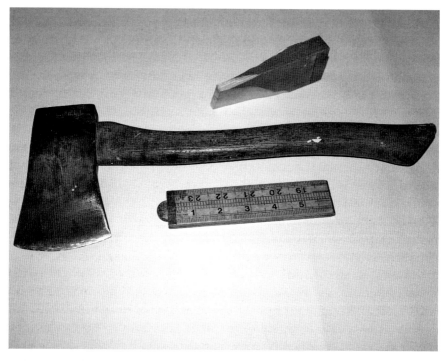

A carpenter's axe, weighing about *2lbs*. The cutting edge is usually honed, with an oil stone to a razor sharp edge and is used for cutting wooden 'plugs', which are driven into brickwork joints, with the blunt end of the axe, when fixing skirting etc. It was a useful tool in the hands of most carpenters and joiners, but a lethal weapon in the hands of Monsieur Aime Holman Meunier.

After some recollection Mr Pearcey realised the man who had come into his bedroom was the deaf and dumb man, who had sold him the writing paper the previous Monday. His description of the man was confirmed by other witnesses, who also saw the man on the previous Monday as he peddled his wares from door to door, who professed to be deaf and dumb. He had also been seen on the Friday of the murder by other witnesses, their description also agreeing with that of Mr Pearcey. The police quickly got onto his trail, tracing him first to Bromsgrove railway station, where he was seen at 11 o'clock as he tried to get a train to Birmingham, but was told he had just missed one. He then took the next train to Droitwich, where he caught a train to Birmingham, that stopped at Bromsgrove station, where the police were checking the carriages. They actually looked into his carriage, but failed to recognise him. Once back in Birmingham he went to his lodgings in Great Colmore Street, where he and his wife were living with Mrs Rachael Levi, under the assumed name of Pendare. He hid himself at the house and did not venture out for a number of days, and instead discussed with his wife what they should do next. Finally his wife obtained a cab, which took him to the railway station, where he caught a train to Dover.

In the mean time, the police had traced the axe to Birmingham and found an H. Daly, a carpenter that worked for a company renovating a shop close to the house of Mrs Levi, where Henry Daly had lost his axe there one day last week.

On being shown the axe, Mr Daly produced the name stamp that he had used to imprint his name on the axe head and his other tools. He remembered a man loitering in the work area observing him at work on 11 January, the day his axe disappeared. He described him as being of medium height and build, of dark complexion with a small moustache, aged about twenty-five and dressed in a brown suit. This description exactly fitted that given by Mr Pearcey and the residents of Lickey End, and also the staff at Bromsgrove station, all fitted the man who was selling the writing paper.

Enquiries in the area of the shop, where the axe went missing, brought the police to the door of Mrs Levi, his landlady. Upon questioning his wife, it was discovered his real name was Aime Holman Meunier, a French speaking Belgium, who spoke very little English, but his wife was English. By now he had reached Brussels, where he was arrested by the Belgian police, on information that had been wired to them, and was extradited back to England for trial. He made a full confession with the aid of an interpreter to the Bromsgrove police. However, no definite motive could be found; the reason for the crime was very vague. Nothing appeared to be missing from the shop or the bedroom. His confession stated he had joined the 'anarchists' movement in Birmingham and that his name had been drawn by lottery to carry out an assassination of a magistrate at Bromsgrove and that the weapon chosen to do the deed was an axe. Having watched the carpenter at work in the shop on 11 January he saw his chance to obtain an axe when the carpenter placed it on the windowsill, and chose the opportunity to pick it up and

conceal it inside his jacket.

Edward Poynton, a young painter lad, was working at the shop in Bellbarn Road, Great Colman Street and saw the prisoner looking around at 1 p.m. He identified the prisoner from a line-up of nine men.

Having struck Charlotte Pearcey a single blow to the head, splitting her head wide open, he went upstairs quite prepared to kill anyone who stood in his way or could act as a witness. He did not at first appear to be aware of Mr Pearcey lying in bed as he went through the boxes, immediately dropping the axe into the box before rushing out of the house. It was perfectly clear to all that he was the guilty man and the only way to save his life was a plea of insanity, which was proposed by his counsel, various doctors provided evidence otherwise.

Whether he hid the axe in the box to incriminate Mr Pearcey, is not known.

The Trial

At exactly 10.30 on Wednesday 18 July, a fanfare of trumpets greeted Justice Baron Pollock as he approached the bench to open the proceedings at Worcester Assizes. The jury were thereupon sworn.

Mr Jelf QC appeared for the prosecution and Mr Marchant, for the defence. Aime Holman Meunier, alias Pendare, was charged with the murder of Charlotte Pearcey of Lickey End. When asked how he pleaded he said not guilty.

The trial of Meunier was clearly hopeless from the start; it was really only a formality. Meunier made no excuse for his conduct and offered no alternative alibi that might save him from the gallows, although a plea of insanity, if proved, could have saved him from execution, but only for him to spend the rest of his life in a lunatic asylum. A verdict of not guilty was impossible, as all evidence had been verified by a large number of witnesses and he had also confessed his guilt, it was premeditated murder, proved by the manner in which he selected his victim. This was shown by his visit on the previous Monday to size up the situation, the stealing of the axe on the Tuesday and the feeling of martyrdom for what he considered a just cause.

His motive was not clear and there was nothing stolen. Money, goods and valuables, etc., were left intact. He stated that he had joined a group of activists called anarchists, who appeared to be a group of extremists, and who would stop at nothing to achieve their ends. As a new member, he had to prove himself that he was worthy of being a loyal trusted member, and was designated a task by his superiors, which had to be executed in a certain manner, i.e. by use of an axe. The planning he had done was done to perfection, a trial run to reconnoitre the district and place where he was to carry out the wicked deed. His only intention was to kill Mrs Pearcey. The evidence was beyond dispute.

The axe was produced in court and identified by Mr Daly as belonging to him and by the PC who received it from Mr Pearcey.

The police found no evidence to prove he was even a member of the anarchists

or that he had any connection with them at all and that the whole story he told had been concocted by him.

After hearing all the evidence the Jury retired and after careful consideration returned a verdict of '*Guilty*'.

The Judge then put on the black cap, and passed the sentence of death.

Letters were sent to the Home Secretary pleading for his life on the grounds of insanity, but to no avail. The Home Secretary replied that he had given careful consideration to the case, but could not find a reason to interfere with the course of justice.

The execution took place on Tuesday 19 July 1893, it was a dull damp morning and by 7 o'clock small groups of people began to gather outside the prison entrance, which was nothing as large as what they were like previously, when the executions were in public and there would hardly have been a space to be found.

Various officials, the Catholic minister and the press, who were to be witnesses of the execution, had arrived to carry out their duties. Inside the prison the condemned man was woken up at 7 a.m. and was attended to by the Revd Father Knight, who administered spiritual consolation. At 7.45 a.m. Billington entered the condemned cell to carry out his duties, of pinioning his hands and the prison bell began to toll each minute remaining of the man's life. He then joined the procession conducting him to the death chamber, where the gallows awaited him. The beam, supported on two upright posts, had previously been prepared by James Billington with a single noose at its central point. As he neared the death chamber the words of the burial service could be clearly heard. He was quickly positioned beneath the noose, standing on the chalked cross on the trap door, whilst his ankles were strapped, the white cap adjusted over his face and the noose adjusted with the ring below the left ear. On the stroke of eight, Billington withdrew the bolt and the drop fell. By 8.15, Amie Holman Meunier was considered to have paid his debt to society and the bell ceased to toll and the black flag was raised.

James Billington, said to have a record of 151 executions recorded in his name, was assisted by his eldest son Thomas who was executioner from 1872 to 1902. His second son William became executioner from 1902 to 1905 and John his third son, from 1880 to 1905. It was a family occupation that passed from father to son(s).

# MURDER OF HANNAH MIDDLETON

On the night of 10 May 1902 Samuel Middleton, aged forty-six, arrived home in his usual state of intoxication. His wife was anxiously waiting for him, with his dinner on the table going cold, which his dearly beloved had spent most of the day preparing for him. Immediately an argument arose resulting with him kicking the table upside down. The argument intensified over some money, which had been borrowed, raising their voices enabling them to be heard by Mrs Perks, who lived across the road and was the local busybody. The row dragged on and at about midnight he told his wife he was going to clear off and leave her, she remonstrated with him putting her arms around him to prevent him leaving. In a fit of rage and drunken stupor, he grabbed the poker and struck her once on the head, instantaneously regretting what he had done. She fell to the floor and within minutes was dead. Having realised what he had done he panicked and decided to burn down the house and hide the evidence of his awful deed. He then deliberately went out to the pigsty and collected armfuls of straw, which he piled in the house and set it alight, totally ignoring the risk to his next-door neighbour, who was an elderly woman. He then set off to his son's house and told him if he wished to see his mother again he had better go now. He then wandered off into the night not knowing, or caring, where he was going, ending up at Droitwich 24 hours later, where he was arrested.

Mrs Perks from across the road was awoken by shouts of fire, by which time the fire was well established. The charred body of Mrs Middleton was recovered the next day. Her body was in a mutilated condition, minus an arm and a leg and a poker and an axe was found in one of the rooms.

He was tried at Worcester Assizes at the Shire Hall on Tuesday 24 June before Mr Justice Wright, with Mr Amphlett KC for the prosecution and Mr Carmichael for the defence. The defence said it was manslaughter and pleaded provocation as she prevented him leaving. The jury were absent about 10 minutes and found the prisoner guilty of wilful murder. The Judge then assumed the black cap and read out the death sentence.

Worcester, Saturday 19th July 1902

The death chamber was part of the wheelhouse, which houses the gallows and also the tread mill, used for punishment of offenders committed for less serious offences. The room was over powered by a large timber beam spanning across the room, each end built into the wall for support, with a short length of chain at its centre to which is fastened the fatal rope with a noose at its end, directly over the trap doors of the drop and the chalk cross upon which the condemned man would stand. At about 7.30, on 15 July, the morning of the execution, a small crowd gathered outside the gaol and watched reporters and officials entering the gaol, older spectators reminisced on times past when executions were held in public, in front of vast crowds, either on the roof or in front of the gaol. Times had changed and even the flagpole on the roof of the gaol was now minus the black flag. The tolling of the bell still remained, but it did not start until the drop fell and the victim sent to eternity. The prisoner was executed on the stroke of 8 o'clock, shortly afterwards, the reporters and officials who had witnessed the execution left the gaol, their duty completed. The bell continued to toll for about 15 minutes then ceased its mournful message. A notice was attached to the main doors stating that Samuel Middleton had been executed in accordance with the law.

# MURDER OF ANNIE YARNOLD

William Yarnold was a forty-nine-year-old man, originally from Catshill, who had had a variety of jobs including that of a rag and bone man, but had spent most of his life in the army in the Worcestershire Regiment. He married Annie, his wife, on 7 April 1900, with whom he had previously lived for eleven years doing very little work. In the course of his army service he went to South Africa to the Boar War, 1896–1902. In his absence, Annie began a relationship with a man named George Miles. On her husband's return from the wars they lived together for only a few days, before she left him and returned to her 'fancy man' as her husband called him, where she continued to live for two years at Brickly Buildings at the Moors, Worcester.

On 4 October 1905 at approximately 5 p.m., she was outside the front of her house brushing the dust off the windowsill and chatting to a neighbour, when William Yarnold wearing a red scarf suddenly appeared. 'What brings you here?' said Mrs Yarnold, at the same time reaching around the front door to get hold of the key and prevent him going into the house. In doing so, she turned her back to him. He reached for something inside his coat and brought out a butcher's knife and plunged it into her spine up to the hilt. She gave a scream and William Yarnold turned and walked sharply away. The neighbour also screamed and shouted murder. Frank Thomas, a neighbour and landlord of the York House Inn nearby, heard the scream and cry of murder, looked in the direction it came from and saw a man in a red scarf quickly leaving. He then went to the aid of Mrs Yarnold, who lay on the ground with the knife in her back. He gripped the handle and pulled with all his might, at the same time pushing against her back with his left hand in order to pull out the knife with his right hand, which finally came free.

William Yarnold, meanwhile, made his getaway towards Pitchcroft, said to be possibly intending to throw himself into the river. He had been in the army for twenty-seven years, sending home some of his pay to his wife each month and was now in the Militia Reserve. He had enlisted under the name of Collins. He was

now living at Bevan's Rooms, Worcester where he was arrested and charged with attempted murder of Annie Yarnold.

Annie was taken to the Worcester Infirmary where she lingered for a while. There was no hope of recovery and she finally made a statement on her deathbed, which was later read out at the trial.

At the Inquest held Wednesday 11 October, Yarnold wore a dark suit and a red scarf. He was charged with the wilful murder of Annie, and was committed to appear at the next Assizes at Worcester. Annie Arnold was described as a quiet woman, house-proud and aged about forty years.

Worcester, 18 November 1905

The trial was held at Worcester Assizes, at the Shire Hall, before Mr Justice Kennedy, with Mr Farrant for the prosecution and Mr Harvey for the defence.

Mr Farrant opened the case for prosecution, describing the murder. He stated that William Yarnold, was an ex-soldier of the Worcestershire Regiment, who was discharged, having been in the army for about twenty-seven years, and is now in the militia reserve. He married Annie, in April 1900, and had lived with her previously for eleven years, during which time he did very little in the way of work, and ill-treated her. He was posted to South Africa, and in his absence she lived with George Miles. He asked the Jury to return a verdict of guilty.

His wife's statement was read out in court, she stated he started knocking me about, he was a horrible man, he would not work, I had to keep him by prostitution.

She was co-habitating with George Miles, and at the same time receiving an army 'Wife's Allowance' from the Government, which partly consisted of William Yarnold's own pay, and sharing it with another man, while her husband was on active service at the Boer War. His act, was considered by the Prosecution counsel, as pre-meditated murder, as he went prepared with the butcher's knife, but the Defence counsel viewed it as manslaughter on the grounds, of provocation through his wife receiving his pay whilst he was on active service. Yarnold said he went to see her to persuade her to come home. The judge in his summing played down the latter point of view.

The jury found him guilty and a recommendation was made for mercy on the grounds of provocation.

In Court he wore a suit and a red muffler and pleaded not guilty. He was described as a quiet man.

A reprieve was applied for, but refused, as there were insufficient grounds.

The Execution took place within the prison walls of the gaol at Castle Street, on Tuesday 5 December, 1905. It was a chilly December morning, from about 7.30 onwards, a number of onlookers drifted along, to stand outside the prison, amounting to about 300. A number of pressmen were admitted to witness and record the execution. At about 7.50 a.m., Henry Pierrepoint entered the condemned

man's cell and pinioned his arms, he was then escorted to the execution chamber, accompanied by the melancholy sound of the prison bell, where a reception of dignitaries and pressmen awaited him. The white washed room, recently painted, and furnished with seats to accommodate the visitors and officials, had the apparatus of death at its centre. The gallows consisted of a single beam supported at each end, with a single noose hanging at its centre, previously prepared by Pierrepoint in readiness to receive Yarnold, and positioned directly over the white chalk cross marked on the doors of the drop below. The two doors, upon which Yarnold would stand, opened downwards into the ten-foot deep pit below.

His legs were then strapped by Ellis, while Pierrepoint adjusted the white cap and the noose. The final Amen from the Chaplain was followed by a nod from the Governor and Pierrepoint released the trap, the doors fell with a crash and William Yarnold paid his final debt to humanity.

At 8.20 the prison bell ceased to toll; the practice of flying the black flag had been previously abolished. A notice was pinned to the main doors simply stating that William Yarnold had been executed in accordance with the law. He was later buried in the precincts of the prison.

The clothes he wore, for the occasion, was the same suit as before, but minus, the red scarf.

The multitude that had gathered outside the prison gates, then resumed their Christmas shopping.

# MURDER OF LILLIAN WHARTON

Thomas Fletcher, a press operator, aged twenty-eight, of Oldbury had been courting Lillian Wharton, aged twenty-one for almost two years. They were very fond of each other and planned to marry on 26 March, during Easter week. Her father was the landlord of the Fountain Inn, Albion Street, Brades Village, Oldbury. They had not got a house but they had decided to go ahead with the marriage and that she should continue to live with her father and mother at the Fountain, until they were able to get one. On Tuesday 25 March they went out together. The next day, 26 March, about 10 a.m. Lillian was upstairs preparing to go to the Registry Office to get married, but after a conversation with her mother she decided to call it off. On the arrival of Thomas both mother and daughter explained why the marriage was off, because another man had come into her life and she was finished with Thomas for good. This was a great shock to Thomas at such a late hour in their relationship and he got a bit over heated, lost his temper and said things he should not have done.

He called the next day and asked to see her. Her mother said yes providing he did not threaten her. Afterwards, the mother asked them if they had settled the matter and suggested they keep away from each other for five or six weeks. He said no.

On Saturday 29 March, Thomas saw a revolver in the window of a pawnbroker's shop in Dudley marked up at 10s 6d. When asked why he wanted it he told the assistant he wanted it for his own protection and signed the book accordingly. He then bought fifty cartridges from Mr Griffiths of Stone Street. The following Tuesday, he took the gun fully loaded and called at the Fountain Inn, where Lillian was in the kitchen. He sat in the tap room and called for refreshments, which she served him with. He then took the revolver from his pocket and said he intended to shoot himself in front of her (so he said). She begged him not to, there was a struggle and he accidentally shot her and then turned the gun on himself.

Mrs Wharton had gone into the garden to feed the fowl, when she heard two shots from the house; she met her daughter holding her hand to her stomach, who

Shire Hall, Worcester where Queen Victoria still proudly reigns, was built in 1835 by Charles Day and Henry Rowe, at a cost of almost £37, 000. Most of the Assize Courts were later held here, after moving from the Guildhall.

cried out 'Tom has shot me.' She went into the tap room, which was splattered with blood, and saw the prisoner on his back bleeding from wounds to his right cheek and the revolver lying on the floor.

The prisoner had attempted to kill himself, but the bullet went through his right cheek and came out below his eye. The police were called and they were both removed to the West Bromwich Hospital. The prisoner regained consciousness in the afternoon. The girl died on the Tuesday exactly a week after the shooting. John William Wharton, her father, said the couple were to have been married, but he had no knowledge of it. When he came home on the Tuesday, he found a crowd of people outside the house and found Fletcher on the floor wounded in the right hand cheek.

Lillian Wharton, aged twenty-one, died 8 April at West Bromwich hospital, due to a bullet wound. Fletcher was charged with the murder and pleaded not guilty.

They had been keeping company for about two years, they were engaged and the banns hung at the Registry Office. She was considered a very respectable girl, she lived with her parents and he lived with his mother. The marriage was disapproved of by her father and mother who advised them not to marry.

Her father on giving his evidence said passionately 'my girl was a darling, and a good girl,' he then rose to his feet and shouted out, 'isn't it enough to lose our girl without being cross examined like this?' He was cautioned and told to restrain himself, otherwise he would be ordered out of court. He said they were on affectionate terms until the Wednesday when they were to get married, but they were not afterwards

Dr H. P. Cooke, Oldbury, said he was called to the Fountain Inn, where he saw deceased on a couch with a bullet in the right side of the abdomen. It had gone through her corsets and the prisoner who was nearby had a nasty wound near his right eye. There was blood of the floor, walls and ceiling.

The revolver was identified by the pawnbroker as the one he sold to the prisoner for 10 shillings and sixpence. He said it was faulty and inaccurate at any distance above a foot from the target.

Fletcher was tried at the Assizes held at the Shire Hall on Saturday 5 July 1913 by Mr Justice Bray, with Mr J. P. Cranstoun for the prosecution and the Hon. R. Coventry for the defence, on a charge of wilful murder. He did not deny shooting her, but claimed it was an accident, that his intention was to kill himself in front of the girl.

The Judge's summing up favoured the evidence of the prosecution, it took the jury about 20 minutes to bring in a verdict of guilty. The judge then assumed the black cap and passed the sentence of death.

Shortly before eight o'clock on Wednesday 9 July his arms were pinioned and he was led from his cell to the coach house, where the apparatus of death awaited him. A solitary noose hung from the beam above with a chalk cross on the trap below, on which he was position with a warder on each side. His legs were strapped and a white hood pulled over his head followed by the noose, which was carefully positioned by Ellis the executioner. The warders then stepped back onto the solid platform and Ellis pulled the lever. The drop fell and Thomas Fletcher was conveyed into eternity.

There were less than two hundred people with a morbid curiosity assembled outside the gaol, their eyes fixed upon the flag pole on which the black flag was usually flown. They went away disappointed due to a change in the law doing away with the custom. At ten past eight the Gaol bell began to toll on completion of the execution.

# THE CHINESE CONUNDRUM

Zee Ming Lu, a Chinese man, lived in lodgings in Birmingham with a number of other Chinese men, who were all immigrants living in this country. They left China and their families hoping to find better opportunities in England than they had in their homeland. Many were employed in menial tasks in the service industries such as catering and laundry work, being limited in their choice mainly because of language barriers.

Zee was employed as a labourer. He was a good worker, thrifty and regular in his attendance and time keeping. This was up until Monday 23 June 1919 when he finished at his normal time of 5.15 p.m., but was never seen alive again. His body was found in Warley Woods in a secluded part by a young lad on Friday 27 June, lying full length on the ground with blood around his head. The police were called and a quick examination revealed he had a series of wounds to the head (supposedly inflicted with a hammer), stab wounds and some bodily mutilations, but there was no identification on the body. He died of a fractured skull.

Enquiries amongst the Chinese populace of Warley and Birmingham were met with a wall of silence. There was no apparent motive, although he was known to have a little money saved up. Some of the injuries suggested it might have been a revenge killing, or possibly it may have been the work of a Chinese Tong (secret society). The other reasons for silence, was language, culture and/or threat of deportation for wrongdoing and police intimidation. The investigation was conducted by the police forces of Worcestershire and Warwickshire, as the site of the murder was 100 yards inside the boundary between the two, but on the Worcestershire side.

The police got their first break from London where it appears, that on 24 June a Chinese man attempted to draw cash from a post office savings account at Kensington post office. There was some confusion over the owner of the book and again language difficulties arose between the Chinese man and the counter staff. It was suggested that he should be escorted by a member of staff to a police

station, where his credentials could be checked. He appeared to get the 'wind up' that everything was not going as easy has he had hoped, so he gave his escort the slip, leaving the post office bank book containing £240 in the hands of the escort, which was then traced back to Birmingham and found to belong to Zee Ming Lu, the murdered Chinese man.

On 25 July an English man was living in lodgings at Shepherds Bush, owned by a Chinese man, who was disturbed by a noise from the room above in the early hours of the morning. On looking out of the window he saw a Chinese man run from the building. Upon investigation he found a Chinese man in the room above had been attacked by a Chinese man with a hammer, which was found at the scene of the crime. The description he gave to the police matched that of the Chinese man who tried to draw cash from the post office. The hammer was also traced back to Birmingham, to a company called Briscoe's, who employed a Chinese man called Djang Djing Sung as a warehouseman. He has used such a hammer in the course of his work, but it had been missing since 23 June. He was arrested in Birmingham on 28 July and charged with the attempted murder of the Chinese man at Shepherds Bush and with stealing £7 5s and a watch and chain. The attacked man gave evidence for the prosecution at the trial.

Djang Djing Sung now made a statement saying he 'pinched' the hammer from his employer on 23 June, on the instruction of Li Ding Jig, who he gave it to, and that it was Li Ding Jig who committed the murder and stole the bank book, which he gave to him to withdraw the money so they could divide it between them. Whilst he denied he was the murderer, he admitted being present at the murder. He was considered to have a better understanding of English than what he admitted and it was thought most of his statements were untrue.

The Trial was held at Worcester Assizes at the Shire Hall on Wednesday 22 October, before Mr Justice Rowlatt. Djang Djing Sung, a man less than 5 feet in statute, aged thirty-three and described as a waiter, was indicted of the murder of Zee Ming Wu at Warley Woods, in the Parish of Oldbury, on 23 June. Mr Powell KC was counsel for the prosecution and the Hon. R. Coventry for the defence. An interpreter was engaged for the benefit of the defendant. The court was crowded; many thought it strange that the trial should take place at Worcester rather than Birmingham. Olbury, at this time, was still in Worcestershire, where the murder was committed.

Li Ding Jig took the stand as witness for the prosecution and denied that he had any part in the murder whatsoever. This brought a sudden outburst from Sung, standing in the dock, who shouted out 'He is the murderer, not me!'

The Judge in his summing up stated the prisoner had already admitted being present when the murder took place and to having obtained the hammer to do it, he also had the Post Office Books, which was stolen from the pocket of Lee and was in fact as guilty of murder as the murderer himself.

The jury took less than 10 minutes to reach the verdict of guilty. Mr Justice

Rowlatt then passed the sentence of death, the black cap was then placed upon his head and he recited the following: 'You will be taken from here to the place, from whence you came, and thence to the place of execution, where you will be hung by the neck until you are dead and then buried within the precincts of the Gaol where you were held, and may the lord have mercy on your soul.'

## The Execution 3 December

At ten-to-eight, four members of the press were admitted through the main gate and escorted to the execution chamber housed in the coach house, where the gallows had been erected in the centre with seats surrounding them. They took their places with the dignitaries, who were to witness the very last of the historic executions at Worcester. There was a chalked cross marked on the drop, which most observers focused on, where the condemned man would stand beneath the beam with a single noose hanging from it previously prepared by John Ellis the executioner. At about 7.50, Ellis went into the condemned cell and pinioned the arms of the diminutive Chinese man. Five minutes later Sung strode into the death chamber and positioned himself on the chalk cross beneath the noose, with all the confidence in the world, whilst most of the onlookers were shivering in their boots. His legs were strapped and Ellis pulled the hood over his face and made the final adjustment to the noose. As the last words of the burial service were uttered by the Chaplain, a signal was given by the Governor and Ellis withdrew the bolt. The drop fell and the Chinese man disappeared beneath the floor and out of sight. There was a slight vibration on the tensioned rope, which Ellis steadied with his left hand.

The Gaol bell began its melancholy toll announcing that the Chinese man had paid the penalty demanded by the law for his crime, at about the same time a notice was fixed to the main door with the same message.

The crowd in front of the Gaol was about thirty strong at its maximum.

Djang Djing Sung was the last person to be executed at Worcester after centuries of hanging. He was not the last person to commit murder in the county of Worcestershire or be sentenced to death, but any future executions would take place at Gloucester or Winson Green.

# MURDER OF ALICE MARY ROWLEY

Alice Mary Rowley was a 'brickle wench' aged twenty-two and unmarried. She worked at Hickman's brickyard in Hay Green, Lye, filling mould boxes with clay that first had to be softened by adding water and then treading on it with her bare feet (or 'dancing on it' as it was known in The Lye), to enable it to be compacted into the mould boxes and fill up the corners.

To protect her clothes, she would wear a hessian or hurdon bag around her waist, known locally as an 'urdon-baggen-apen' which all the girls wore. She was six years old when her father died, leaving a number of children of which Alice was the youngest.

A man called James Checketts, a widower, who had lost his wife some time ago, leaving him with a number of children, met up with Mrs Rowley, mother of Alice, and they became very friendly and decided to marry. The marriage was quite happy and the eldest children grew up and left home, leaving Alice Mary Rowley and Bert Checketts, the youngest children from each family, at home. James had a job at the brickyard looking after the horses, stables, and a house that went with the job, which he had occupied for a long time and where the two families continued to live comfortably until they reached maturity.

Bert Checketts, aged twenty-four, youngest son of James, took a fancy to Alice, his stepsister, aged twenty-two. Unfortunately she did not feel the same way about him. She rejected his advances and distanced herself from him, but this was not always easy living in the same house. Bert naturally felt hurt and dejected and they became outwardly hostile towards each other. She was a goodlooking girl, single and without a boyfriend. Things came to a head on the night of Sunday 5 July 1925, because Bert wanted to borrow sixpence off Alice, which she refused to lend him. James Checketts and his wife had gone to the Rose and Crown public house in Hay Green, opposite the brickworks. The two children found themselves on their own together and at loggerheads with each other over sixpence. At some point Alice fetched her mother back from the public house, which was only a short

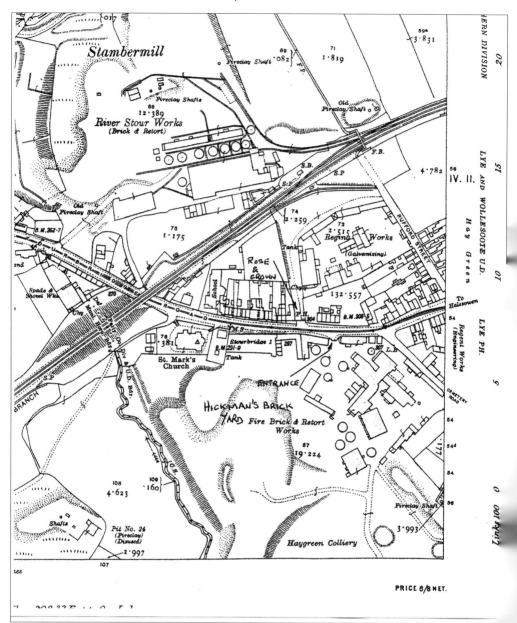

Above is the 1920 ordinance survey map of Stambermill and Hickman's brickyard. It clearly shows the position of the Rose & Crown and the entrance, almost opposite, where Bert Checkett stood covered in blood. The Hickmans, at one time, owned large areas of land in the 'Lye', where they obtained clay for the bricks and coal to fire them with and also the water mill, from which Stambermill takes its name. Stambermill was just to the left of the map and was fed by the Shepherds Brook (bottom left), on which there once stood second water mill, also owned by the Hickman's called Shepherds Brook Mill. Both made scythes. A second public house of the same name, stood at Lye Cross often called the New Rose & Crown, but was better known as the Americky Bar.

distance away. What the purpose of fetching her back was, is unknown. What is known though is that Alice's mother returned to the Rose and Crown with Bert, who left her there and walked on in the direction of Lye Cross.

Checketts was next seen outside the gates of the brickyard, saturated in blood. He spoke to a passing witness and said that a girl had cut her throat in the yard and that he was innocent and he had tried to prevent her harming herself further. The girl was later found dead in the stable yard with her throat cut and the wounds amounting to about fifty – to her neck, throat, upper part of her body, shoulders and arms.

News of the murder spread like wild fire throughout Lye and within minutes crowds gathered around the brickyard gates to watch the comings and goings, blocking the road. Checketts was arrested and secured at Lye police station and later taken to Stourbridge police station for questioning. He stated he was innocent and that the girl had cut her own throat with the razor, which he tried to take from her. The sanity of Checketts was questioned, but all evidence suggested he was not insane – perhaps simple minded, but not mad – and that he knew the difference between right and wrong. Her injuries were numerous. Many were on her forearms as if trying to protect herself from a frenzied attack and some were of a sexual nature, including slashes across her chest that could not have been self inflicted. A razor was produced in Court and identified as belonging to Bert Checketts, which he said he took off the girl. Dr Darby, a well-known, local and popular doctor, who lived near the Lye football ground just up the road from the brickyard, examined the girl and gave his findings at the inquest held at Stourbridge police station, which brought in a verdict of wilful murder. Bert Checketts was then committed to appear before the next assizes at Worcester and transferred to the Castle Gaol at Worcester.

He was tried at Worcester Assizes on Friday 23 October 1925 before Mr Justice Roche with Mr W. S. Mobberley, solicitor of Lye for his defence. A plea of insanity was made but turned down. He was found guilty and sentenced to death. His execution was set for Thursday 26 November at Winson Green. In the meantime Mr Mobberley, family and friends sent a letter to the Home Secretary pleading for a reprieve. After several days of anxiously waiting, a reprieve was granted and his sentence converted to life imprisonment and penal servitude (hard labour), which would be served at Pentonville or Maidstone prison.

# TRIPLE MURDER AT THE GARIBALDI

Twenty-three-year-old Herbert Burrows was a probationary policeman in the Worcester City force. He lodged at a house in Wylds Lane, Worcester, near a public house called the Garibaldi Inn, which he often frequented and was on friendly terms with the landlord and landlady. On Friday 27 November 1925, he stayed talking and finishing his drink after closing time, by which time all the other customers had gone home, leaving the landlord clearing away assisted by his wife. At about 12.30 the landlord decided to go into the cellar to turn off the taps to the barrels. He was followed by PC Burrows who pulled on a pair of gloves while chatting away, then suddenly pulled a revolver from his pocket and cold bloodedly (and for no apparent reason) shot the landlord Mr Laight aged thirty-one, in the back. The noise brought his wife Doris, aged thirty, into the cellar who he also shot. He then commenced a systematic search of the premises starting at the till in the bar, where he found the day's takings, which he empted. Next he moved upstairs to the bedrooms where Robert their son, aged two, started to cry. Herbert was afraid that the child's crying might attract the attention of others, so he battered the little boy to death fracturing his skull. He then continued his search and found a tin box with more money and a gold sovereign in a gold mount, which he slipped into his pocket. All in total amounted to about £65. After this, he let himself out.

The next day, Mrs Hardwick the cleaner, arrived about 7 a.m. only to find the front door locked, so she used her own key and let herself in. She called out to Mr and Mrs Laight as she entered, but got no reply, so she went up stairs to the bedrooms and found the master's bed had not been slept in. On going into the children's room, she spoke to the girl, but thought the little boy was still asleep, so did not attempt to wake him. She then went for assistance, to Mr Oram, who found the bodies in the cellar. The police were informed and arrived about 8 a.m.

Some time before 8 a.m. on 28 November, PC Burrows, in the course of his duty, met up with his colleague PC Devey and during their conversation Burrows asked him if he had heard about the shooting of Mr and Mrs Laight. This was a

fatal mistake. The police had not yet been informed, so how could PC Burrows know about them? PC Devey returned to the station and reported to his sergeant what he had heard.

Sergeant Fisher then went to the Garibaldi, saw the bodies and found the house in disarray and the empty till and cash boxes. Burrows was arrested on suspicion, his lodgings searched and the money and the sovereign was recovered. In a locked drawer a revolver was found, having recently been fired, along with a box of ammunition and a pair of gloves.

At first he stated that the landlord had let him out on the night of the murder, but he later admitted to the murder, although he refused to give a motive why he killed them.

On 27 January 1926, he was brought by a 'black maria' under a police escort from the gaol in Castle Street to his trial at Worcester Assizes, at the Shire Hall. En route there were jeers and insulting remarks shouted by people lining the streets and outside the court.

He was tried for triple murder by Mr Justice Sankey and defended by Mr H. R. Johnston, who pleaded for his life on the grounds of insanity, which was rejected.

During the trial he was cool, calm and collected and showed no signs of emotion. He did occasionally smile but he made no confession. The Judge in his summing up, described the murder as foul and brutal and that his motive was money, although there had been a suggestion of a relationship between him and Mrs Laight. This was denied. The Judge then assumed the black cap and passed the sentence of death, but with one slight difference from that of the past. The place of execution was no longer Worcester. He therefore had to be transferred to Gloucester, where he was hung at 8 a.m. on Wednesday 17 February 1926 by Thomas Pierrepoint. The assembled crowd was small, probably less than what could have been expected had it been at Worcester. A few minutes before 8 a.m. Pierrepoint entered the condemned cell to pinion his arms. The short walk to the execution chamber took only minutes, to where he was positioned beneath the noose and final preparations carried out. By 8.05 he had paid the price demanded by society.

It is said that at no time did he show any remorse, he ate a hearty breakfast and his time spent in the condemned cell was spent playing cards.

The arrangements at Gloucester for the condemned man differed to that of Worcester. The condemned cell was split into two parts, the day room and sleeping accommodation, with a door leading directly into the death chamber, which meant a very short walk for the prisoner. This reduced the normal escort required to a minimum of the principal participants of the chaplain, governor, executioner and a couple of warders.

From 8.00 he was accompanied by the tolling of the bell of the local church of St Mary, with the clear message that he was about to pay the price for his crime. There were a few people assembled outside the gates, possibly a hundred or so,

who were there out of morbid curiosity to read the notices of his death pinned to the main entrance doors. They showed no sympathy at all to the prisoner, most were outwardly hostile and glad he had been executed for the despicable crime, committed by a man who was supposedly upholding the law. The hoisting of the black flag after an execution was no longer a formality and the practice of hanging another human being was losing its popularity – it did not have the same attraction or reason as years gone by.

### OBITUARY

In April 1929 Worcester Gaol was divided into lots and sold. It was demolished in the 1930s. Capital punishment for murder was abolished in November 1965 and confirmed by Parliament in 1969.

The Assizes and Quarter Sessions, dating back to the twelfth century, ended in 1971, with the introduction of the Crown Courts.

The only indication of the existence of the gaol today are the street signs 'Castle Street' and 'Infirmary Walk', where the crowds once gathered to watch the executions. All contributing factors, which relate to 'Crimes of Worcestershire' have gone, except for murders of today, which still continue, along with the newspapers that report them and of course the ghosts of the criminals executed here in the past.